Drawing Grant Control of the Control

Second Edition

Mustrated

by John Layman and David Hutchison for Idea + Design Works, LLC

(www.idea and design works.com)

A member of Penguin Group (USA) Inc.

To everybody who's ever loved comics, especially those brave and foolhardy enough to make the leap from reading comics to creating comics. Also to Banfield Pet Hospital of North Seattle, for removing a nasty cyst from my favorite cat's head while I was writing this book.

—7ohn Layman

To every artist and writer in comics. To everyone who read a comic or manga and made the decision to become a part of it. And to Mom, who would draw Superman for me before I went to school each day.

—David Hutchison

ALPHA BOOKS

Published by the Penguin Group

Penguin Group (USA) Inc., 375 Hudson Street, New York, New York 10014, USA

Penguin Group (Canada), 90 Eglinton Avenue East, Suite 700, Toronto, Ontario M4P 2Y3, Canada (a division of Pearson Penguin Canada Inc.)

Penguin Books Ltd., 80 Strand, London WC2R 0RL, England

Penguin Ireland, 25 St. Stephen's Green, Dublin 2, Ireland (a division of Penguin Books Ltd.)

Penguin Group (Australia), 250 Camberwell Road, Camberwell, Victoria 3124, Australia (a division of Pearson Australia Group Pty. Ltd.)

Penguin Books India Pvt. Ltd., 11 Community Centre, Panchsheel Park, New Delhi-110 017, India

Penguin Group (NZ), 67 Apollo Drive, Rosedale, North Shore, Auckland 1311, New Zealand (a division of Pearson New Zealand Ltd.)

Penguin Books (South Africa) (Pty.) Ltd., 24 Sturdee Avenue, Rosebank, Johannesburg 2196, South Africa

Penguin Books Ltd., Registered Offices: 80 Strand, London WC2R 0RL, England

Copyright @ 2008 by Idea + Design Works, LLC

All rights reserved. No part of this book shall be reproduced, stored in a retrieval system, or transmitted by any means, electronic, mechanical, photocopying, recording, or otherwise, without written permission from the publisher. No patent liability is assumed with respect to the use of the information contained herein. Although every precaution has been taken in the preparation of this book, the publisher and authors assume no responsibility for errors or omissions. Neither is any liability assumed for damages resulting from the use of information contained herein. For information, address Alpha Books, 800 East 96th Street, Indianapolis, IN 46240.

THE COMPLETE IDIOT'S GUIDE TO and Design are registered trademarks of Penguin Group (USA) Inc.

International Standard Book Number: 978-1-59257-823-8 Library of Congress Catalog Card Number: 2008929019

10 8 7 6 5 4 3

Interpretation of the printing code: The rightmost number of the first series of numbers is the year of the book's printing; the rightmost number of the second series of numbers is the number of the book's printing. For example, a printing code of 08-1 shows that the first printing occurred in 2008.

Printed in the United States of America

Note: This publication contains the opinions and ideas of its authors. It is intended to provide helpful and informative material on the subject matter covered. It is sold with the understanding that the authors and publisher are not engaged in rendering professional services in the book. If the reader requires personal assistance or advice, a competent professional should be consulted.

The authors and publisher specifically disclaim any responsibility for any liability, loss, or risk, personal or otherwise, which is incurred as a consequence, directly or indirectly, of the use and application of any of the contents of this book.

Most Alpha books are available at special quantity discounts for bulk purchases for sales promotions, premiums, fund-raising, or educational use. Special books, or book excerpts, can also be created to fit specific needs.

For details, write: Special Markets, Alpha Books, 375 Hudson Street, New York, NY 10014.

Publisher: Marie Butler-Knight
Editorial Director/Acquiring Editor: Mike Sanders
Senior Managing Editor: Billy Fields
Development Editor: Lynn Northrup
Senior Production Editor: Janette Lynn
Copy Editor: Teresa Elsey

Illustrator: David Hutchison Cover Designer: Robbie Robbins for Idea + Design Works, LLC Book Designer: Kurt Owens Layout: Chad Dressler Proofreader: Laura Caddell

Contents at a Glance

Part 1:	Manga Basics2
1	Meet Manga!
2	Beginning Body Building
3	Man Alive: Some Basic Male Body Shapes
4	Sugar and Spice and Everything Nice: Some Basic Female Body Shapes
5	Bodies in Motion
6	Talk to the Hand
Part 2:	Making Faces80
7	Not Just Another Pretty Face
8	The Eyes Have It
9	Face Off
10	Hair Today
11	Express Yourself
Part 3:	Character Types
12	Stars of the Show
13	Support Staff

14	Rough and Tumble	154
15		
13	Heavies Bad guys (and gals) steal the show.	164
16	Weird and Wild Oddball creatures in the world of manga.	176
Part 4:	Manga Nuts and Bolts	196
17	Put It into Perspective	
	How to give your art dimension.	
18	All the Angles	208
	Choosing the best angle for your panel.	
19	Need for Speed	222
	An examination of manga's unique speed lines.	
20	Light Up Your Life	236
	An illuminating discussion of light and shadow.	
21	Words and Pictures	250
	Comics are words as well as pictures.	
Part 5:	Round Out Your World	266
22	Make It Mech	
	Manga's mechanical universe.	
23	Draw Arms!	278
	Weapons for your artistic arsenal.	
24	Manga's Driving Force	
	How to draw vehicles.	
25	World Piece: Backgrounds and Environments	296
	Drawing backgrounds, cities, and landscapes.	
Appendi	Xes	
A	Recommended Reading	316
В	Online Resources	321

Contents

Part 1:	Manga Basics	
1	Meet Manga!	5
	Manga? What's That?	
	Manga in Japan	6
	So, What's the Diff?	6
	What's the Matter with Manga?	7
	Mangamerica: Manga in the United States	7
	Anime: Manga's Cartoon Cousin	8
	Reading Manga Right or Left?	
	What You Bring to the Table	
2	Beginning Body Building	11
	The Shape of Things to Come	11
	Everything in Order	12
	Figure It Out	14
	More So with the Torso	18
	Bodies and Language	
3	Man Alive: Some Basic Male Body Shapes	
	The Athletic Male	
	The Teenage Male	
	The Muscular Male	35
	The Husky Male	
	The Young Male	42
4	Sugar and Spice and Everything Nice: Some Basic Female Body Shapes	
	Battle of the Sexes	
	The Athletic Female	
	The Teen Female	
	The Adult Female	
	The Female Child	
5	Bodies in Motion	65
	Manga to Move You	65
	Sucker Punch	66
	Run for Your Life	
	Leap into Action	70
	High Kick	72

6	Talk to the Hand	75
	Helping Hands	75
	A Handy Lesson	76
	Hands as Character Traits	
	The Many Faces of Hands!	79
	A Fine Body of Work	
Part 2:	Making Faces	81
7	Not Just Another Pretty Face	83
	Facial Proportions Made Easy	83
	The Female Face	
	The Male Face	
	The Child's Face	
8	The Eyes Have It	
	Windows to the Soul	91
	Them Big Baby Blues	92
	Exemplary Eyeballs	93
	Advanced Placement	95
9	Face Off	99
	Now Ear This	99
	Nosing Around	
	Mouthing Off	
	Put Your Best Face Forward	107
10	Hair Today	109
	Some Male Styles	109
	Some Female Styles	
	Coloring Hair in a Black-and-White World	113
	Setting the Tone	114
11	Express Yourself	119
	Making Faces	119
	Get Happy	
	Tears and Tragedy	
	Mad Manga	
	3.61 (1.75)	125

Part 3:	Character Types	129
12	Stars of the Show	131
	The Fantasy Swordfighter	
	The Schoolboy and Schoolgirl	
	The Pilot	
	The Punk	
	The Kid Detective	
13	Support Staff	143
	The Second-in-Command	
	The Best Bud	
	The Goofy Pal	
	The Science Mentor	150
	The War Horse	
	The Coach or Trainer	
14	Rough and Tumble	155
	Bruisin' and Brawlin'	155
	The Gunslinger	156
	The Tough Guy	160
	The Martial Artist	161
	The Sports Hero	162
	The Beautiful Spy	162
15	Heavies	165
	The Vampire	166
	The Soldier	170
	The Mage	
	The Sorceress	173
	The Corrupt Businessman/Government Agent	175
16	Weird and Wild	
	Crafting Critters	177
	Amphibian in Armor	178
	The Bront Beast of Burden	180
	Winged Wonder	
	Claw Critter	184
	Two Tails	
	Snake-Eyed	188
	Ant-Art-Trick	189
	A Whale for Your Tale	191
	Introducing Mr. Octopus	193
	Fierce Flyer	194

art 4:	Manga Nuts and Bolts	197
17	Put It into Perspective	199
	What Is Perspective?	
	Points of Perspective	
	The Bisected Square	
	Perspective and Scale	204
	Circles in Perspective	206
18	All the Angles	209
	Three Basic Shots	209
	Getting Extreme	
	Going Long	
	New Views for You	
	Foreshortening	
19	Need for Speed	223
	To Speed or Not to Speed?	224
	Speed It Up	
	Walking the Fine Line	
	Burst of Energy	
	Last Line	235
20	Light Up Your Life	237
	Source, of Course	237
	Illuminating Illumination	
	Silhouetiquette	
21	Words and Pictures	
	Exported Manga	251
	Talking About Talking	252
	Shaping Your Balloons	252
	Balloon Effects	254
	Every Balloon in Place	
	Sound Off	261
	Visual Effects	262

Round Out Your World	267
Make It Mech	269
Mech vs. Mecha	269
The Marvelous Mechanical World of Manga	270
Robo-Babe	270
Mecha Man	274
Common Mech	276
Military Mech	
Draw Arms!	279
Close-Quarter Combat Weapons	282
Oddball Armaments	284
Manga's Driving Force	287
Keeping the Skies Safe	293
World Piece: Backgrounds and Environments	297
Making the Outdoors Great	298
Cities of Manga	303
Just the Beginning	315
xes	
Recommended Reading	317
Online Resources	
	Make It Mech

and the second of the second o

en de la companya de la co

Introduction

This is the second edition of *The Complete Idiot's Guide to Drawing Manga Illustrated*. After taking a critical look at the information we presented the last time around, we've made some improvements. Some of the information has been streamlined, and we've added more detailed step-by-step instructions and illustrations for creating several different character types. We also discovered and rectified one glaring omission, adding a chapter specifically devoted to drawing one of the most difficult of all body parts, the hand.

But much has stayed the same. This book was *still* created by manga fans, for manga fans. The style remains simple and easy-to-follow, whether you're new to comics in general and manga in particular, or whether you're just looking for a refresher. As before, this book is intended to be useful—and enjoyable—to artists, aspiring artists, and even people aspiring to be aspiring artists!

In the following pages we'll give you a better understanding of what manga is, why it is so popular, and why it is growing ever *more* popular in Japan, in the United States, and all around the world. We'll look at different manga characters, archetypes, themes, and genres. We'll give you advice on what to do and what not to do, along with timesaving shortcuts, to help you make the best manga comic book you can.

Most importantly, we'll show you how to draw in the manga style, with simple, step-by-step illustrations and instructions and literally hundreds of manga drawings and figures you can use for reference, all supplied by our resident manga artist extraordinaire, David Hutchison. We can't guarantee you'll be a great artist after reading this book, but if you take our advice to heart and are willing to put in long hours at the drawing board practicing and challenging yourself, this book will definitely put you on the right track.

Thanks for picking up the second edition of *The Complete Idiot's Guide to Drawing Manga Illustrated*. If you missed the first edition and are coming in clueless about what all the fuss is about—what *is* manga?—read on!

What You'll Find in This Book

This book is organized into five parts. We've designed the book to start with simple stuff, though the material will become increasingly complex as we move on.

- Part 1, "Manga Basics," looks at the most fundamental aspects of manga: what manga is and what characteristics make it manga. Then we move to drawing very basic body shapes, giving you a foundation for the rest of the art that follows.
- Part 2, "Making Faces," focuses on the most important part of a character: the face. We explore every part of the face, including how to draw each component and where to position it. Then we show you how to use these components to bring your characters to life as expressive and emotional beings.
- Part 3, "Character Types," explores the various characters that are popular in manga. We talk about heroes and villains; sidekicks and tough guys; sexy spies; not-so-innocent school kids; and even animals, robots, and monsters.

- Part 4, "Manga Nuts and Bolts," shares various artistic approaches to making your pages and panels more exciting and dynamic. We show you ways to give your art more dimension, flair, and realism. We also look at some of the artistic aspects that make manga so unique.
- Part 5, "Round Out Your World," explores everything else that goes into populating the universes you create, from modes of transportation and weapons to cities and landscapes and all things mechanical.

You'll also find two helpful appendixes: a list of books we recommend for delving even deeper into the world of art, comics, and manga; and a list of online resources.

Extras

Throughout this book you'll find boxes of information designed to enhance your manga experience, define new terms, and alert you to potential pitfalls.

Manga Meanings

These boxes contain definitions of words that may be unfamiliar to you. Some of these words are unique to manga; others are used in the worlds of comics, art, and cinema.

Sketchbook Savvy

These boxes offer tips and tricks to help make your manga-drawing experience trouble-free. Sometimes we offer shortcuts; other times we point you in a direction that will help you make your art even stronger.

Mangled Manga

In these boxes we warn you about the "do not's" of making manga. We've made all the mistakes already—so you don't have to!

Say What?

Check these boxes for quotes culled from wise and articulate individuals who offer words that are applicable to our discussion—and sometimes even inspirational.

Acknowledgments

Thanks to Kris Oprisko and the good folks at IDW for shepherding this book and giving me the opportunity to work on it and explore my great love for manga. Special thanks to David Hutchison for being a brilliant collaborator. Thanks to my wife, Kim Peterson; Marvel editors Mike Marts and Stephanie Moore; and drinking buddy Tom Peyer for their patience as I buried my head in manga and nothin' but and did not come up for air for weeks at a time. Thanks to manga experts Maki Yamane, Rich Amtower, and C. B. Cebulski for being cheerfully willing to lend their expertise and advice. Thanks, too, to Herkimer Coffee; Apple Computer; and the soothing, soothing writing music of Alice Donut, Frank Black, and The Cramps.

—John Layman

Of course, thanks to Kris Oprisko and IDW for giving me the opportunity to work on such a great project. Special thanks to John Layman for bringing so much thought and imagination to this book. Thanks to my editors at Antarctic Press, Joe Weltjen and Lee Duhig, who made it possible for me to work on this book; and thanks to Joseph Wight, Sherard Jackson, Kelsey Shannon, Gary D. Francis, Robby Bevard, and all the Antarctic Press staff. And very special thanks to my mother, Ruth Hutchison, for all of her support and feedback over the years.

—David Hutchison

Trademarks

All terms mentioned in this book that are known to be or are suspected of being trademarks or service marks have been appropriately capitalized. Alpha Books and Penguin Group (USA) Inc. cannot attest to the accuracy of this information. Use of a term in this book should not be regarded as affecting the validity of any trademark or service mark.

Part

Manga Basics

Manga comics are originally from Japan, but they've become a full-fledged phenomenon here in the United States. Before you pick up a pencil and get started making your own contributions to the wide world of manga, we'll spend a short time talking about exactly what manga is, how to read manga, and the ways it differs from traditional American comics. But we won't spend too much time on the talkie-talk. We know what you're here for—to draw!

Whether you are a fledgling artist or a seasoned vet, you start drawing figures the same way. Even if all you can draw is a simple stick figure, you're off to a good start, because the stick figure is literally the first step in figure building. In this part, we look at all the steps of figure building—from that first skinny stick figure to the final image, and all the components in between. We examine what goes into building a figure, and then explore different types of figures and ways to build different body shapes.

Eventually, we'll show you that your figure can tell a story. Your faceless figures can still let you know what they are doing and what they are thinking, just by their poses, actions, and body language. Most of the lessons in this part are universal to *all* comics and art, not just manga. But what you take from this part of the book will give you a crucial foundation for the manga-specific instructions and examples that follow.

In This Chapter

- What is manga?
- How manga differs from comic books
- Manga mania in the United States
- Anime: Japanese animated cartoons
- How to read manga
- Some basic art supplies to get you started

Chapter

Meet Manga!

If you've just picked up this book, clearly you've got some curiosity about manga, even if you don't know what it is. Maybe you've got an interest in comic books and would like to learn more about the genre called manga—a genre growing in popularity every day in America. Maybe you're already a fan of manga—or even anime—and want to try your hand at drawing in this distinctive visual style, but you don't know where to begin.

For whatever reason, no matter what your background or previous knowledge of manga is, you're here now. In the pages to follow, I'm going to lay out for you a primer of the principles of manga in terms that even an idiot could figure out—and everybody else, too!

Manga? What's That?

Manga isn't just a style of *comics* from Japan; it *is* comics from Japan. Manga has been enjoyed for decades in Japan, just as *comic books* have been enjoyed for decades in America. However, in recent years, American audiences have discovered the unique visual style and vocabulary of manga, and more and more English-speaking comic readers are embracing it. As they do, more than a few of these American readers want to learn the tricks and techniques of drawing manga for themselves. If you're one of those readers, you've come to the right place!

Manga Meanings

Manga is a type of comic and comic visual style native to Japan, which is growing increasingly popular in America. A comic or comic book is a periodical or book of sequential art; a story told

in a combination of pictures and words. Think of it this way: manga is a category of comics. All manga are comic books, but not all comic books are manga.

Manga in Japan

Manga in Japan is very different from comics in America. Whereas American comic book readership is very small, currently less than one person in a thousand—mostly confined to males between the ages of 18 and 35—manga readership is a huge part of Japanese life, comprising the majority of its citizens. Manga readers are of all ages and from all walks of life. Popular manga storylines or digests sell in the hundreds of thousands. It's quite common to see commuters in Japan reading manga on the way to and from work like Americans might digest the morning paper. Literally *millions* of manga books are printed and sold every year. And worldwide, that number is growing.

So, What's the Diff?

There's a big difference in art styles between manga, which is more stylized, and American comics, which tend to be more realistic. We'll spend the majority of this book examining the manga art style. However, several other crucial differences exist between the two types of comics.

Manga is created and presented differently than American comics. While American comics are primarily in color, manga is printed in black and white. Manga is smaller than traditional American comic books, usually digest-sized and roughly one half to one third the size of American comics. But where the American comics are generally thin, often running 32 pages with 22 pages of story, manga comic books are thick and can be hundreds of pages in length. This makes manga, in terms of page count, more akin to graphic novels, which are often just collections of serialized American comic books. But unlike American graphic novels, which usually collect monthly comics into a single unified story or story arc, manga digests are often serialized into even bigger stories, so a complete manga story line can run thousands of pages.

Manga Meanings

A term often used to make comic reading seem less juvenile and more respectable, the **graphic novel** is, essentially, a thick comic book. Sometimes it's a lengthy original comic book "novel"; other

times it's a collection of traditional American comics repackaged to be appropriate for the bookshelf. All graphic novels are comic books, but not all comic books are graphic novels.

Here's another amazing difference between traditional American comics and manga: mainstream American comics are often drawn in a sort of assembly-line fashion. They have a writer and a penciler and an inker and a letterer and a colorist. In contrast, most manga books are drawn by a single creator. Manga story lines usually move at a faster pace, too. Because of their hefty page counts, manga books are read at an accelerated pace. Manga books almost always have fewer panels and less dialogue per page than their American comic counterparts. And although manga books are a bit pricier than the average comic book, and a bit pricier than a standard paperback novel, the small size of manga and the black-and-white printing rather than color keeps the books affordable.

What's the Matter with Manga?

Subject matter, that is. Anyone familiar with American comic books knows that you think of superheroes first when you think of comics. Those heroic, super-fit, spandex-clad dogooders who have been bitten by radioactive spiders or come from other planets to pursue justice and knock super-powered villains through walls. Of course, not *all* American comic books are about superheroes, but the vast majority are. And superheroes is what they have primarily been associated with and will likely continue to *be* associated with.

Not manga, however. One of the strengths of manga, and one of the reasons it appeals to such a diverse cross section of readers, is its vast subject matter. Manga includes comics for boys (called *shonen* manga), comics for girls (called shojo manga), and comics meant for adults—and adults only!—(called hentai manga). A wealth of manga subject matter is available for all tastes and for everyone. Manga offers books about giant robots, futuristic societies, contemporary societies, ancient societies, samurais, schoolgirls in love, sports stars, spies, wizards, warriors, cooks, criminals, computer hackers, businessmen, mah-jongg players, pilots, princes, and much, much more. Just about any story imaginable can be told in manga—and is!

Oddly, *one* genre is not all that popular in Japanese manga: American-style superheroes.

Manga Meanings

Manga in Japan is not considered just "for kids," the way the general American public (erroneously) presumes that comic books are for kids. There's a manga for everyone:

- Shonen manga literally means "boys' comics," comics that showcase action and adventure.
- Shojo manga, "girls' comics," is geared toward the opposite gender and often contains more cerebral stories.
- Hentai manga is adults-only manga, sexually explicit or adult-themed books. Fair warning: John, this book's author, is far too much of a gentleman to go into detail on this subject. If you want a book on hentai, look elsewhere!

Mangamerica: Manga in the United States

In recent years, manga has made huge inroads in the United States and other English-speaking countries, both culturally and commercially. And manga has succeeded in something that American superhero comics never have: attracting a female readership. This is likely due to manga's wide range of subject matters, beyond the power fantasies of American superheroes, and also that a large portion of manga is outright directed toward females.

As manga's popularity has grown in America, it's come to take up a large section of the shelves in both comic book stores and traditional bookstores. In fact, the American bookstore graphic novel section continues to expand every year, and much of this is because of manga's increasing presence and popularity.

As more people discover manga, it continues to grow. More publishers and creators are appearing every day, more translated Japanese works are making their way into the United States, and more Americans are discovering a love for creating comics in a manga style.

Mangled Manga

Don't make the mistake of thinking manga automatically means "comics from Japan." That was once true, but no longer. There is plenty of manga produced here in the good ol" United States.

Anime: Manga's Cartoon Cousin

Also gaining in popularity is *anime*, which is essentially Japanese animated cartoons that share a lot of the stylistic tropes and the characteristic look of manga. Is it wrong to call anime animated manga? I don't think so. And it should also be noted that many anime cartoons are based directly on manga comics.

Manga Meanings

Anime is Japanese animation, which shares most of the elements and visual style of its printed counterpart, manga.

If you're interested in drawing for anime, you could do worse than to read this book, since manga and anime share many of the same visual cues, such as speed lines, extreme foreshortening, and dynamic angles. The characters also share similar features, with small noses, humongous eyes, and big feet.

Reading Manga Right ... or Left?

In Japanese, text characters are read from top to bottom, from the rightmost column to the leftmost. This is the opposite of English, where characters are read from left to right, across one line and then down to the next. This means that reading *true* Japanese manga (assuming you can read the Japanese!) requires some getting used to, like driving on the "wrong" side of the road.

There's no "right" way to do manga; no pun intended. If you want to do the more authentic type of right-to-left manga, there's nothing to stop you.

What You Bring to the Table

Hey, it's up to you how seriously you want to take this book. If you want to be the next Osamu Tezuka, more power to you. If you're content to just doodle with a crayon or a pencil in a manga style, that's fine, too.

Sketchbook Savvy

Perhaps the most famous and influential manga creator, Osamu Tezuka (1928–1989) brought a cinematic style to manga and helped popularize it among all ages. He was the creator of

Tetsuwan Atomu, better known as "Astro Boy" in the United States, as well as Jungle Taitei, or "Kimba the White Lion," among many, many other popular and beloved manga and anime works.

With that in mind, there's no reason to run out to your local art supply store and load up on expensive art tools, doodads, and doohickeys. But if you want to use what the professional manga artists use, here's what our esteemed artist David Hutchison recommends:

- ◆ Paper: 11" × 17" two-ply Bristol board.
- Pencil: David uses one mechanical pencil with a 5mm 2H lead and one lead holder with 3H lead for details.
- ◆ Erasers: David has a kneaded eraser, which can be molded by hand into whatever shape is required and lasts longer than common erasers. He also uses an eraser stick, which is a holder that contains a length of eraser that can be pushed out of the end as the eraser is used up.
- Ink: Nearly any India ink will do. David prefers Bombay black India ink. It covers well, and it costs about half as much as other inks.
- Quills: David uses Hunt 102 pen nibs from Speedball. These are basically allpurpose nibs you can use for a variety of inking jobs.
- ♦ Brushes: Windsor and Newton Series 7 number 2 brushes. These brushes are versatile and long lasting. After you get the hang of them, you can use them to ink almost any image.
- Computer: Macintosh with latest operating system and latest version of Photoshop. David uses a Wacom tablet to tone and color because of the great range of input available.

Say What?

Art is the most intense mode of individualism that the world has known.

-Oscar Wilde (1854-1900), writer

Now your crash course in manga is complete, and we can get to what you're really after. It's the reason you bought this book, after all, isn't it? You're here to draw, to create art, to make comics, and to do it in the manga style. So what are you waiting for? Let's get to it!

The Least You Need to Know

- Manga are comics from Japan. Manga has been popular for decades, but in recent years it has grown increasingly popular in America.
- The subject matter of manga is much more diverse than traditional American comics. Manga books are written for girls, for boys, and for people of all ages and from all walks of life.
- Manga books are smaller than American comics and have a much higher page count.
- Anime is the name for Japanese animation, which shares many of the same visual traits as manga.
- The Japanese read manga right to left, while American manga is printed right to left or left to right, depending on the publisher.
- Manga artists use a variety of art supplies, but a pencil and paper are all you really need to get started.

In This Chapter

Shapes as basic body building blocks

Body building fundamentals

Sketching, penciling, and inking

Drawing the torso

Body language

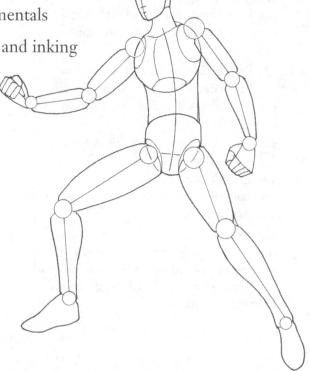

Beginning Body Building

As eager as you might be to jump into things and start drawing manga faces and figures, panels and pages, you'll soon realize that becoming a good artist doesn't happen overnight. It takes practice, and lots of it. Planning goes into every single page, from the design of the character's costume, to the subtleties of a character's body language, to the number of panels on a page and the way a page is composed.

So naturally, we're going to start at the beginning. We're going to look first at the steps to creating a manga figure. Some of it might seem elementary, but it's part of a larger, more important whole.

The Shape of Things to Come

Now, I know what you're thinking: "I just paid how much for this book, and they want to teach me to draw *circles!?!*" Yes, it's true that just about any idiot can draw a circle or a square, but it's also true that you can look at just about any picture and break it down into these very simplistic geometric shapes. And after you understand shapes and their relationships to one another, you'll have a better handle on how to draw figures.

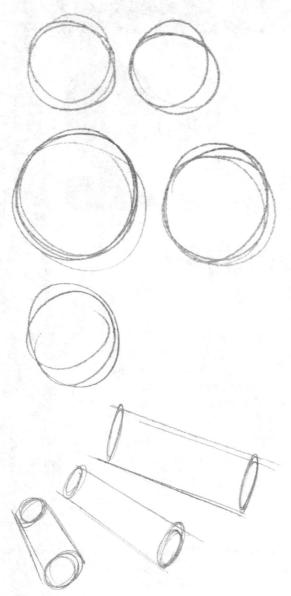

Circles and cylinders form the basis for figures.

When you're drawing bodies, circles and cylinders are your best friends. You can make a rough outline of your character using only circles and cylinders. You can create a figure that looks human-shaped and make sure you have the character in the pose you want and using the body language you desire.

Squares are also very important in composing your page.

Squares aren't valuable in the way circles and cylinders are for building bodies, but they come in handy for many other objects, including vehicles, buildings, and even humanoid-shaped nonhumans (such as robots).

Everything in Order

Artists usually start with a basic outline of what they intend to draw, done in pencils (or sometimes blue pencil: the color blue does not reproduce when photocopied). They then develop this outline into a *rough* sketch. And then they add detail to the sketch until it is a fully realized pencil drawing.

Up until this point, if you don't like what you've drawn, or if you want to try a different angle or approach, you're free to erase the penciled drawing and start again. Once satisfied with the penciled drawing, the next step is to go over it in ink (and erase the pencils after the ink is dry).

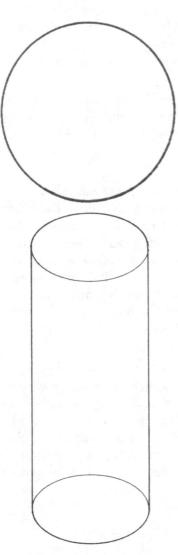

Inked circle and cylinder.

Sketchbook Savvy

Follow this drawing order:

- Outline
- ♦ Sketch or "rough"
- Finished pencils, adding detail and definition to the rough
- ♦ Ink over finished pencils
- Erase pencils after ink is dry

Many American comics are put together in an assembly-line fashion. The writer, penciler, inker, letterer, and colorists are often different people, passing the page on from one person to the next. Most manga, in contrast, is a singleperson labor of love. For this book, we're going to assume you are doing it all yourself, or, at least, doing the pencils and the inks.

You should not commit your manga to ink until you are satisfied with your pencils. Often you will want to start with a *blue line drawing* or a rough before moving to full pencils. As you gain confidence as an artist, you might choose to add detail to your drawing in the *inking* stage, and skip certain details while *penciling*. Always remember, ink does not erase.

Manga Meanings

A blue line drawing is literally done with a blue pencil and will not reproduce when photocopied in black and white. A rough is a page or figure that is penciled in a preliminary stage. Penciling

a page is to draw it in pencils, elaborating on and expanding upon the rough, making it into a finished drawing. **Inking** a page is to go over the pencils in ink, making the art permanent and unerasable.

Figure It Out

The most basic step: a single line.

The first step in drawing a figure is a simple line. This line follows the path of the character's spine, based on the pose the character will be in. In this case, we're going to draw a figure standing upright and facing forward.

Defining the shoulders and hips.

Next you add two lines to denote where the shoulders and the hips will be. You are defining your character's torso here, even if you can't see it at this point.

Now the character takes shape. We'll show in great detail in future chapters how to flesh out your character, adding a face, clothes, and features. Here, we simply want to present a body.

As you can see, the figure is built primarily out of circles and cylinders. The head, chest, and joints are circular, whereas the limbs, neck, midsection, and fingers are cylindrical. Of course, not everything is a perfect circle or cylinder, and some differently shaped objects, such as the feet, pelvis, and elements of the hands, will simply take practice. But in general, the body consists of circles and cylinders put together in a human shape.

Finally, we see the finished body. Or as finished as it's going to get in this chapter. It still needs to be fleshed out, and there is a lot more to do to this figure before an artist would ink it. Here we just want to make sure the figure's body parts are in the correct proportions and that the figure is in the pose or stance that we want.

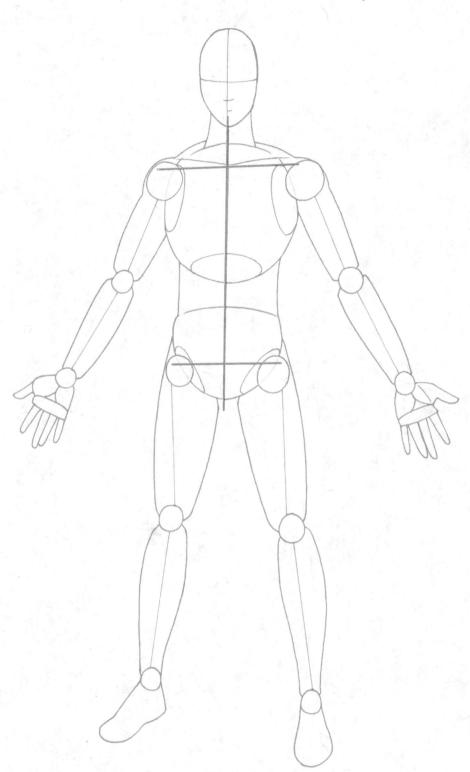

Adding the body.

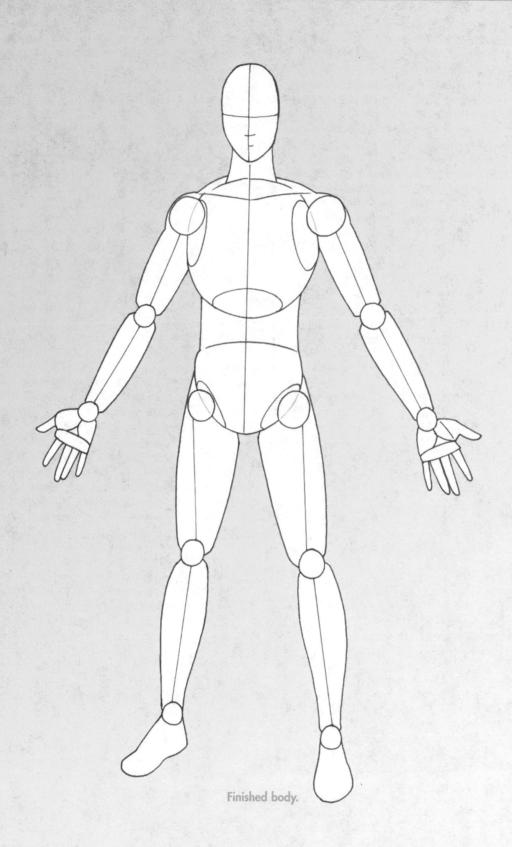

The start of an action pose.

Next we'll tackle a character in a more active pose. In this step, all we see is a curved line, and we can't tell too much about the figure other than that the spine is not perfectly straight.

Defining the shoulders and hips.

Lines to mark the shoulders and hips are added next. Consider this a very basic skeleton, a wire frame or foundation to build your character around. As you are drawing this, the figure should be taking shape in your head. The hard part will be getting it onto paper the way you want it, but this outline should help.

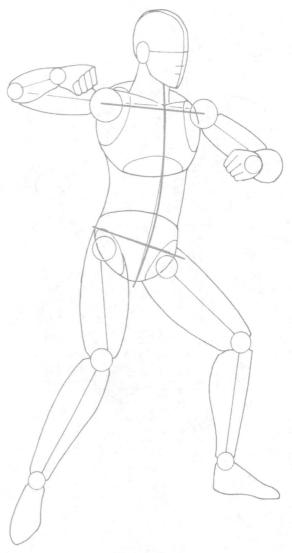

Adding the body.

Now, with the body added, we see exactly why the spine was curved and why the hips and shoulder lines were drawn at an angle. In this scene, the character's stance shows him drawing back or throwing a punch. His shoulders are straight, but his back is arched. His legs are not straight; the figure's knees are bent and his weight is on his left (front) leg, to support his weight as he throws the blow.

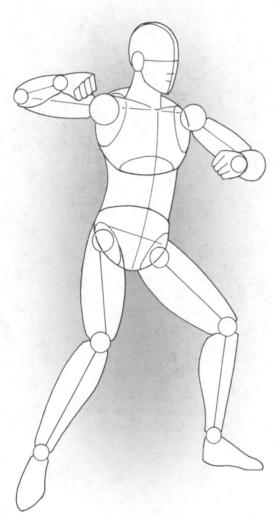

Finished figure.

Here we have the figure, sans outline. As we saw in the last step, the way the body moves affects the direction and curve of the spine, shoulders, and hips, as well as their lengths. Keep this in mind, because your characters' bodies will often be in motion and active.

More So with the Torso

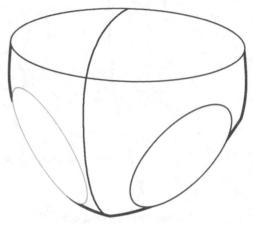

The pelvis.

This is a figure of a pelvis, the lower half of the torso.

The overall figure is that of a half oval, bisected by a wide oval so we see only the lower half. Two other tall, tilted ovals mark the position of the legs.

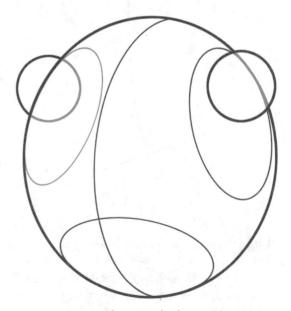

The upper body.

The chest is more of a perfect circle, with smaller circles high on each side to denote the joints to the arms.

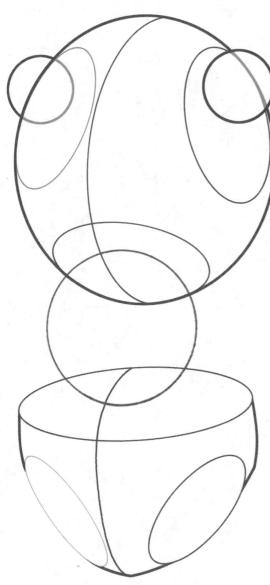

The complete torso.

And finally, here are the pelvis and upper body together, united by a circle (sometimes a cylinder) to denote the stomach and rib cage area. Think of the natural movement of your own body. The chest can pivot forward or sideto-side on the "ball" that represents the stomach, but it can't lean too far.

Bodies and Language

We're going to be talking a lot about pictures telling the story. That is the fundamental difference between comics and prose. Comics *show* things. Pictures often replace words, which makes it all the more important to show things the way you intend.

Body language is an important aspect of that. The correct body language can, and should, help tell your character's story.

Sketchbook Savvy

Small poseable wooden mannequins are available at most art supply stores. You can manipulate them into the poses you desire and use them for visual reference.

In the subsequent chapters, we're going to look at different types of bodies and learn how to flesh out a character's figure and face. But don't underestimate the importance of body language. If your characters can tell some aspect of their stories with just the way they are posed, think how effective your storytelling will be when you add the correct facial expression and body elements to that perfect pose!

This next drawing is another action stance, a character moving forward, ready for a fight.

Capturing a character's body language does not mean capturing him or her in action. This figure shows a character relaxing in a chair and lost in deep thought. It is possible (and preferable) to give your characters interesting poses, even if they aren't doing anything particularly interesting.

In the next figure, we see another inactive pose: a character squatting, looking at something or waiting for something.

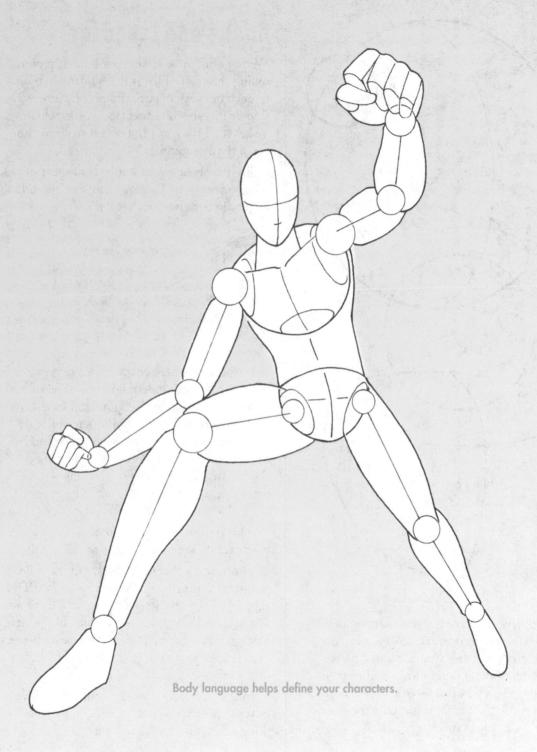

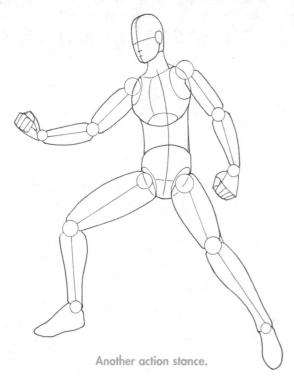

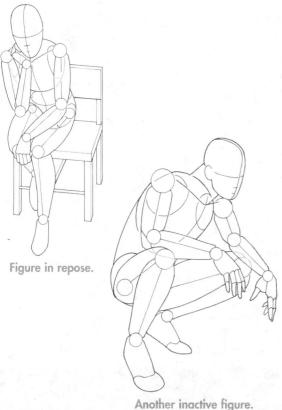

Try being aware of your own body language and watching the body language of friends and people you see. People rarely do nothing, even if they aren't doing much. A reader should be able to thumb through your manga and get a feel for your character and the situations he or she is in without reading a single word. Body language is an important part of that.

The Least You Need to Know

- Figures and pages take planning and preparation.
- Figures and objects can be broken down into simple geometric shapes. They can also be built using simple geometric shapes.
- Characters usually start as an outline, then a rough, and then finished pencils. Only after that does the artist commit the figure to ink.
- Don't ink a figure with which you are not happy. Erase and redraw with pencil until you are satisfied, then ink.
- ◆ The torso is your character's physical center. It consists primarily of a circular chest above a half-oval pelvis. A smaller circle unites the two and represents the stomach; this is the point where the torso's flexibility is greatest.
- Use body language to help your characters tell their stories. Try to keep body language interesting, even if the character you are drawing is not active.

In This Chapter

- Svelte and sporty
- Head of the class
- Beefcake bodybuilders
- Large and in charge
- Boys will be boys

Chapter 3

Man Alive: Some Basic Male Body Shapes

No two people are alike. Just as in real life, people come in all shapes and sizes—slim and fat, short and tall, and every combination in between. Even age has an effect on body type. So in this chapter we're going to look at the differences that go into creating different male body shapes, and talk about what sort of character is the best match for a particular size and shape.

The Athletic Male

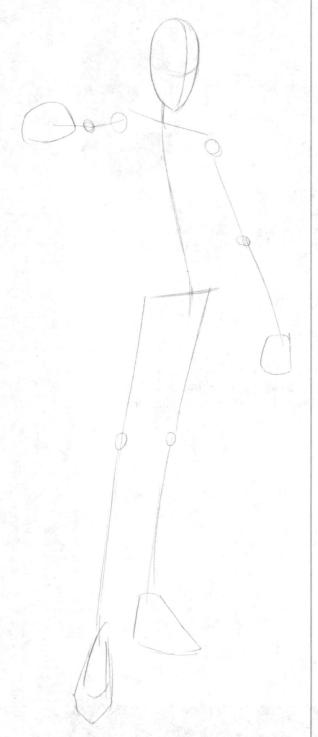

Stick figure for athletic male body type.

We begin with the athletic male. In this case, we start with a stick figure of our male-to-be. In this figure, we get the basics of the character's posture and skeleton but can't really tell too much about the character. The shoulders are not particularly wide, so this is probably not a strong or heroic figure. The character does not seem short, nor the head particularly large, so this is very likely just an average male or teen male (or maybe even a female).

As we add some cylinders to represent the limbs and circles for the joints, the chest, and midsection, our character comes into view. The chest is more circular than the head and about one and a half times the head's height and width. The forearm cylinder is larger than the upper arm (we'll explore the foreshortening of the outstretched arm in Chapter 17). For the legs, instead of seeing them as two cylinders representing the calves and thighs, visualize them as one unit, getting progressively bigger and wider as it approaches the hips.

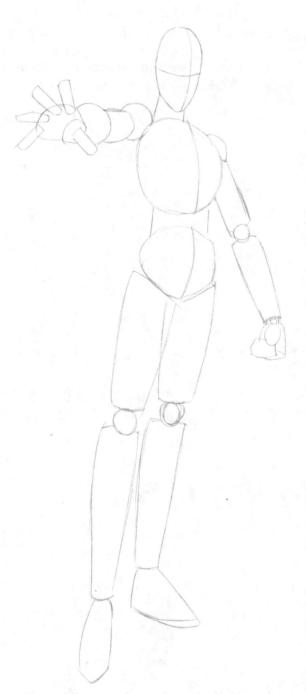

What a difference a few circles and cylinders make!

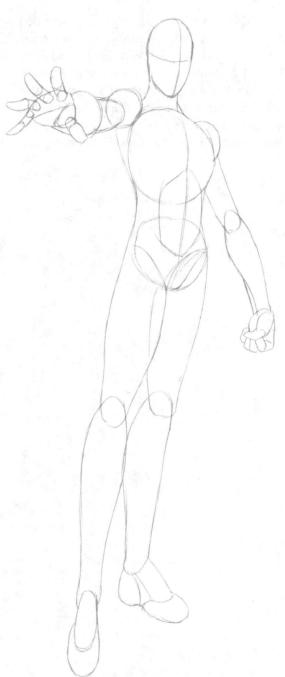

Adding more definition to the athletic figure.

In this figure, the body is getting more definition, looking more like an actual human than a man-shaped compilation of circles and cylinders. The limbs curve more and connect to one another. We see the outline of a stomach. We also see a little more evidence of dimension to the body, in the wrist of the lowered hand as well as in the upper back and the upraised arm.

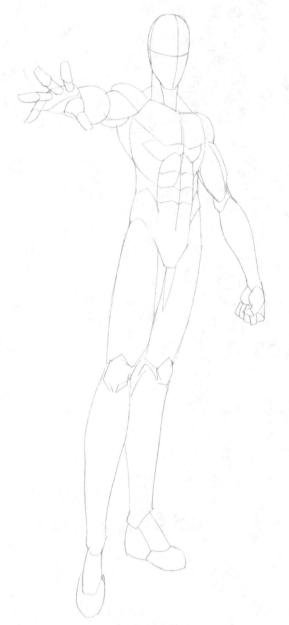

Outlines added to define muscles.

In this figure, we see outlines defining the musculature. In males, this is most obvious in the abdomen. We see some definition as well to the ribs, the pecs, the clavicle, and the biceps.

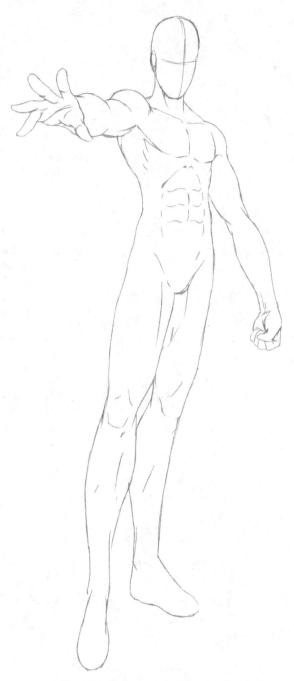

The athletic figure is taking shape.

In the preceding figure, what was outlined previously is now more realistically rendered. In addition to the abdominal muscles and the chest, we see some lines denoting the upper rib cage and others defining the neck, the thighs, and the calves.

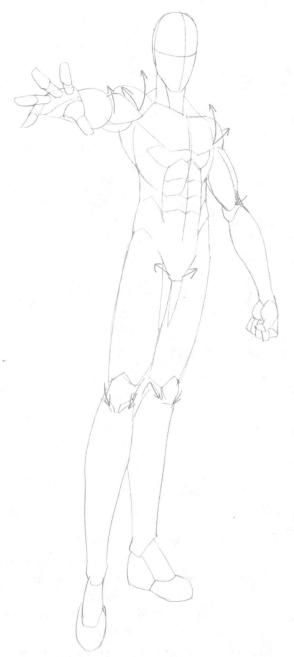

Arrows indicate points of articulation.

In this figure, David uses arrows to identify some of the key *points of articulation* (or *anchor points*) on the character. This is something to take into consideration when drawing your character; the points that have the most movement consequently will have the most clothing folds. These points around the joints—the shoulders, neck, elbows, crotch, and knees—are all areas of articulation.

Manga Meanings

If articulation is the connection of different parts of the body by joints, points of articulation (also known as anchor points) are the areas of the body that move, such as the elbow, knee, or neck. The

hand, for example, has many joints and therefore many points of articulation.

In the next figure, the character is garbed in some sort of jumpsuit. We see the outline of the chest, but most of the rest of the body is lost to folds in his naturally fitting clothes. As you can see, this character's outfit of choice is not particularly tight, as it would be on a more muscular character. Nobody actually thinks Superman's or Spider-Man's costumes are made out of skintight spandex fabric, but the word has become convenient shorthand among comic book readers to describe the outfits of the American superhero set.

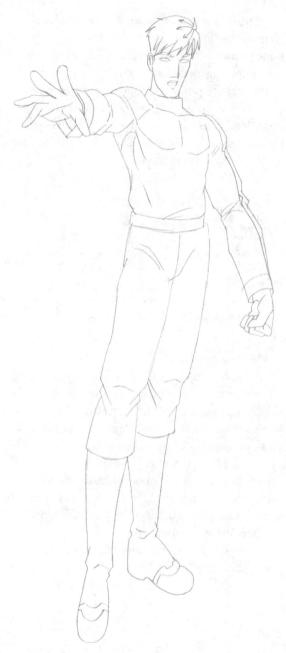

The clothed figure.

Just for fun, David has added some elements to this character's outfit to make the character more visually interesting. We see some miscellaneous pockets to add to the character's belt and some lines down his outfit, which will make his clothing appear less like a jumpsuit and more like a uniform.

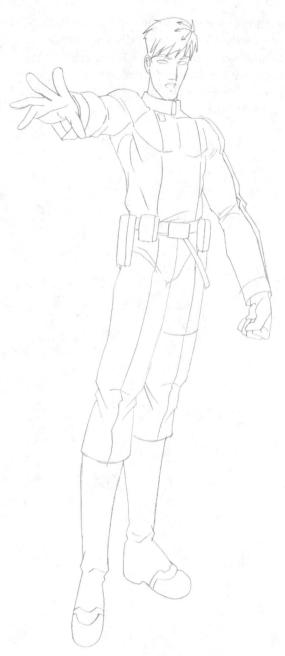

Adding clothing details.

Clearly this is a young soldier or perhaps a pilot. This character should be in shape, but there is no reason for him to be grotesquely muscular. A person in this position would be expected to keep himself in some semblance of good shape.

Consider this body type for your young adult male protagonist.

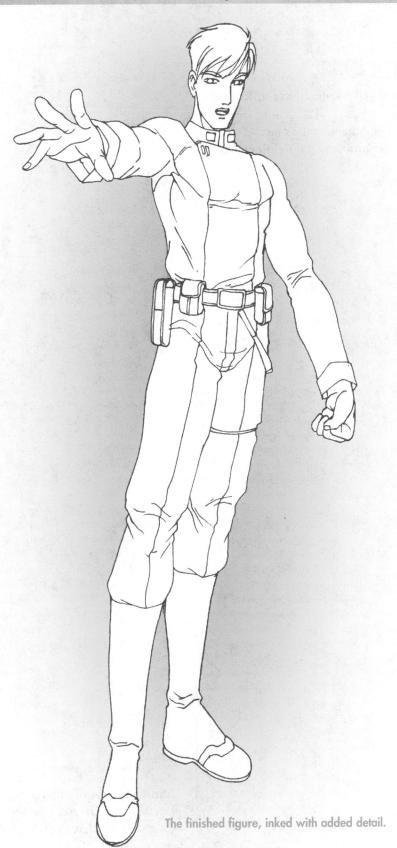

The Teenage Male

There is not a tremendous amount of difference between the teenage male and the athletic male, except for less development of the muscles (particularly less definition to the abdomen and chest).

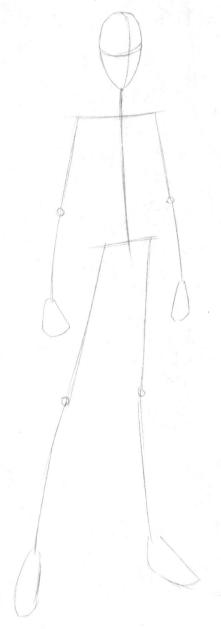

Stick figure for teenage male body type.

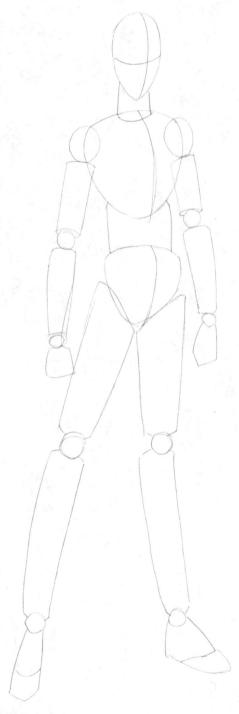

Circles and cylinders help define the figure.

Still not a lot of difference, as we see the placement of circles and cylinders to give us a better idea of what the body will look like.

The largest difference is the chest, which is smaller at the bottom and less circular than the athletic male's. This is because this chest will ultimately be less developed.

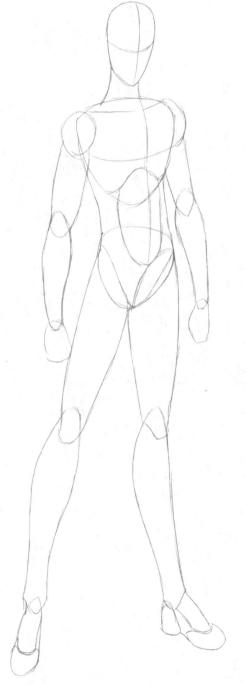

Smoothing out the shape.

The limbs have changed from cylindrical to smooth in this picture, and the midsection is wide, making the chest appear smaller. The legs are a bit thinner than the athletic figure's legs shown earlier. The arms are less muscular, too.

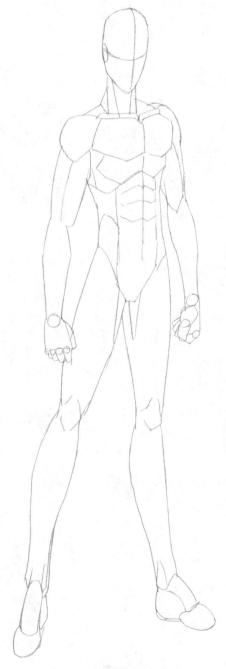

The muscles are defined.

Here we see the outline of the musculature. We see the outline of the abdomen and chest, much like those of the athletic figure shown earlier, as well as a much less pronounced bicep.

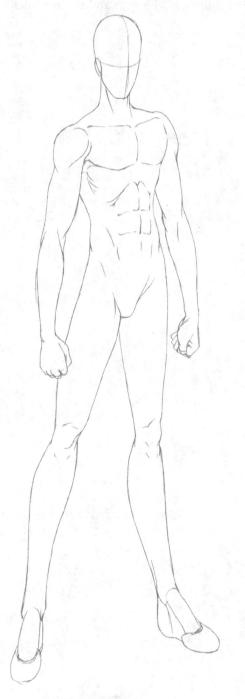

More definition of the muscles.

Now, with the muscles more defined, we see that this is a figure with some upper-body definition, but not a lot in the way of muscles in the arms and legs.

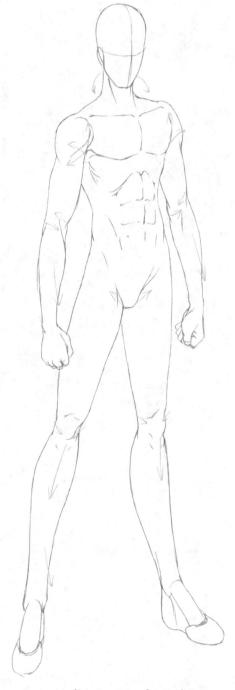

Arrows indicate points of articulation.

Again, based on the natural movement of the body and the limbs, David identifies the points on the character's body where there are most likely to be folds in the clothes.

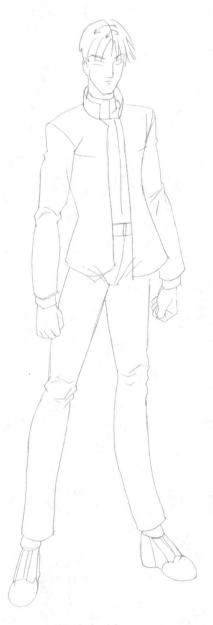

The clothed figure.

Mangled Manga

Keep in mind that, unless the plot specifically calls for it, your characters should not dress against their body type. Someone with gargantuan muscles should not wear baggy clothes—because

then you don't get to see the gargantuan muscles! Our teenage male figure does not wear form-fitting clothes, because there is no reason to emphasize the body of a slender and nonmuscular character.

The character is decked out in sporty, yet casual clothes. We don't see much in the way of upper-body definition, some of which is due to the jacket.

In the finished figure, we see that David chose for the character's jacket to have a pronounced cut in the midsection, which emphasizes that this is a slender character.

Another nice touch is that the character is wearing pants that appear just a tad too short, and the cuffs of his jacket are just a bit short for his arms. It's a subtle but effective detail, implying that this character is growing faster than his parents can keep him in new clothes.

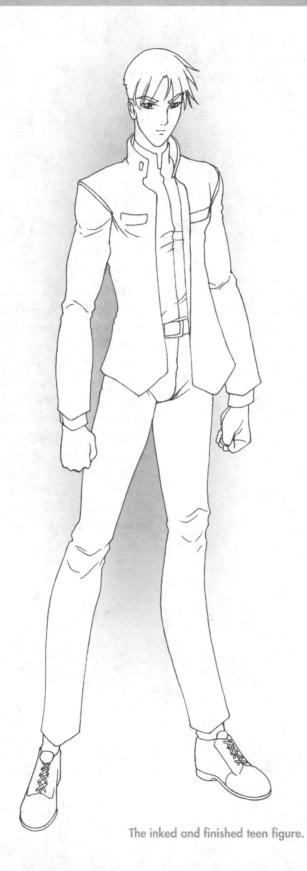

The Muscular Male

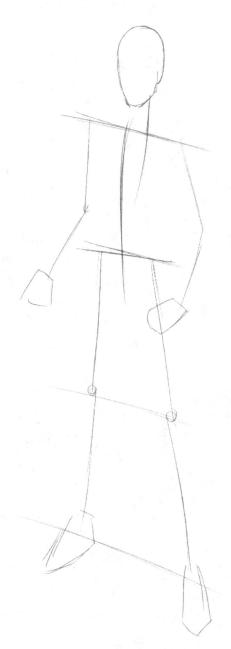

Stick figure for muscular male body type.

Immediately we see one crucial difference between this figure and the outlines of the previous two: this character has broader shoulders. Of course, the shoulders here are simply represented as a longer line from arm to arm.

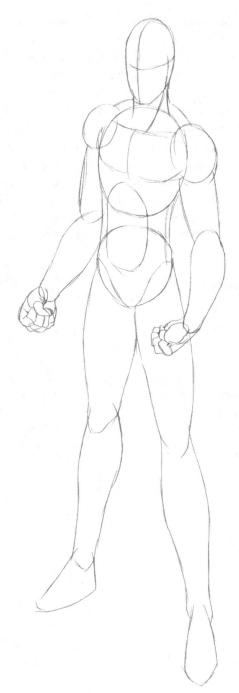

Circular shapes define a more muscular figure.

The biggest difference here is the upper arms, where we see what are clearly going to be bulging muscles. The shoulders are larger and beefier, too, as is the area above the chest and around the neck.

Not only do we have more defined musculature on the abs, chest, and neck, but we see more outlines of muscles all over the body: forearms, upper arms, thighs, and calves. This is a character who visits the gym religiously, and the results show. In particular, the upper arms are much more rounded and sculpted than those of the previous figures.

David has chosen for this particular strongman to be a boxer, and he enhances the image with some thick, dense lines to represent bruises or scuffs, as well as some bandages on the face. This is a character who can take punishment.

Sketchbook Savvy

Although a book on anatomy is fundamental to every artist, a more real-world or practical visual reference is a must for most. Magazines are an excellent resource. Men's fashion magazine.

are great references for dressing and accessorizing your character, and can even help you find the right hairstyle. Fitness and muscle magazines are good places to see muscular figures in action and in various poses, both natural and unnatural.

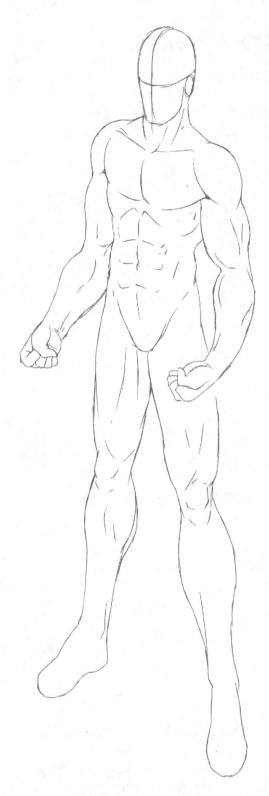

Definition of the muscles.

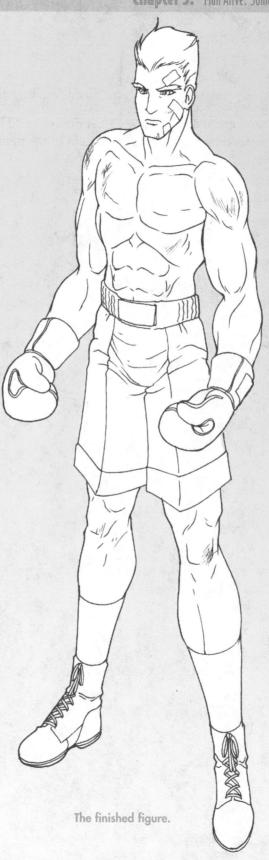

The Husky Male

For the husky man, we start with an outline with very wide shoulders and hips. We're going to draw a character of tremendous girth. One

thing to keep in mind when designing a character like this is the stance. Note that David has the arms and legs far apart, to support the weight of the figure's center of gravity.

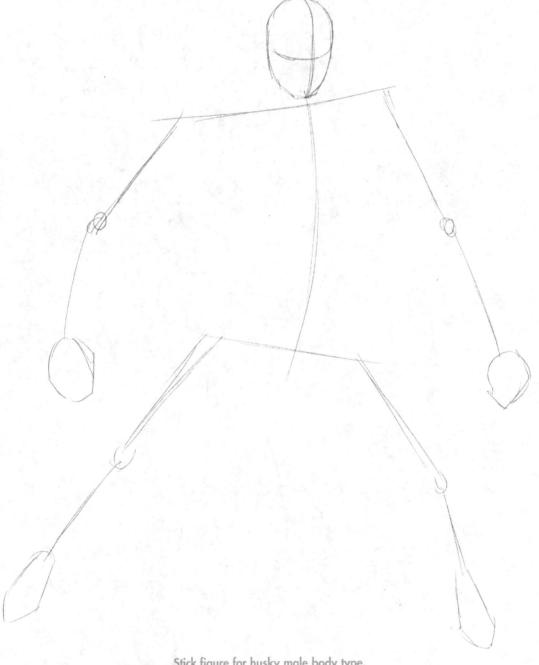

Stick figure for husky male body type.

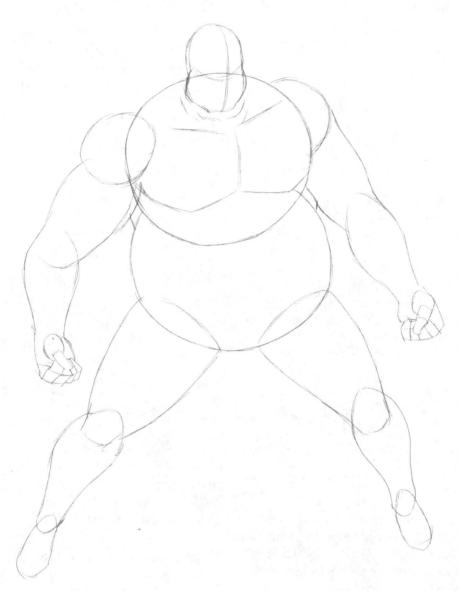

Big and round are the operative words for this figure type!

The chest and midsection of this character are both round and much larger than the head, two and a half to three times the height of the head and roughly three and a half times the width. While the chest and midsection in previous figures were laid out as smaller circles separated by a small cylinder, there is no room for the cylinder here. There are just two big circles on top of each other. The circle representing the upper body is so large that it extends

above the shoulder area of the previous figures. In fact, you'll note that this character's head is halfway inside the circle, rather than above it and separated by a small cylinder to represent the neck.

The upper arms are much wider than the forearms, and the character's thighs grow progressively beefier as they approach the midsection. We see some outlines of a chest—but no six-pack abs here!

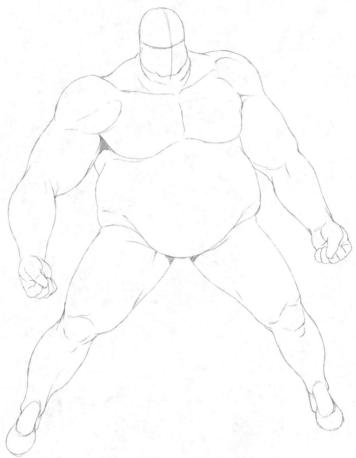

The husky figure takes shape.

There is still a lot of roundness to this character, but perhaps the most noticeable thing here is the sag to the character's belly. The fact that the stomach hangs down in a frontal shot suggests this is a character of enormous mass. As a general rule of thumb, your character's tubbiness can be determined by the size of the lower circle representing the midsection.

This character, like the muscular character, has more rounded limbs, especially in the thighs and upper arms. But unlike the muscular character, the limbs are less defined. You'll also notice that this character has no neck. We see some lines to represent chins and double chins,

and the head is resting inside the character's upper body.

We present our finished character, garbed in some vestments to make him look like a monk or a member of some sect of religious martial artists.

Sketchbook Savvy

Want to make a fat character appear even fatter? Sink the head lower into the body and increase the circumference and quantity of the double chins. It's a fact that the larger you are, the less of a neck

you appear to have, and by increasing the thickness of the neck, you add pound upon pound to your character.

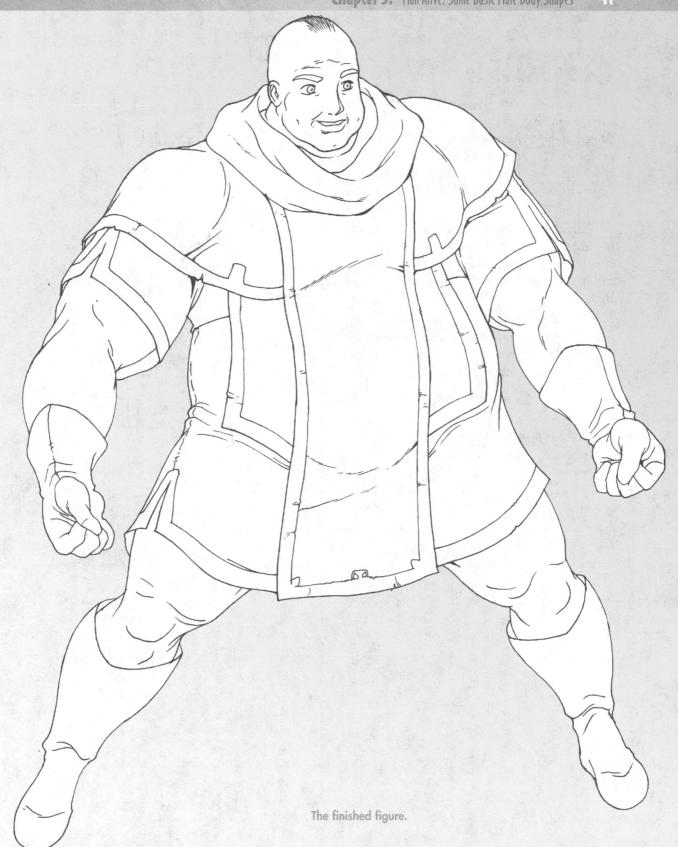

The Young Male

Now we move to the opposite end of the spectrum, from large to small. There are some fundamental differences in drawing children; most obviously, kids are shorter. Not only do they lack height, but their heads are proportionally larger, to emphasize that the rest of the body is comparatively smaller.

Naturally, when you are drawing the outline of your child character, the limbs will be short, as will the line representing the spine. They are still proportional to adult bodies, just miniaturized.

In the drawing on the next page, we can see that the boy's features are slender, and his neck in particular is slight. The chest and midsection are oval-shaped rather than circular, giving the figure a thin aspect.

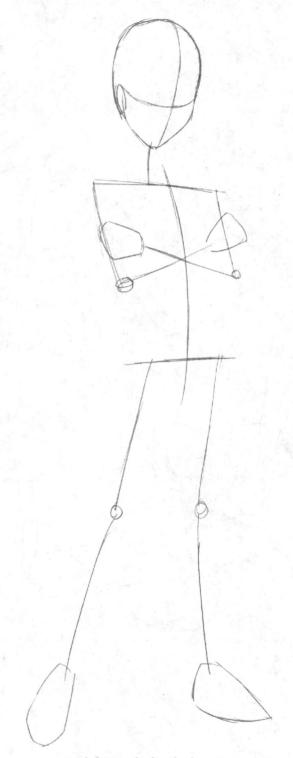

Stick figure of a boy body type.

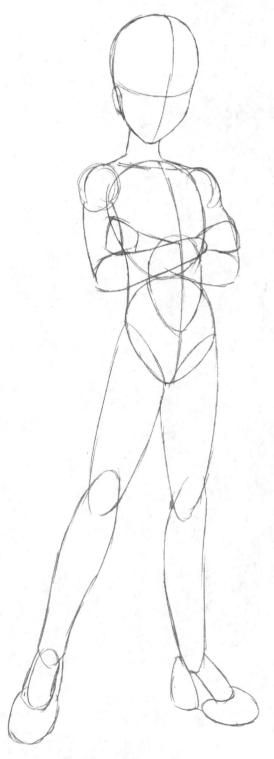

Filling in the details.

Fleshing out the body.

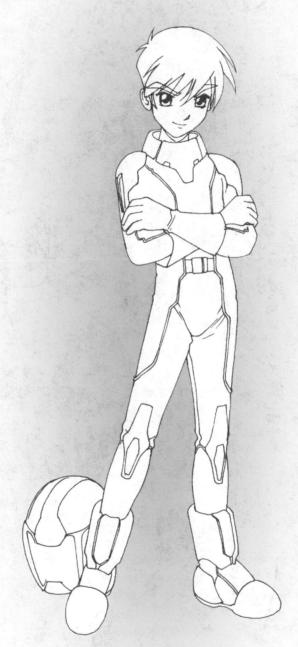

The finished figure.

As this figure is fleshed out, we see that the limbs remain thin like the torso. There are no defined muscles, and the arms and legs are mostly straight.

Even when he's decked out in a futurist outfit, we can tell that this youngster's head is proportionally bigger compared to his body than the heads of previous figures. The clothing this kid is wearing gives him just a bit more bulk, but he's got the build of a skinny stick figure.

The Least You Need to Know

- ◆ The initial outlines for characters appear similar, unless they have radically different body types like that of an obese person or a child. It's not until you flesh out the characters that differences appear.
- Some of the most important parts of the body are the chest and the abdomen. The size and scale of these features will help determine your character's size, age, and fitness level.
- A working knowledge of anatomy—or at least reference books on anatomy—can be extremely helpful in defining your character's musculature.
- Dress your character to accentuate his body type. A muscular character will show off his muscles. A fat character will not be able to conceal his girth. And there is no reason to emphasize muscles on nonmuscular characters.

In This Chapter

- Basic differences between male and female figures
- Fit female
- Sweet sixteen
- Jane Doe
- ♦ Little lass

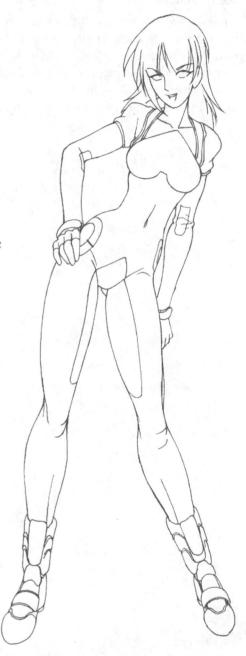

Chapter

Sugar and Spice and Everything Nice: Some Basic Female Body Shapes

As with the males in manga, and perhaps even more so, female characters tend to be attractive, whether they are protagonists, girlfriends, supporting characters, or damsels in distress. Sure, you might find a pudgy house matron or wise grandmother, but manga is mostly populated with teen and young adult hotties, even in the shojo books geared toward female readers.

Naturally, females have a different body shape than males, even as different females have varying body shapes from one another. We'll explore these differences in this chapter.

Battle of the Sexes

Before we get into specific character types, let's look at some differences between the male and female figure. In this cutaway torso of the female figure, we can see that the profile of the back is kind of an S-shape from the back of the neck to the posterior, curving outward at the shoulder blade, inward toward the stomach and waist, and outward again as it approaches the rump.

The front of the torso has round breasts that slope over the curve of the chest. Below the breast is a stomach, slightly concave at the same level where the back curves the farthest inward. This is because females generally have much smaller waists than males.

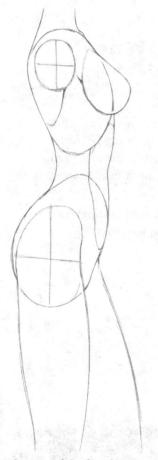

A side view of the female torso.

Sketchbook Savvy

Breast size in females can often be a good indicator of the character's age. In general, the more developed the figure, the older the female.

The Athletic Female

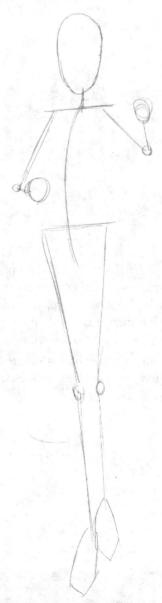

Stick figure of an athletic body type.

We open with the standard stick figure, which shows the character's body language more than its body type.

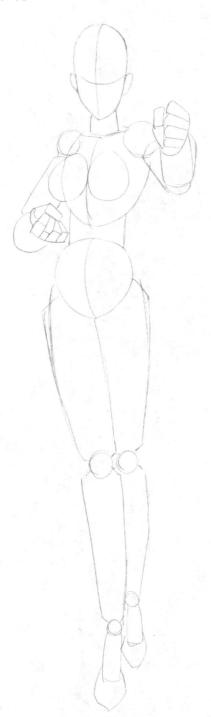

The figure takes on a female shape.

Our circles and cylinders mannequin settles the question of the sex of this character once and for all. This typical manga female has much more of an hourglass figure than her male counterparts, a small waist, larger hips, and more pronounced breasts. Manga females also have slightly longer and thinner necks, as well as thinner ankles and smaller feet.

Sketchbook Savvy

Females have ...

- Smaller waists.
- Breasts.
- Curvier hips and limbs.

Males have ...

- Wider necks.
- Wider torsos.
- More muscular definition to limbs and abdomen

As this figure is smoothed out, we see that the female figure is much curvier than the male in every aspect of the body: legs, arms, and torso. Unlike in the male figure, there are no defined "washboard" abs.

Here is the figure fleshed out further, with lines representing the musculature. Females do not have the muscle definition that males do. Or even if they do, the muscles are smaller, so there is less emphasis on them.

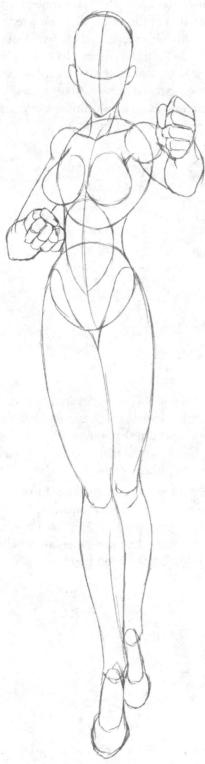

Adding curves.

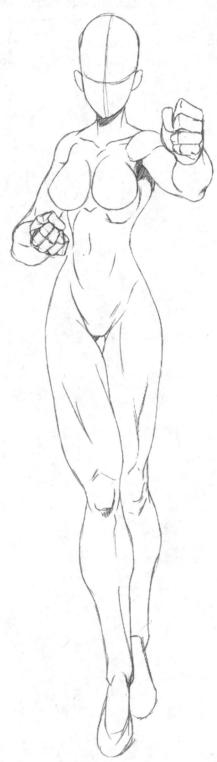

Fleshing out the details.

We can't stress enough how valuable a knowledge of and reference on anatomy is for an artist, especially for proportions and musculature. There are plenty of magazines to use as references for hairstyles, clothing, accessories, and body types. Women's fashion magazines are an excellent way to keep up on the latest hair and clothing styles.

In this figure, David uses arrows to indicate where clothing folds will be, based on the character's anchor points. As we will see, this female martial artist figure wears a smaller outfit that does not cover most of her points of articulation. David also anticipates how the hair is going to fall and flow.

In the finished and inked figure, our athletic female appears to be some sort of martial artist or fighter character. As in every other part of Japanese and American culture, there is more emphasis on female flesh than male, so costumes tend to be a bit more revealing.

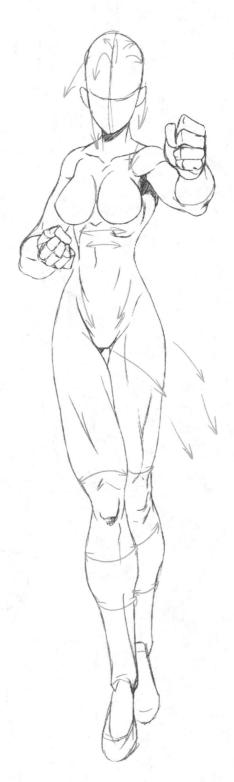

Arrows indicate points of articulation.

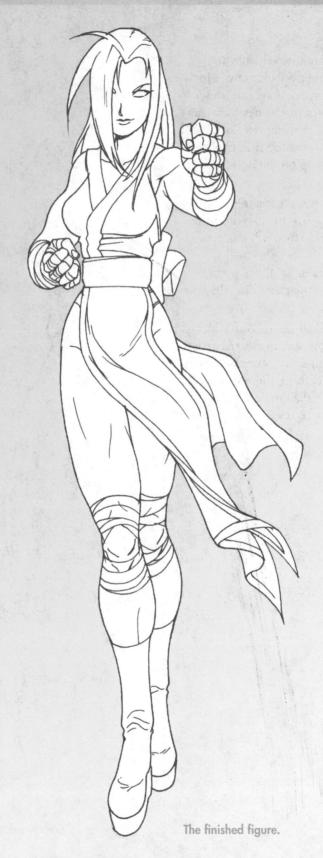

The Teen Female

Stick figure of teen body type.

Here is the stick outline of our teen figure. In this case, we can see that the body language is more reserved than that of our previous female. Already, we can tell that we are probably dealing with a much less aggressive character.

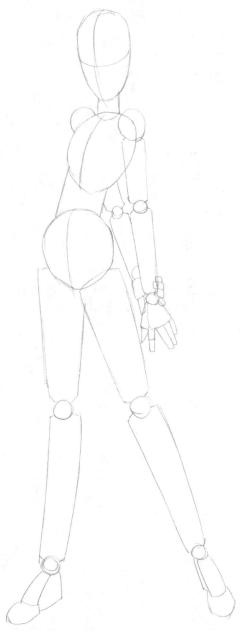

The figure takes shape.

From this circle and cylinder figure, we can determine that the character is a girl. There are no breasts, the chest is slim and oval, and the cylinder between the waist and midsection is thin, suggesting this figure will have the curves of the female hourglass. The limbs are thin, as is the neck. Additionally, the body language of this character seems to suggest a female.

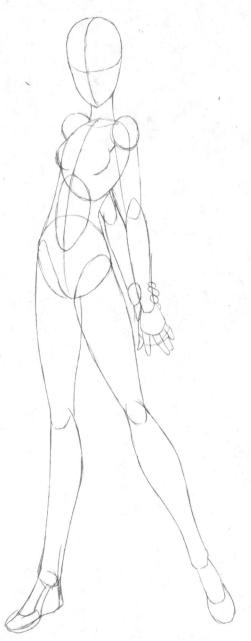

Smoothing out the shape.

As David rounds out the character from shapes into limbs, it becomes more obviously female, with curved elements to the torso and limbs. We also see the outlines of breasts, although they are considerably smaller than those of the adult figure we saw previously, a sure tip-off this is someone in her early-to-mid teens.

Fleshing out the figure.

As the character is fleshed out, we can see there is no evidence of muscles. The limbs and neck are long and thin, and the limbs are mostly straight, without a tremendous amount of curvature.

Arrows indicate points of articulation.

David anticipates the hair and the clothing of the character. We can tell that this character will be wearing a dress, based on the guides David has put on her legs.

The final figure is indeed wearing a dress, and we can see that the guides David drew not only accounted for the skirt, but accessories on the arms and hands as well.

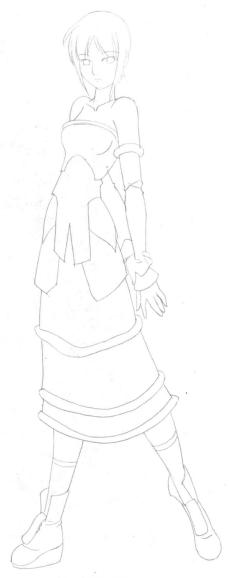

The clothed figure.

David commits the character to ink, adding details as he does, such as some lacy frills on the dress and matching arm bands.

Sketchbook Savvy

In this nearly finished figure, the character has breasts, but no visible cleavage. Again, David is suggesting that this is a character who is developing, but not fully developed.

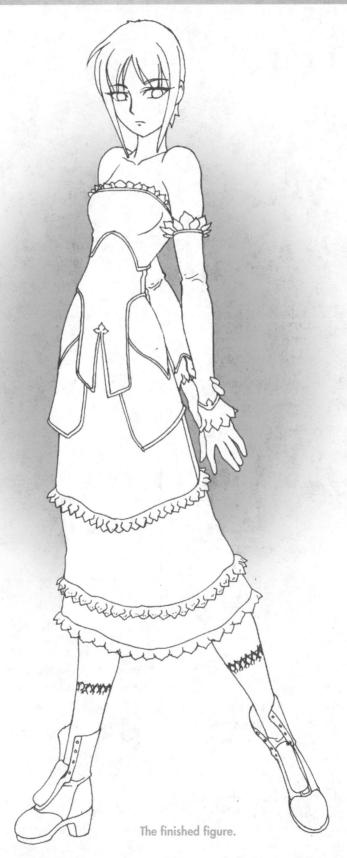

The Adult Female

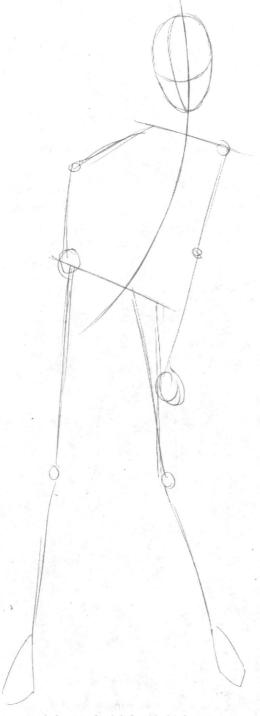

Stick figure of adult female body type.

This figure is for an adult female, and, arguably, a "sexy adult female." The body language of this character is certainly more suggestive than the teen figure's was in outline. As you can see, you often can tell a lot about a character just from a stick figure outline.

Sketchbook Savvy

Never underestimate the power of body language. Body language can tell what your character is thinking and his or her emotions, feelings, and personality.

The next figure is leaning to accentuate an already curvy body shape, as if the character is trying to be sexy and seductive.

The hourglass is much more pronounced in this figure than in the teen female, and the breasts are much larger and rounder, suggesting this is an adult female. There is little to no emphasis on the muscles. The legs are much curvier in this female figure than the scrawnier teen figure.

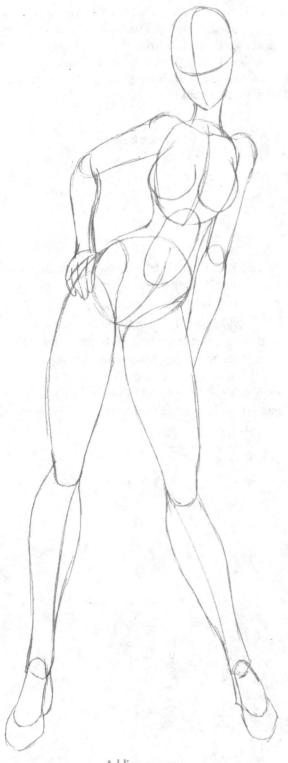

Adding curves.

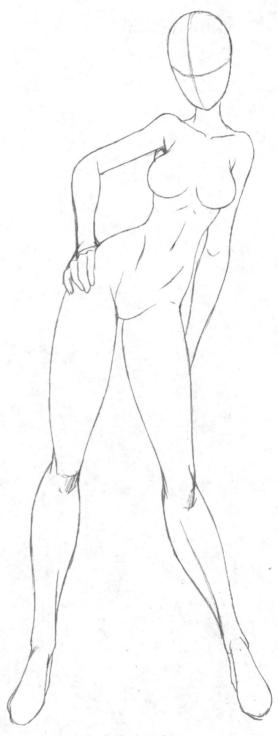

The fleshed-out figure.

The character is wearing a skintight outfit, which accentuates her curves and body type.

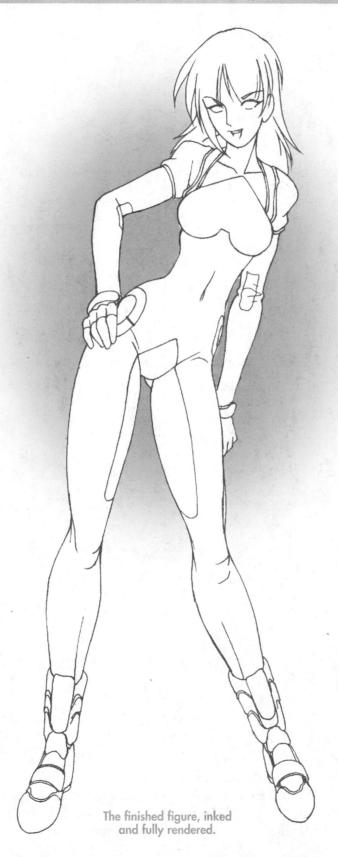

The Female Child

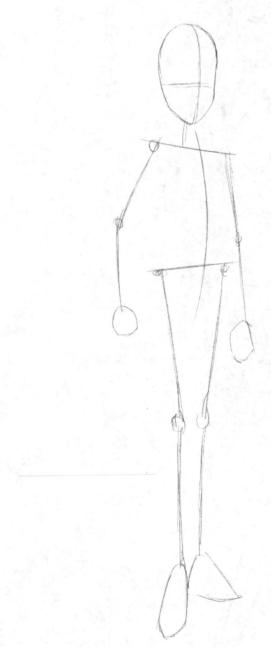

Stick figure of a girl body type.

Now we present the female child body type, which is not much different from the male child body type. Again, we start with a larger head and limbs and a torso that is smaller and shorter than the adult or teen body type.

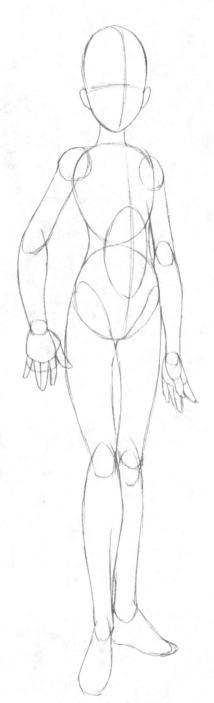

Sketching the details.

There is less attention to curves here. There are no breasts, and the hourglass aspect of the female figure is not pronounced like it is in older females. There is no evidence of muscle development, either.

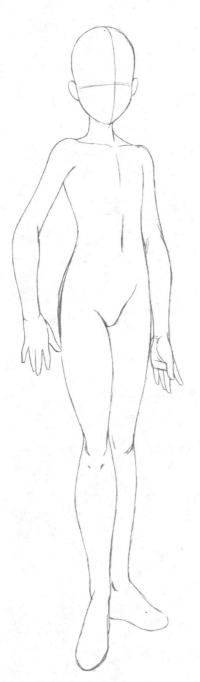

Fleshing out the shape.

Fleshed out, there is still very little difference between the male and female child. There is slightly more curvature to the legs, particularly the thighs. This character's outfit does not accentuate any curves, because at this stage in her development there are no curves to accentuate.

The Least You Need to Know

- Female figures have more curves than males, with wider hips, smaller waists, lessdefined muscles, and breasts.
- Female arms and legs tend to be curvier as well.
- Female characters do not have the muscle definition that males have. This is most apparent in the abdomen, biceps, and thighs.
- Breast size is a good indicator of the age of a female character. Teens generally have smaller breasts than adult characters, and children have none at all.
- There is very little difference between the body types of male and female children. The differences become apparent as the character's features are rendered.

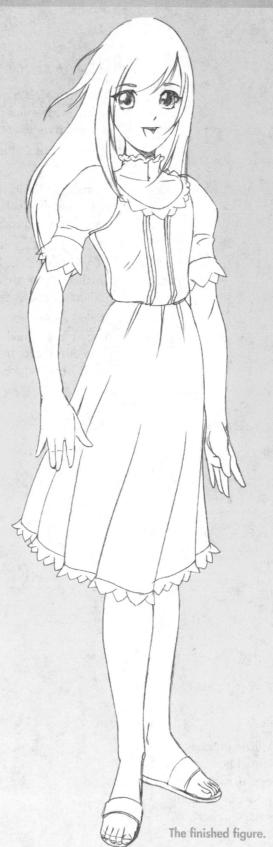

- Go with the flow
- Exaggerated poses
- Awesome action
- Reflex and reaction

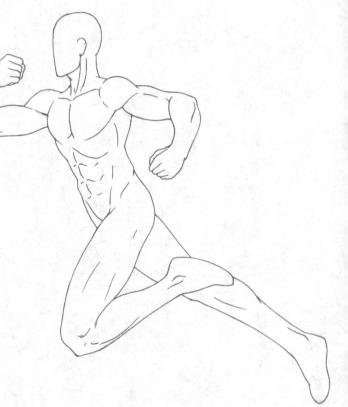

Bodies in Motion

You're going find many opportunities to spotlight your character in action during the course of your story. You may be able to draw great characters, but it's just as important to be able to capture them *doing* something.

Manga to Move You

Face it, your characters don't actually move in your drawings. They are static black lines on a page. Your picture is a split-second freeze frame of your character in motion, fixed forever on a page. Your job is to give your characters the illusion of movement, and to do that successfully you need to infuse your drawing with as much energy as possible. Action should be exaggerated and the characters' poses as extreme as possible.

Sucker Punch

Spine line.

As always, it's good to start with a line to represent the center of a character and the way the character is moving ... the character's flow. This line corresponds to the character's spine, but it's an oversimplification to say you are just drawing the spine. The character's flow might extend down to the legs, up to the arms, or both, depending on the character's pose. Laying down the main line provides the guide for the overall motion of the character.

Lines indicating the shoulders and pelvis.

Next add lines to indicate the directional flow of the shoulders and pelvis, which, respectively, guide the direction of the arms and legs. The length and angle of this line depend on the character's motion. The line will often be longer, for example, if the corresponding limb is extended.

Say What?

For every action there is an equal and opposite reaction.

—Sir Isaac Newton (1642–1727), Third Law of Motion

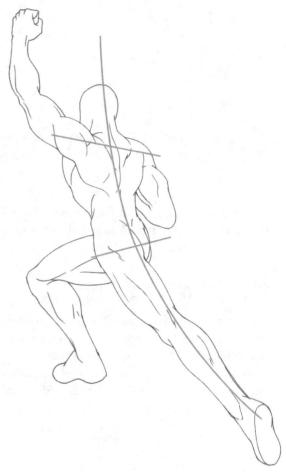

The uppercut.

As this figure throws an uppercut, one leg is extended while the other is bent forward. This is a reaction to the extended leg, helping to balance the character. The upper body is turning into the punch, so naturally the arm that is not punching is being pulled back.

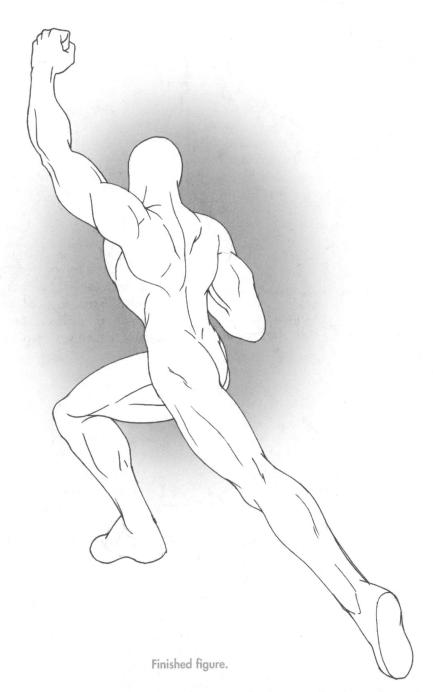

Here is the figure without the motion guides. Each side of the body counterbalances the other and tends to move oppositely the other. If you had both legs backward or forward, your character would fall over. If both arms were forward, your character would punch with much less force.

Another aspect of action and reaction to consider is the character on the receiving end of the punch. Likely that character would be wildly off balance, and the rules of one limb counterbalancing the other would not apply.

Run for Your Life

This line will show extreme curved motion.

From the extreme curve, we can tell that this character is going to be in a very exaggerated action pose.

Lines indicating the shoulders and pelvis.

The torso takes shape in this picture, as we see from the lines denoting the shoulders and pelvis. Extreme speed is suggested by how far forward the character's torso is from his extended leg. Note the counterbalance of the limbs.

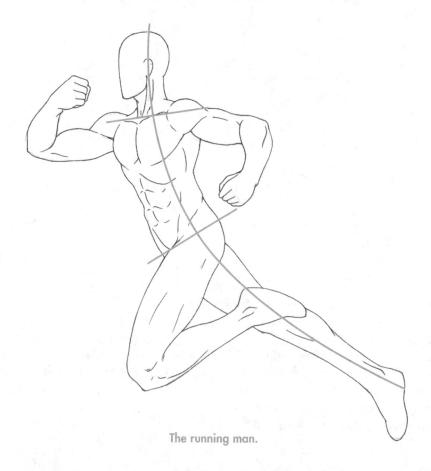

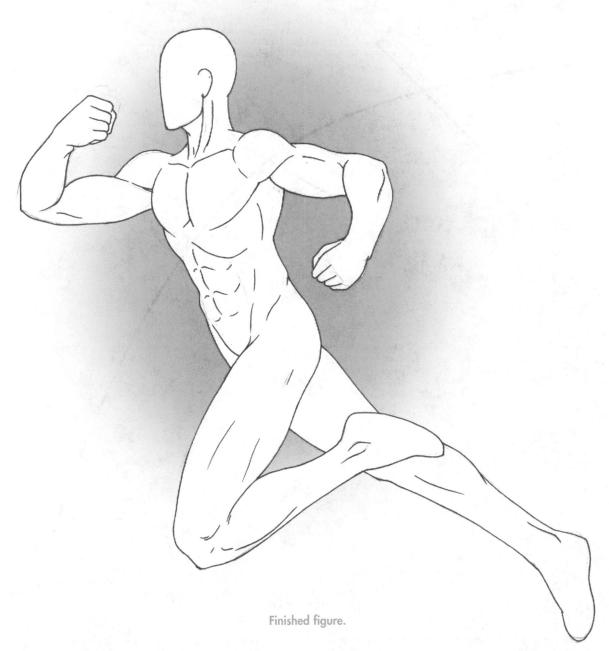

Note in this finished figure that not only does one arm counterbalance the other, and one leg the other, but also one arm counterbalances its opposite leg. This becomes even more pronounced when a character is moving quickly.

Sketchbook Savvy

The pause button on your DVD player, TiVo, or VCR can be very handy when you need to reference action poses. Martial arts magazines are another great reference, particularly for fight sequences.

Leap into Action

Curved motion line.

The long, curved motion line in this figure is curved in the opposite direction of our previous figures. The shoulder and pelvis lines are close together here, suggesting that the bend of the back is pronounced.

In the next figure, you see that this character is taking a leaping punch, one leg extended, the other tucked back. While one arm is extended for the punch, the second arm is back.

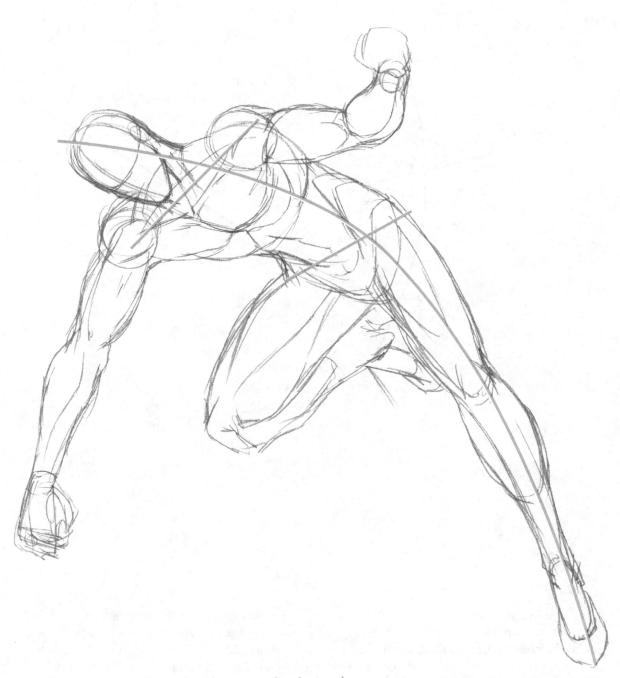

Leaping punch.

High Kick

Dual motion line.

Here's a different sort of motion line. Actually, it's a dual motion line, with a small line to represent the body of the character, a small line to represent the shoulders, and a very long curved line showing the motion flow.

In this figure, the primary motion line follows the legs, because that is where the motion flow originates. The arm opposite the kicking leg shows that the character is reacting to, and compensating for, the strength of the kick. Drawing in the arm helps the character keep his balance.

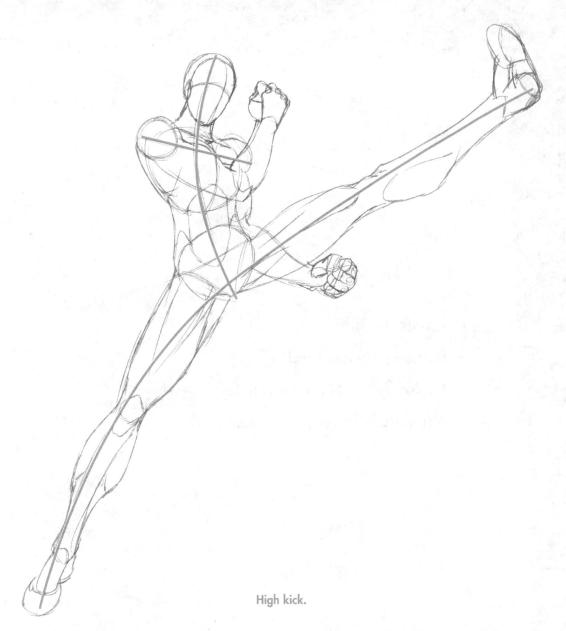

The Least You Need to Know

- For action shots, more is better. It's preferable to exaggerate the poses than to down-play them for a more "realistic" effect.
- Limbs tend to counterbalance one another. When one arm moves forward, the other moves back. Ditto for the legs.
- Arms and legs also counterbalance their opposite counterpart. When a right arm is forward, a left leg is back.
- Consider Newton's Third Law of Motion when drawing action: "For every action there is an equal and opposite reaction." It's not enough to show your character hitting; make sure you also show the effect on what (or who!) is being hit.

- Hands and story
- Building a better hand
- Exploring hands from all angles
- A multitude of poses and meanings

Talk to the Hand

Of all body parts, hands probably deserve the most attention. With five extremely flexible digits, hands can be a challenge to draw. As means of showing your character's emotions and state of mind, hands can be every bit as important as facial expressions and body language. Ideally, you would use all three to complement one another.

Helping Hands

Hands *do* things. Rarely are they still and motionless at somebody's side. What a character's hand is doing gives insight into the character's state of mind. A character with a closed, tense fist is saying something very different than a character clapping excitedly or holding her palms to her cheeks. Consider what your character is feeling or thinking, and try to find something for the hands to do to help your character express it.

Sketchbook Savvy

Try muting a television show and watching how the characters interact. Often, you can tell exactly what point a character is trying to get across just by the way he moves his hands and what he does with them.

A Handy Lesson

A preliminary pair of hands.

When drawing hands, it's best to start with a rough outline of where you intend your hands to be.

First signs of fingers.

Just as we've drawn lines to indicate the motion of the body, we approach hands by roughly approximating the direction of the fingers. The diamond-shaped objects, however, are not the ends of the fingers, but the beginning: they will be the knuckles.

One more thing: this may seem obvious, but don't forget which side of the hand the thumbs go on when you are drawing a character opposite you!

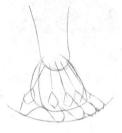

Segments are added.

Note the length of the diamonds that represent the knuckles. A crescent shape is now added, roughly the length of each diamond. Fingers have multiple joints and components, and this is the first.

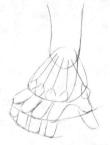

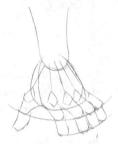

Longer fingers.

Another segment is added for the next component of the fingers, from joint to joint. You'll notice this crescent is not an even distance from the previous crescent. There is more distance on the inside between crescents than on the outside (because the index finger on the inside is much longer than the pinkie finger on the outside).

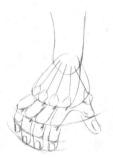

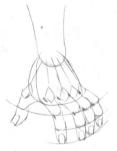

Nails and fingertips.

The final segment represents the fingertips, along with fingernails. Notice that the thumb does not have a third segment. Thumbs are stubbier than other fingers, with only a single joint.

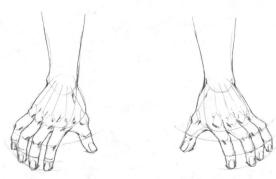

Getting ink on your hands.

Ink is applied to the pencils, with lines to denote knuckles, where your crescent-shaped roughs were, as well as to the diamond shapes at the end of each hand.

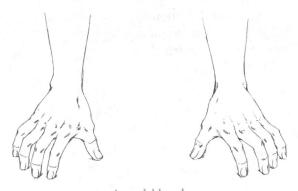

A model hand.

The pencils are erased, and—behold!—the final pair of hands.

Hands as Character Traits

Everybody uses their hands, but some people use them more than others. Less active hands, which are crossed or shoved into fists or pockets, belong to people who don't want to socialize, while friendlier and more expressive characters tend to "talk" with their hands. Keep in mind, then, both your character's frame of mind and personality, and take both into account when drawing hands.

Mangled Manga

If you aren't comfortable drawing hands, you might go to extreme lengths to compose your shot with hands out of the picture. You can get away with this here and there, but eventually it leads to too many

static shots and a dull comic. Master hands, and you'll accelerate your progress as an artist.

A new starting point.

Since hands are so flexible and expressive, it's a good idea to practice them from a multitude of angles and in a variety of poses.

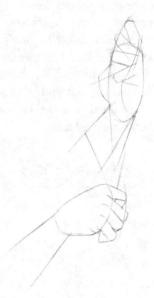

Fingers and joints.

The first segments of the fingers are roughed out. In the right (lower) hand, the rest of the finger is blocked out as well, but most of it is obscured because of the choice of angle.

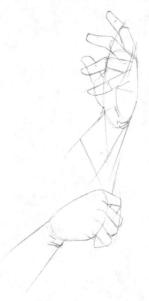

Fingers take shape.

This time around, David skipped a step and included the rest of the fingers, rather than just one more segment up to the second joint. That second joint, however, is noted with a slight line.

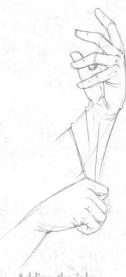

Adding the ink.

Ink is now added into the mix. Note that there is more definition to the knuckles, and we see folds and lines to indicate this hand is putting on a form-fitting glove.

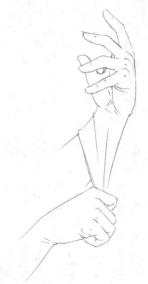

Pencil lines erased and final figure.

And here is the final figure, sans pencil roughs.

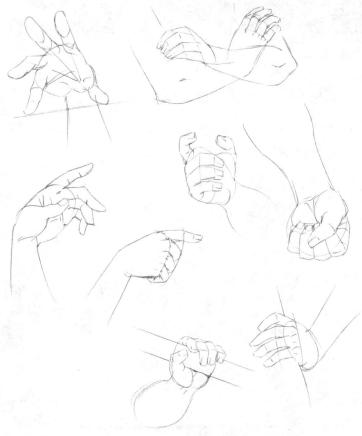

All hands on deck.

The Many Faces ... of Hands!

Hands are perhaps the most consistently active part of the body, so keep them in mind when you are drawing your character. Hands hold, shake, grasp, grab, grapple, clasp, clutch, punch, point ... and the list goes on. What a hand can say is almost as limitless as what the human face can express.

A Fine Body of Work

We're now done with our chapters on body language. Used properly, it can tell your story with visuals only, especially when you use body language in conjunction with facial expressions. We'll get to the faces next ... but first, give yourself a hand!

The Least You Need to Know

- What a character does with his or her hands should be considered in unison with body language and facial expressions.
- With multiple flexible components, hands can be one of the most difficult parts of the body to master.
- Hand gestures are an important way to convey a character's state of mind.
- Characters that are excitable or exuberant tend to gesture more with their hands, and you can use hand gestures (or a lack thereof) to help convey a character's personality.
- Hands are one of the most consistently active parts of the body.

Making Faces

Now that we've mastered making a figure, it's time to give it a human face. Literally, in this case. In this part we focus on the most expressive and emotional part of a figure: the face. The face is also one of the most crucial parts of your art if you want to make a manga-style comic. Manga faces are easily recognizable for their large and expressive eyes; their facial features are small or subdued. And manga characters aren't just emotional, but are often emotional to the extreme.

In the following pages we'll examine in detail every component of the face: eyes, ears, nose, hair, and mouth. We'll look at where to position them on a face and how this differs on different faces, as well as how to place the features at different angles. In short, we show you everything you need to know to bring your character alive with emotion.

In This Chapter

- The basics of manga faces
- Female facial proportions
- Male facial proportions
- Children's facial proportions

Chapter

Not Just Another Pretty Face

So now that you know some fundamentals of building bodies, it's time to bring your characters to life, giving them individuality and personality. And there's no better place to start than with that thing that makes you who you are and separates you from everyone else: the human face.

Facial Proportions Made Easy

We'll explore differences between faces soon, but first let's discuss some similarities. Let's assume we're working with the standard facial features of two eyes, two eyebrows, two ears, a nose, and a mouth, and that we want them to correspond to the average human face.

For the purposes of manga, the portion of the face comprising the eyes down to the chin will take up only the lower half of the head. A good rule of thumb is to keep the eyes an eye-width distance apart and a half-eye distance from the sides of the head.

In a profile shot, the face is still roughly divided in half. The front of the face to the beginning of the ear makes one half, and the ear and the back of the head are the other. The *eye-width* rule of thumb is reversed: there is a half-eye distance between the eye and the bridge of the nose and a full-eye distance between the eye and the ear.

How cute or how old you want your character to be will help decide the placement of the nose. For young or cute characters, keep the nose lined up with the lower eyelashes. On the more adult characters, lower (and often lengthen) the nose.

The size of the mouth varies with the gender of the character. Female mouths are often much smaller—but also rounder and fuller—than male mouths.

Manga Meanings

Eye-width, as the name implies, is the horizontal length of the eye. It's an informal unit of measure, but a good gauge when positioning the eyes in relation to one another and the rest of the face.

The Female Face

We'll begin with the quintessential manga face: small features except for the eyes, which clearly dominate the face. The face is roughly divided in two, with the forehead and skull area above the eyes composing the upper half of the face, and the tops of the eyes down to the chin composing the lower half.

The nose is understated, suggested with a line or shadow, and the features of the mouth are smaller for females than they are for males. The lower lip tends to be more rounded, as well, suggesting fuller lips.

Also, we should note that these portions and features are not exclusive to female characters. In manga, many male characters, often

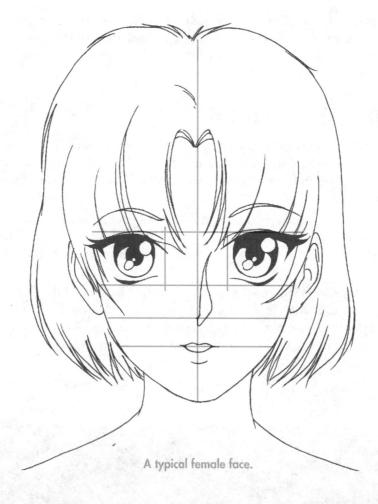

teens, students, or "innocent" characters, are portrayed somewhat androgynously, with more pronounced "female" facial features.

In this picture, we get a better sense for the placement of the nose and ears. The top of the ear is roughly aligned with the top of the eyes, and the bottom of the ear is aligned with the tip of the nose. Where the nose was hardly visible in the straight-on shot, here the slope and shape of the nose are quite distinct.

Sketchbook Savvy

In a nutshell, women's faces have ...

- Bigger eyes.
- ◆ Thicker eyelashes.
- Smaller, rounder mouths.

Men's faces have ...

- Bigger chins.
- Thicker necks.
- Longer noses.

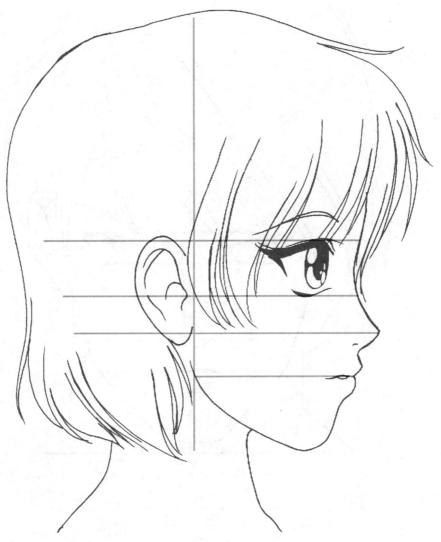

The female face in profile.

The Male Face

We'll discuss eyes in greater detail in the next chapter, but what should be immediately apparent in the drawing of this male character is that his eyes are much smaller than his female counterpart's. The eyes are about half the height of the eyes in the female face, and the majority of the lower half of the face is taken up by the nose, which is more clearly defined than the nose in the female face.

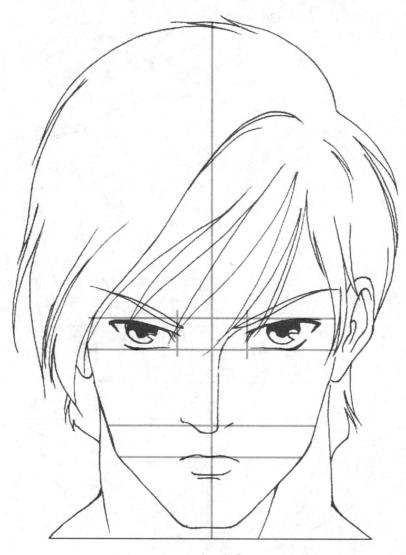

A typical male face.

The ears of this face are higher than those of the female face: the tops of the ears are aligned with the eyebrows and the bottoms of the ears end about midway down the length of the nose.

Note, too, certain features that emphasize a more masculine face. The neck is thicker, and the chin is wider and flatter. The lips are longer and hence appear to be flatter.

Here we have the side view of our male character. As in our straight-on face, this profile shows a more serious, worldly character, just by making the eyes smaller and less round, the nose lengthier, and the chin fuller.

And, again, this character has a thicker neck. Where the female neck in profile was concave, this neck has a slight outward bulge, suggesting the male Adam's apple.

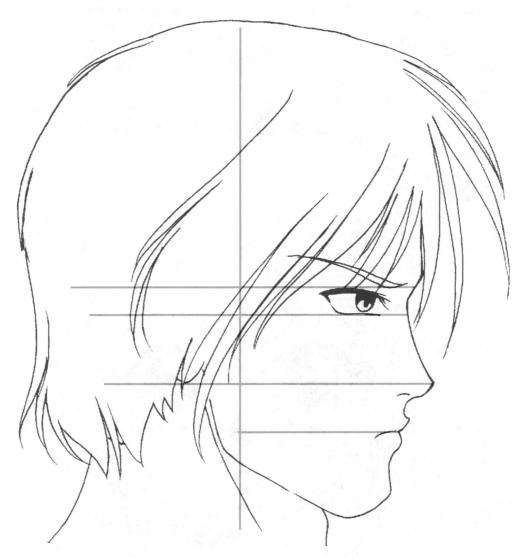

The male face in profile.

The Child's Face

In a straight-on shot, the child's face is almost heart-shaped, as opposed to the more oval shape of the adult face. The top of the skull is larger and wider than the female head. The chin is smaller and there is considerably less length from the nose to the chin.

In younger characters, the tip of the nose is lined up with the lower eyelids. The eyes are significantly larger, too, taller and longer than the adult female's eyes. And the ears, although not significantly larger, are placed lower and angled to stick out.

In the following profile view, we get a better sense of the placement of the ears, which tend to be much lower on a child's face. This puts extra emphasis on the enlarged head, as does the nose, which tends to be even smaller on a youth than it is on a female face.

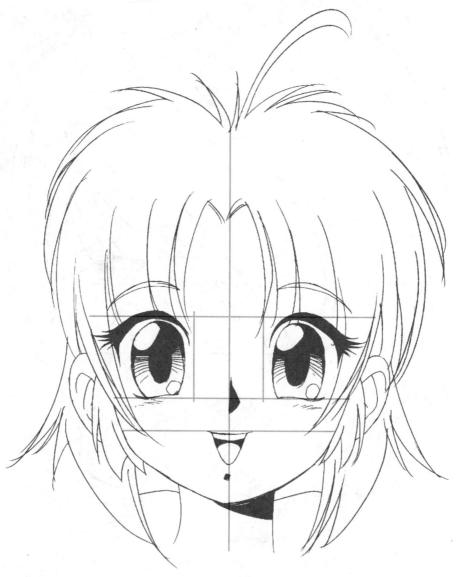

A typical child's face.

Sketchbook Savvy

Looking for the fountain of youth? For your characters, it might be no more difficult than the placement and size of the ears. The younger your character, the lower the ears tend to be on the head, and the

bigger they are, too. The height of the ears can make the exact same face appear to be a young child or an early teen, depending on where the ears are placed.

As always, the best way to learn more is to take these lessons and experiment with variations of them. Often you discover something really new and cool. Otherwise, you know what *not* to do next time.

The Least You Need to Know

- ◆ There are some simple tricks to learning facial proportions, including bisecting a face into two halves and using eye-width and half-eye-width distances to assist in placing the eyes.
- A character's gender can be determined by accentuating different facial features and changing the placement of these features.
- On the other hand, youthful or innocent male characters often take on more stereotypically female facial features.
- You can radically alter a character's apparent age based on the position or size of facial features.

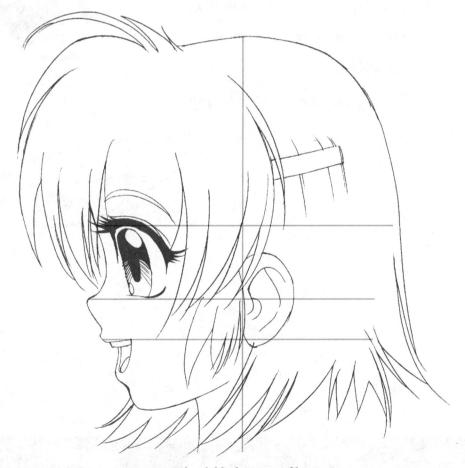

The child's face in profile.

In This Chapter

- The importance of eyes in manga
- The basics of drawing an eye
- Drawing different types of eyes
- Putting eyes together at an angle

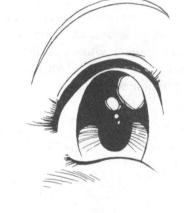

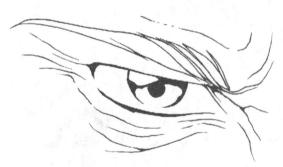

The Eyes Have It

It's an oversimplification to say that manga is *just* characters with big eyes and feet, but there's no denying that manga characters *do* have big eyes and big feet. Manga, in contrast to American-style comics, is a style of wild exaggeration, and nowhere is this more prevalent than in the eyes of its characters.

Windows to the Soul

In manga, the eyes truly are the windows to the soul, a tool to express what your character is thinking or feeling. Body language also speaks volumes, especially when it comes to action, but there is no better portal into your character's head than the eyes.

Say What?

An eye can threaten like a loaded and leveled gun, or it can insult like hissing and kicking; or, in its altered mood, by beams of kindness, it can make the heart dance for joy.

Ralph Waldo Emerson, The Conduct of Life,
 1860

Them Big Baby Blues

By the end of this chapter, you'll see there is no one way to draw eyes. Learning different types of eyes is one of the best ways to express your characters' personalities and their feelings.

Begin with the basic eye shape.

Getting the eye right is crucial to showing the reader what's going on in the character's head—or heart. For this basic eye, we start with a roughly oval shape, pinched on both ends. The higher end is toward the outside of the face, where the eyelashes are longest. On the inside of the face, placed lower, is the character's tear duct.

Add the lash line.

Give your eye some instant definition by building up the lashes. The lash line thickens toward the outside of the face. The widest point of the lash line is where the oval of the eye is pinched on the outside of the face.

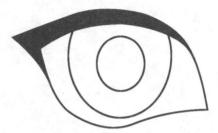

Add the iris and pupil.

The next step is to add a circular *iris* and *pupil*. In this basic eye, these are both perfectly round, although often these elements take a more oval shape to show different emotions. Also, try a larger pupil (the inner circle) to show the character is excited.

Manga Meanings

The **iris** is the colored portion of the eye, which controls the amount of light that passes through the pupil. The **pupil** is the black circle within the iris, which expands in size when a character gets excited.

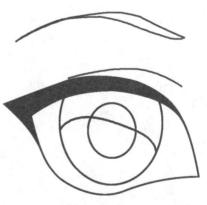

Add the eyebrow.

Here we add an eyebrow, comfortably above the eye, growing thicker as it curves toward the center of the face. A thin line above the eye denotes the eyelid, and a shadow from the brow falls across the upper pupil and iris.

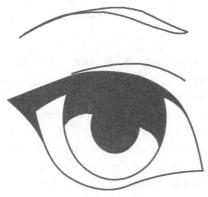

Fill in iris and shadow.

When you fill in this shadow, it adds a whole new sense of realism to the eye. Your eyeball is coming to life!

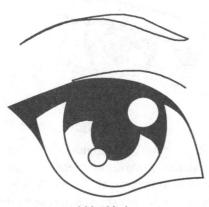

Add highlights.

A circle or two to denote highlights—reflections of what the eye is taking in—make for additional realism. The upper highlight is usually larger, representing a light source. Additional (smaller and lower) highlights are generally just reflections in the eye, to lend more realism.

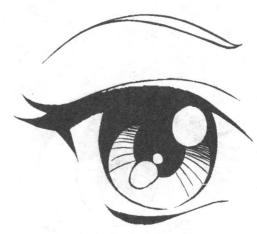

The finished eye.

Here is the inked and completed eye, with added flourishes such as eyelashes, secondary highlights, and some detail to the iris. In manga, the eyelashes are often exaggerated, in both the female *and* the male. Sometimes the eyelashes are impossibly long, just like manga eyes and feet.

The vast majority of manga is black and white, but you can often differentiate eye color in a close-up of a character. Blue-eyed characters have fewer radial lines in the iris, indicating a lighter color, whereas brown-eyed characters have more.

Exemplary Eyeballs

After you've got the hang of constructing an eye, you can add an amazing variety of expressions to your character with just a few simple modifications.

You can indicate surprise, shock, or wonder by elongating the eye. Stretch out the shape of the eye vertically, while making the pupil and iris more egg-shaped, to achieve this effect. Note that the eyebrow is also raised, and the lashes have been extended.

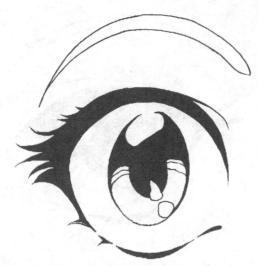

A look of surprise.

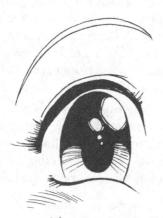

A happy eye.

This eye has a happier aspect than the previous eye. The eyebrow is lifted, and the iris and pupil are elongated into an egg-shape, but the lower eyelid curves above the lower eye. This eye shape suggests emotion, unlike the extended face showing gaping shock; the cheeks have been forced up as the result of a smile.

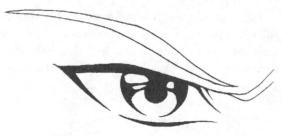

An angry eye.

Anger, disgust, and disdain can be seen in this image. The angles of this eye, as well as the eyebrow, veer sharply downward toward the middle of the face, to the point where the brow hangs slightly over the eye. Eyelashes, which give the eye a more sympathetic aspect, are minimized, and the area above the nose has some lines to indicate a furrowed brow, adding a severe expression.

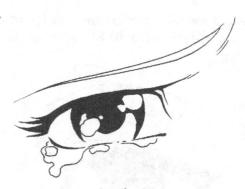

A sad eye.

While the angry eye angles downward, this sad eye angles upward, the eyebrow following the same trajectory as the eye. Where the angry eye's angles are sharp and severe, this eye is mushy and more organic. The highlights are similarly mushy and loose, suggesting a layer of tears clouding the eye. Here, the eyelashes return, giving the eye a more humanizing, empathetic aspect.

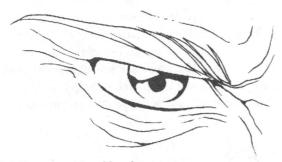

An older character's eye.

Modeled after the angry eye, this eye is given extra dimension with added detail. Bags under the eyes, crow's-feet, and bushy eyebrows can all add character and realism to an older face.

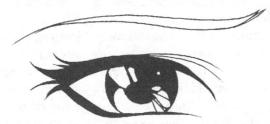

Basic eye variation.

A variation on the basic eye we practiced earlier, this eye is thinner, less oval-shaped, and

more masculine. This eye, less exaggerated, might be used on a male (or even a female) to denote a more mature, worldly frame of mind.

Advanced Placement

So far, we've just looked at putting faces together from a front or profile view, but if you stick solely to those angles, you're going to end up creating a pretty boring illustration.

The ideal placement for eyes for a straighton shot is with an eye-width distance between the eyes and a half-eye distance from the sides of the head. For the profile shot, reverse it: there's a half-eye width between the eye and the bridge of the nose, and a full-eye width between the eye and the ear.

Here are some tricks to getting your eyes aligned correctly at an angle. David has kindly shown us some guides (highlighted in color) for a better sense of facial proportions and proper placement. Although these guides were helpful in the previous chapter, here they are *crucial*.

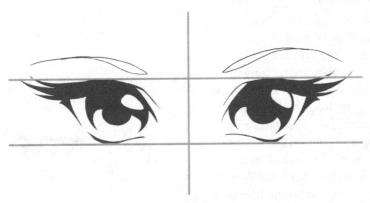

Ideal eye placement for a straight-on shot.

Mangled Manga

Don't draw both eyes on a face exactly the same. Eyes are symmetrical, so draw them as a mirror image of each other, as if the "mirror" runs vertically down the center of the face.

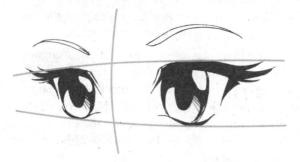

The angled eye.

If you need to draw the head at a ³/₄ angle, here is what you should do to distort the eye correctly (or at least give the illusion of distortion). The primary difference between this figure and the previous straight-on shot is the obvious curve to the lines. We don't have the straight lines on a flat surface we saw in our front and profile shots. The human face is round, and placement of eyes on an angled face should reflect that (as should the "eye guides").

The guides curve outward in a standard $^{3}/_{4}$ -angle shot; the horizontal lines denoting the tops and bottoms of the eyes are farther apart the closer they are to us, narrowing as they reach the far side of the face. The vertical line bisecting the face no longer does so in the middle. Instead, it splits the eyes, leaving the horizontal lines longer on the side of the closer eye and shorter on the farther line. The math gets a little trickier here, but there is a $^{1}/_{2}$ to $^{3}/_{4}$ eye-width from the closest eye to the line signifying the center of the face, and there is little or no distance between the far eye and the center of the face.

If you follow these guides, the closer eye will naturally seem larger. The pupil and iris of the farther-away eye are not smaller, but they sure look that way. That's because the eyeball itself is thinner. There is less visible *sclera*. That is, the eye narrows, and we see less of the whites of the eyes. This is a nifty trick to help capture the distortion of the faraway eye on a round face.

Manga Meanings

The $\frac{3}{4}$ angle is a shot in which the person or object is captured at a 45-degree angle (either to the left or right). The sclera, quite simply, is the white of the eye.

The same principle applies to a downward shot at a ³/₄ angle, with the eye guide getting narrower as it gets farther away. However, you'll notice that both eye guides curve upward (like a smile!). There is a half-eye width between the closest eye and the center of the face and no distance at all from the farthest eye and center, reinforcing the illusions of distance and the curvature of the face.

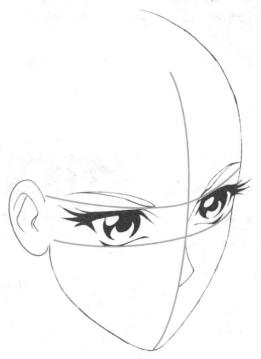

Eyes looking downward.

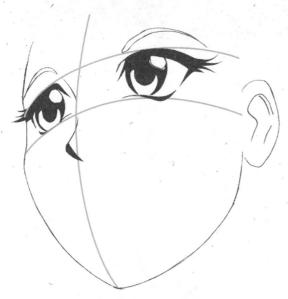

Eyes looking upward.

In many ways the figure of the eyes looking upward is the opposite of the previous figure, where the eyes looked downward, although the same rules apply. In the latter shot the guide lines curve downward. As we look up, the lower line follows the curves of the cheeks. As before, we still have the lines converging slightly as they recede from view. And, again, you'll notice the farther eye looks smaller, but only because there is less visible sclera. The pupil and iris are still the same size.

Sketchbook Savvy

Want a quick and easy reference tool for placing and positioning eyes when drawing a face from an angle? Look no further than your refrigerator. Try drawing eyes—as well as the guides to position

eyes—on an egg. You can look at the egg from whatever angle you like, which will help you get the hang of capturing eyes on a round face from a multitude of angles.

We could end nearly every chapter saying the same thing: practice! It may be redundant, but it's also true. Practicing eyes, though, should be fun, since they're one of the most critical aspects to bringing your character to life.

The Least You Need to Know

- Eyes are big in manga, literally and figuratively, and they play a critical part in effective storytelling and characterization.
- Being able to draw a basic eye is the foundation of showing a wealth of character emotions and expressions.
- ♠ A few simple variations in the shape of eyes can radically alter a character's presentation and mood.
- Positioning eyes on a face from an angle can be difficult, but some handy tricks using guides can help you get the right perspective.
- Keep practicing. Don't skimp; I've got my eye on you!

In This Chapter

- Mastering other facial components
- The key to drawing ears
- Nose-y shapes and sizes
- Drawing expressive mouths

Face Off

Now it's time to look at the other components of the human face: the ears, the nose, and the mouth.

Of these, noses and ears are the least expressive. There's not a lot that these features can do. So you really just need to get the nose and ears right once per character. The mouth is trickier, so we'll tackle that last.

Now Ear This

This figure is the ear's skeleton. The reversed "C" follows the slope of the cartilage, and the lower object represents the hanging lobe of the ear. Everything inside the "C" is the inner ear. (This is the ear for the left side of a character's face. For the right ear, you would reverse the image.)

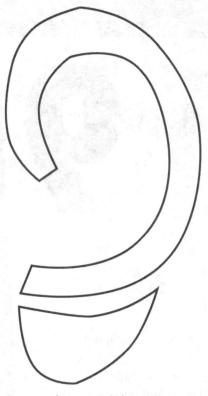

The ear's "skeleton."

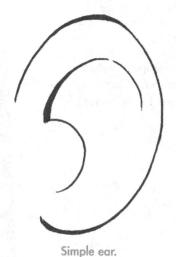

This is the most basic ear, without a lot of detail or extra flourishes. The lines follow the outline of the previous figure, but we see nothing other than the *pinna* and the *tragus*. The simplicity of this figure gives it a more cartoony feel, as does its roundness.

Manga Meanings

The pinna, or auricle, is the visible portion of the ear, and the tragus is that little projection of cartilage in front of the inner ear.

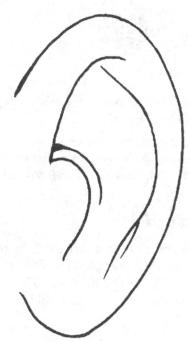

More realistic ear.

Here is an ear that has a little more detail and, hence, is more realistic. It's longer and more realistically shaped than the basic ear. There's a second line behind the tragus, and the lobe and the lines denoting the inner ear are less perfectly rounded. Although the basic ear had two lines to indicate the inner ear following a clean and simple arc, the lines of the inner ear in this figure do not follow one arc. The lower line veers toward the upper line, giving the ear a sense of depth missing in the simple ear.

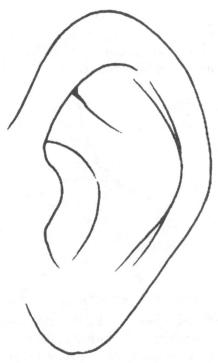

Complex ear.

The complex ear takes things even further. The tragus is more realistically shaped, and there are more lines in the inner ear. The ear is quite complex when drawn accurately, so the more effort put into capturing its detail, the closer to authentic it appears.

Sketchbook Savvy

Ears giving you trouble? The good news here is you're not going to have to draw them too often. Many characters have hair that obscures the ears entirely, and most have hair that obscures the

upper half of the ear. But even though ears may be less fun to draw than eyes and mouths, you'll still need to practice them.

It gets awfully boring to see the same character from the same angle again and again. And you can only draw a profile shot so many times before it starts getting really old.

Front view of ear.

The front view of an ear is much more of an oval than the circular side view, and you'll notice it's tilted a bit, as most ears tend to stick out from the head to a degree. (The ear on the opposite side of the head tilts in the opposite direction.)

Lines to denote the inner ear follow roughly the same paths, although the lower inner ear protrudes from the line of the outer back ear.

Back view of ear.

Easier than the front view, the back outer ear is basically a tall, wide cone with an inner and outer circle facing outward.

Character ear.

Just for fun, here's a different sort of ear: a pointed ear you might find on an elf or fantasy-based humanoid. The lines of the inner ear still follow roughly the same path and intersect the same way, but they take a much more dynamic angle. The lower line of the inner ear intersects with the upper line much earlier, and the upper line extends farther, which makes the ear appear longer, bigger, and deeper.

Nosing Around

To nose, or not to nose? That is the question, at least when drawing manga characters. Manga characters are often drawn without a nose at all. Other times, the nose is small or implied with a shadow.

The large-nosed lead character is extremely rare. You may find a large nose, however, on characters such as villains, lanky sidekicks, wizards, and insensitive ethnic types.

Cute nose.

This nose is best for a kid or a cutesy girl. It's small in size, slightly upturned at the tip, and has a few lines above the tip to give the nose some added dimension. A small nose like this leaves more facial real estate for the eyes and would probably work best on a larger, childlike head.

Viewed from the front, the actual nose outline would likely disappear altogether, although the lines above the tip of the nose would remain visible.

An "implied nose."

This is a different type of nose. Elongate the cute nose, and it is not just larger and longer, but its angles give the nose a regal bearing.

Note that the bottom of the nose is implied with a shadow, just a simple line starting at the tip of the nose and curving around to the lower nose, which gives the nose a sense of top and bottom.

Basic nose.

This is a more standard nose. This is probably a male nose, since most girls in manga will have a "cute" nose. In this case, David has drawn just a slight line to imply a nostril.

More elongated nose.

This is a variation on the standard nose, with the nose elongated.

Shadow nose.

On its own, this might not even look like a nose. In many cases, this is the most typical of manga noses—a shadow that suggests, rather than shows, the nose. It's also a good indicator of which direction light is coming from. This nose is even less obvious than the implied nose.

Variation of the shadow nose.

A variation on the previous figure, this nose appears even more abstract. Longer shadows indicate less light is hitting the right side of the face. Whatever the light source, it is coming from the character's left side.

Combo nose.

This combo nose uses elements of the first two figures in this section. It has the slight curve toward the middle of the cute nose, but suggests the bottom of the nose with shadows like the implied nose. In the case of this figure, the light may be coming from above, and the nose is casting a slight shadow. The lines above the tip of the nose still give us the sense that the nose is upturned slightly. Aw ... isn't it cute?

Another combo nose.

The super combo uses elements of the previous figures in this section: the shaded curvy lines in the center of the cute nose, the suggested bottom of the implied nose, and the sidelit shadow nose. Since the side shadow is inked to make it progressively darker as it goes up, the lower shadow would probably be most effective with some sort of gray tone.

Another combo nose with shadow cast over the face.

Another combo nose, this one has a long shadow cast over the face. This is probably on a face in a dark room, or a room full of shadows, trying to achieve some moody *noir* effect.

Manga Meanings

Noir is a genre of crime literature and film featuring tough-talking and cynical characters, bleak settings, and generous use of shadows. Please note: most film terms can also be applied to comics.

The non-nose.

This nose, or absence of nose, generally belongs on an elderly person. It is typically above a mouth that sits low on the face, and the long nostrils are indicative of a face that has sagged somewhat due to gravity and age.

Mouthing Off

We've saved the other most interesting and expressive component of the face for last. The mouth, like the eyes, can express a multitude of emotions and can change with the slightest or most subtle line adjustment. In tandem with the eves, the mouth makes the emotional range of your characters nearly limitless.

Mangled Manga

Don't worry about matching word balloons to the speaker's mouth. A character can be "speaking" even if he or she has a closed mouth, aritted teeth, or a big smile. There is an understood suspension of

disbelief here by the reader. It is more important to convey your character's expression than it is to portray a character's mouth completely realisti-

Frontal view of a pair of lips.

These are female lips, as less-full male lips are usually not drawn in any detail. The top upper lip and bottom upper lip are basically wide M-shapes, and the lower lip is a large half-oval. The upper lip is roughly one third the entire lip, and the lower lip takes up the remaining two thirds.

Angled lips.

Less clearly delineated than the lips in the previous shot, these lips belong on a threequarter view face. The upper lip is a more curvy M-shape, and the bottom of the lip is a single smooth curve. This lower bottom lip is more of an elongated V-shape. Note the slight curve to the far side of the upper lip, giving the upper lip some extra definition. The sides of the mouth are a bit thicker, too, as the lips come together.

This slight smile shows you how easy it is to convey an emotion with little more than a single line. It is simply an upward arc, with a small tilted line to each side of the "mouth" and a little dimpled circle to show the bottom of the lower lip.

Big smile.

In many smiles, the lower row of teeth is not visible—but the tongue is. Note that this is a three-quarter view of a smile, which is why the line of the upper mouth trails off to the right.

Big laughing smile.

For the big laugh, we get both upper and lower teeth, as well as a much better look at the tongue. There is some definition to the shape of the teeth, some bumps to indicate canines up top, and molars in the lower back of the mouth. We also see dimples in the upper corners of the mouth and a line to emphasize the lower lip and chin, being forced together as a result of the wide-open mouth.

Downward facing smile.

The sad face is a downward facing smile. Lines to each side of the face emphasize the downward arc of the mouth, and a shadow falls below the unseen lower lip, the result of the lip's pronounced pout.

Angry expression.

An angry expression such as this generally appears on one side of the mouth. The mouth curves upward from a point in the front of the mouth, and the teeth are gritted together in an expression of rage. The lower back lip is also emphasized, and the mouth is open and straining with such rage that it appears to be pushing the lip back.

Exclamation of joy.

An exclamation of joy, wonder, or surprise is different from the big smile because the mouth is open wider and there are no visible teeth.

Put Your Best Face Forward

We now have almost all the pieces we need to make faces. As you practice them, play around with what you've seen and try to come up with things that are new and different.

The Least You Need to Know

- The nose and ears are the least expressive components of the face. Unlike the mouth and eyes, they do not change based on a character's mood.
- Noses are often minimized (or completely ignored) in manga to make more room for manga's large and expressive eyes.
- Ears can be tricky to draw but, fortunately, are often obscured by a character's hairstyle.
- Like the eyes, a well-drawn mouth is an effective tool to convey your character's thoughts or feelings.

In This Chapter

- Hairdos for your characters
- Male styles
- Female styles
- Making hair colors and highlights

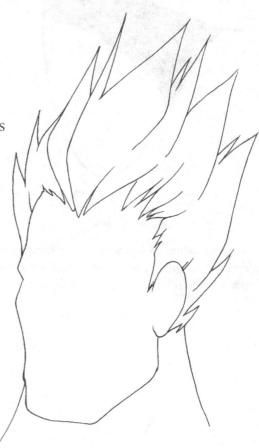

Chapter

Hair Today

Unlike the parts of the face, hair doesn't actively express emotion. But just as in real life, a character's choice of hairstyle can tell you a lot about the character and his or her circumstances and personality.

Some Male Styles

As in real life, male haircuts show less variety than female haircuts. There are always exceptions, of course, but male hair tends to be shorter, and female hair is, if not longer, portrayed in a wider variety of styles.

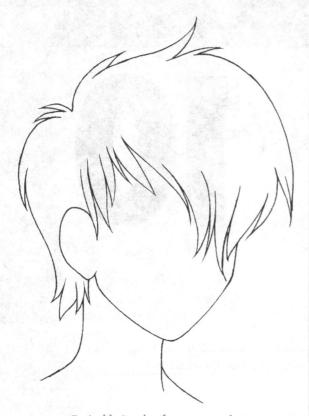

Typical hairstyle of a young male.

This hairstyle is like that of a young male. The hair comes to various curved points, and the individual locks give the hair a scruffy, unkempt appearance—that of a young boy who either doesn't know better or care enough to attend to his appearance.

On the other hand, this could just as easily pass as a girl's haircut. *Androgynous* characters are popular story devices in manga. This haircut would work perfectly for a tomboy girl trying to get by in a man's world.

Manga Meanings

Androgynous characters are those whose mannerisms and appearances deliberately blur the line between male and female. Is that a guy or a girl? Good question!

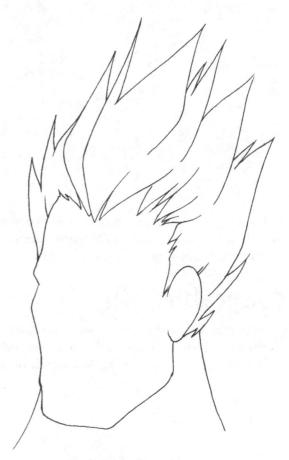

Punky hairstyle.

This haircut, curving upward in sharp angles and standing in tall, spiky points, suggests a more rebellious personality.

Some Female Styles

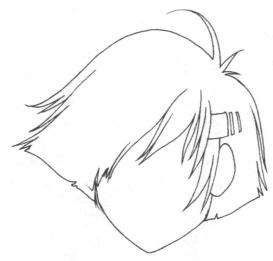

Spunky hairstyle that suggests a young character.

Short and angled in the back, hair in the face but not obscuring it, parted to flop over on one side and reveal only one ear, this is the haircut of a spunky character.

Say What?

Hair style is the final tip-off whether or not a woman really knows herself.

-Hubert de Givenchy, Vogue magazine, July 1985

The hair clip contributes to the "cute factor," and the out-of-place hairs on the side and top of the head suggest this is a "real girl," not some unattainable feminine ideal.

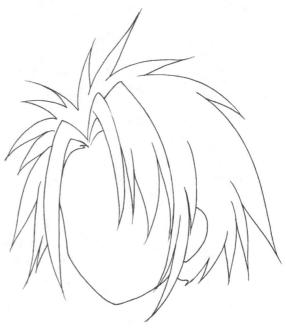

Another spunky haircut.

Here's another spunky haircut, but this one feels punk as well. Although the hair still meets in curved points, the angles are generally sharper, which suggests a character with an edgier personality. This haircut belongs to the detached older sister, the goth gal, or the leather-jacketed, multipierced girlfriend of some street hooligan or *Yakuza* member.

Manga Meanings

The Yakuza is the Japanese criminal underworld, Japan's Mafia or Cosa Nostra.

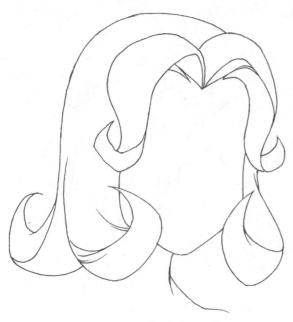

Feminine, "good girl" hairstyle.

This is the haircut of a good girl, rich girl, pampered girlfriend, spoiled girl, unattainable cheerleader, or some variation on the campus hot chick. The gentle curving and curved hair implies a softness and femininity to this character.

In the next drawing, the hair is pulled back 'tightly and its long tresses are interlocked and overlapping in a braid.

However, this could also easily be the haircut of a young monk. Remove the hair hanging in the face, and it becomes the disciplined haircut of an older and more mature monk or male martial artist.

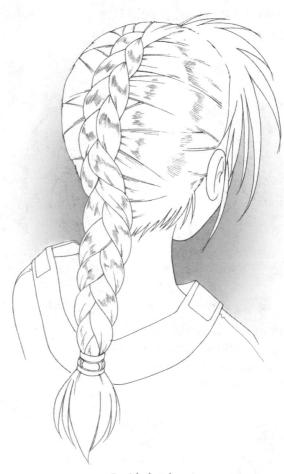

Braided style.

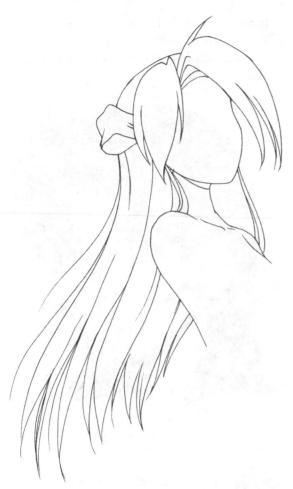

Quintessential "cute girl" hairstyle.

Long flowing hair, a bow, a front part, and hair hanging slightly over the eyes are fundamental aspects of this very popular girls' manga hairstyle. This is the quintessential "cute girl" style, and since many (if not most) of the girls in manga fit in the cute category, you'll see it again and again. This style is particularly well suited to stories with schoolgirl protagonists or shojo manga ("girl's comics") stories.

The next style is a more fantasy-oriented version of the cute girl cut, one that you might find in a futuristic, sci-fi, or fantasy setting such as *Final Fantasy* or *Sailor Moon*. This particular hairstyle is gravity defying and utterly unrealistic, but also unmistakable and unique and cool.

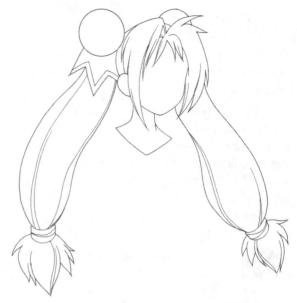

Fantasy-oriented version of "cute girl" hairstyle.

Coloring Hair in a Blackand-White World

In the previous drawings, David purposely left the hair blank, so there would be no mistaking the line work. When you are creating a graphic novel with a multitude of characters, however, you're going to have to figure out some tricks to make the characters quickly and easily distinguishable from one another.

Of course, the manga we are talking about is in black and white, so when I say "colors," I mean *implying* colors. Rather than drawing everybody with black hair, you can draw some characters with gray-toned hair instead of black, some darker gray and some lighter gray. And some characters' hair, like the drawings we saw previously, is simply uncolored. Manga readers readily accept a simplification of reality, and this includes changes to hair colors from the natural.

Setting the Tone

Tones are most easily achieved by scanning penciled and inked artwork into a computer and coloring it using Adobe Photoshop.

For those who don't have the money to invest in a scanner, a computer, and software, there is the old-fashioned method of applying the tone directly to the artwork, usually using a sticky "tape" of gray dots, cut and placed on the art to achieve the desired effect. These tones are called Zip-A-Tone or Zip-Tone.

Sketchbook Savvy

A scanner, a computer, and Photoshop are the tools you need to add tones digitally to your art. If adding tones by hand, buy an adhesive mechanical tone from your local art supply store. There

are many manufacturers of mechanical tones, but like Kleenex, Vaseline, or Xerox, mechanical tones have come to be referred to generically as Zip-A-Tone or Zip-Tone, the name of the company most associated with selling them.

Of course, another option is to *not* use tones. Many manga books are simply pencil and ink, black and white with no grays or anything else in between.

The next figure's hair has been rendered simply in ink, so the figure is black and white with nothing in between. The advantage to this style is that it is faster. The disadvantage is that you lose much of the detail of the hairstyle, as well as a sense of the individual hairs.

In the next figure, David has used some White-Out or white ink to add a few white lines, giving the hair more personality and definition.

Black hair rendered in ink.

Sketchbook Savvy

Yes, there is such a thing as white ink. And it's available in the same art supply store that carries black ink (and in the same section, too). Make sure you pick some up along with your other art supplies; it's invaluable for adding highlights.

Highlights added to black hair.

This is the same figure as previously, but with highlights added. They give the hair a vibrancy you don't see with just flat black.

In the case of this drawing, David added a graduated tone in Photoshop. You'll notice that the gray at the top of the girl's hair gets progressively lighter. After that, David drew white lines over the gray (also in Photoshop) to achieve an even more pronounced highlight effect.

It would not be difficult to achieve the same effect by hand. When inking the figure, leave the area to which you would like to add a tone black. You can then lay down gray Zip-A-Tone (or even gray watercolor, or pen, if you prefer). Then go over the gray you've just added with White-Out or white ink. *Voilá!*

"Haloing" highlights.

There's a different sort of highlight on this head. A graduated gray tone is added first, followed by some thin lines of white outlining, or haloing, the hairs between the gray and black of the hair. This has the result of separating the hair a little more. Perhaps this is the result of an overhead light or hair that is lighter on the top and darker at the bottom.

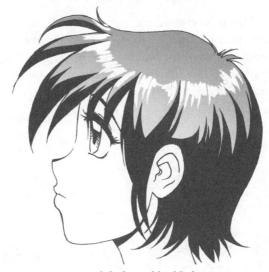

Hair with halo and highlights.

The previous figure uses the same highlight effect as the highlighted figure before it but the white highlight lines are wider, giving the impression that this hair is thicker and coarser than the hair in the first figure.

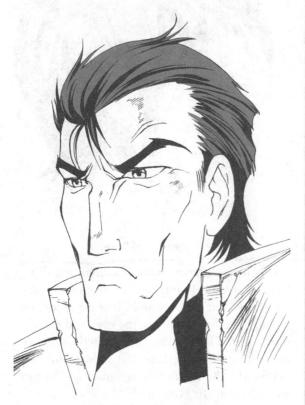

A single tone, no highlights.

This is an example of a single tone being used to color hair, as we saw earlier. But this time, instead of that color being black, it's a gray tone. This allows us to see more detail in the character's hairstyle.

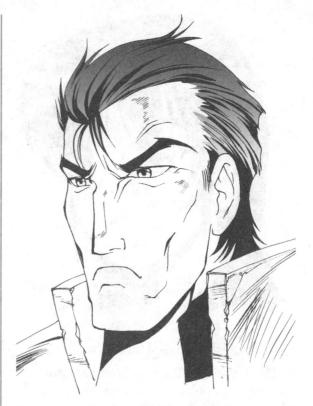

Graduated shades of gray.

In the next figure, we've added white highlights. This is a great way to add some dimension and make your character's hair a bit more dynamic.

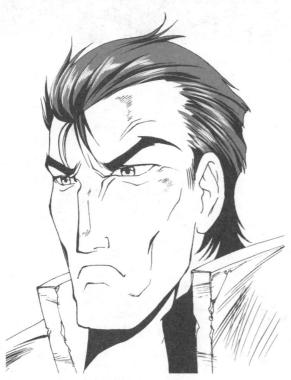

White highlights added.

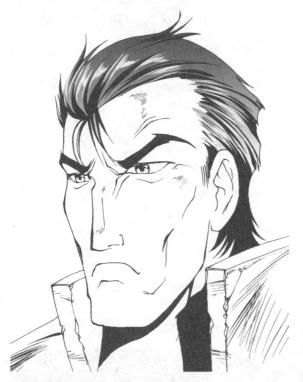

Graduated shades of gray and white highlights.

The final version has a graduated tone *and* white highlights. Compare it to the others and decide what you like best. Experiment with the hairstyles featured in the first half of this chapter, trying them with different colors, filling them completely in black, or adding highlights, tones, or graduated tones (or combinations of all three).

The Least You Need to Know

- Hairstyles can convey your characters' personalities and circumstances.
- Many hairstyles are not for one specific gender: what works on one female personality type might work just as well on a male (and say something completely different about his personality).
- Tones and highlights can be added to differentiate characters and make their hair more visually interesting.
- Lighter-toned hair does not necessarily mean the character has light-colored hair. Manga readers are used to a certain suspension of disbelief when it comes to hair "color."

In This Chapter

 Conveying emotions through facial expressions

♦ Happy faces ...

♦ Sad faces ...

Mad faces ...

... and more!

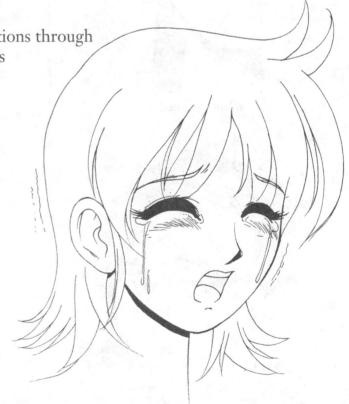

Chapter

Express Yourself

Now we're going to explore various ways to bring your faces to life, making your characters into emotional—and *emoting*—beings. It is infinitely more important to *show* than to tell. Expressive faces go a long way toward getting your reader emotionally involved in your story.

Making Faces

It's up to the artist to make the characters in his or her stories "act." Your comic book characters need to persuasively and believably convey their emotions and feelings.

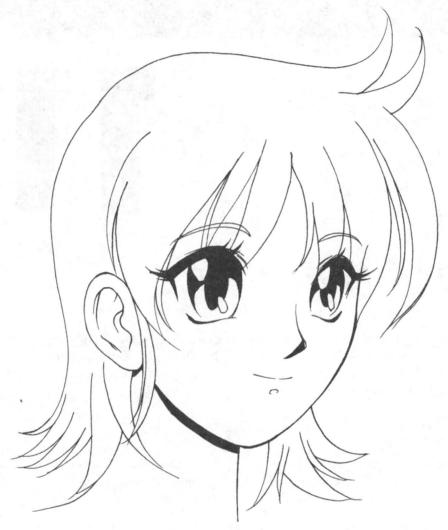

An expressionless face.

We'll begin, though, with a "control face." This blank canvas of a face doesn't convey any particular emotion, so we can compare against it as we crank up the dramatic tension.

In this case, we have the face of a quintessential sort of manga girl—large eyes and small nose. Her chin is thin, and her ears are low on the face, indicating that she is a young adult. Her eyes are wide open; her mouth is slight and slightly upturned. This is a perfectly adequate manga face. And yet, we have no idea what's going on in this character's head.

Say What?

When dealing with people remember you are not dealing with creatures of logic, but with creatures of emotion, creatures bristling with prejudice, and motivated by pride and vanity.

-Dale Carnegie, How to Win Friends and Influence People

Get Happy

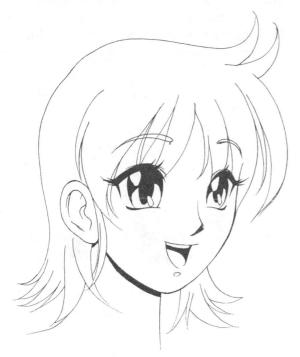

A happy face.

Most of the changes between the control face and this happy face can be seen in the mouth and eyebrows. The mouth is the more obvious of the two. Although there is no discernable difference in the chin, the mouth is open, thereby occupying more of the lower face. The upper lip curves upward, and the lower lip has the same curve, but far more pronounced.

Between this face and the expressionless face, the eyebrows are different, but subtly so. They maintain the same shape and curvature but are slightly higher on the face, farther up the forehead and away from the eye.

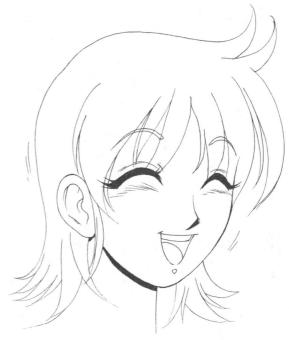

A very happy face.

The primary difference between the happy face and the very happy face is the eyes, which are squeezed shut (with joy!) and follow the same curve as the eyebrows. A few lines were added to suggest the upper eyelid, while some lines below the eyes follow the slight arc of the raised cheeks, suggesting they are flushed.

A small but key difference can be found in the mouth. It's probably no secret that the bigger the smile, the happier the character. However, in this case, the mouth is not significantly larger than the mouth in the previous panel. But David's decision not to ink the interior of the mouth reduces the amount of negative space and is a cool optical illusion that makes the mouth seem wider open than it is.

Sketchbook Savvy

Although the eyes and mouth get most of the credit for doing the emotional heavy lifting, the tilt and curve of an eyebrow can speak volumes. In general, to express a positive emotion such as happiness

or surprise, the eyebrow is raised on the face and retains its natural curve. For negative emotions—worry, anger, or sadness—the eyebrow is positioned closer to the eye, and curves opposite the curve of the upper eye.

Tears and Tragedy

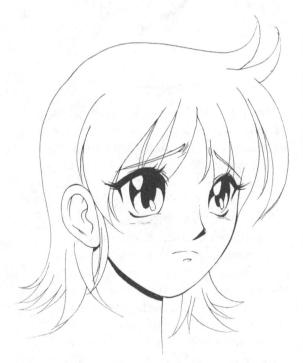

A sad face.

The curved mouth of the sad face has literally been turned over from the mouth of the control face. And note that this mouth is not one continuous line, but two small ones following the same arc. This suggests a bit of a pout.

The eyes have not significantly changed shape or size from the control face. The eyebrows, however, are straight, heading upward toward the middle of the face, where some slight lines indicate a furrowed brow. We also see some thin lines below the eyes.

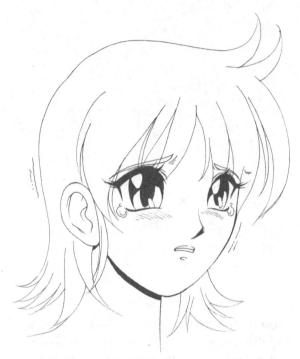

A very sad face.

Everything in this drawing is taken just a bit further than it was in the last. The mouth retains its same shape, but is open, and a simple line through the horizontal center of the mouth shows that though the mouth is open, the jaw is shut.

The eyes are smaller in this drawing, as the lower eyelid rises. The eyes are being forced smaller by the cheeks, which are pinched up even further, and the lines of the upper cheeks are more pronounced to convey the increased emotional intensity.

Note that the eyebrows are even closer to the upper eyes, although they keep the same angle and shape they had in our previous sad face. The capper, of course, is the tears welling to the outer side of each of her eyes—some mushy circles with slight highlights indicating gathering and inevitable tears.

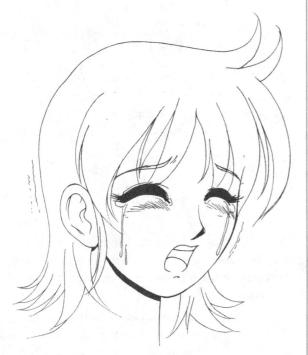

A miserable face.

As with the very happy face, the eyebrows suddenly seem higher, but only because the eyes are now closed and therefore take up less room on the face. But these closed eyes are looser than those on the very happy face, their inner ends splitting into a couple of messy points rather than one smooth point. The shape of the closed eye is less smooth and precise.

Those tears we saw welling in the eyes in the last picture are now streaming down the cheeks in unsteady lines. The flushed upper cheeks have moved even higher, and are now puffy, inflamed lower eyelids. The mouth is more of an elongated, open-mouthed frown, although we can see a curve on the upper lip.

Sketchbook Savvy

Say it with symbols. You can complement, and thus intensify, a character's mood with just a couple of small—and not completely realistic—artistic flourishes.

the following:

- Nervousness
- Anger
- Agitation

Motion lines are good with the following:

- Laughter
- Rage
- Despair

Mad Manga

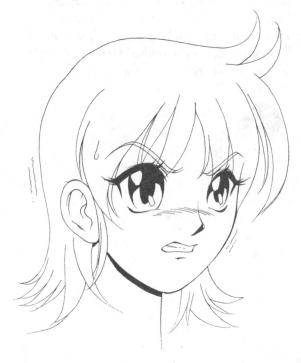

A mad face.

Here we present the mad face. The eyes are wide open again, and roughly the same size and shape as those in the control expression, the happy expression, and even the sad expression. Her eyebrows, however, are descending furiously toward the brow, arcing downward and converging upon it.

The upper lip of the mouth is almost an elongated M-shape: the middle upper lip curves downward as the midpoints curve upward like a snarl. The lower lip is flat, and the teeth within are more pronounced, with slight bumps representing the teeth. Where a single line in the sad face showed teeth that were together, these teeth are gritted, possibly even gnashing.

Above the mouth, curving over the nose, is a different sort of flushed face. The lines indicate a face flushed with rage, and this is subtly reinforced by the overall arc of the lines, which curve downward like a frown.

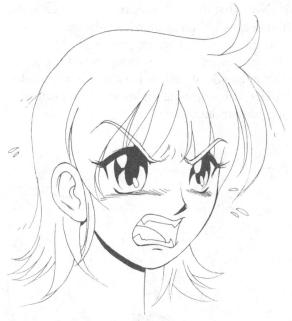

A furious face.

In this drawing the eyebrows even more dramatically descend upon the brow, even hanging over the inner eyes slightly. The lines indicating the curve of the furrow are more pronounced and dramatic as well.

The lines of the cheeks have moved above the eyes again and are tighter together. This makes them darker, a nifty way of implying the face is even more red with fury. The lines are close to the bottom of the eye, as the wide-open mouth is pushing up the cheeks.

The mouth is open, and there's a trick with the teeth that's unique to manga. The mouth is drawn long and wide, wide enough that we can see the teeth curving back into the mouth. This has the added effect of suggesting fangs, which are certainly appropriate for a character who is this livid. In fact, it's arguable that many artists do this not to show the horseshoe-shaped curve of teeth inside the mouth, but to deliberately achieve this fanglike effect. Exaggerate the canine teeth to achieve a more angry, wild-animal effect.

Mixed Emotions

Here are a few more faces to add to our repertoire. We'll begin with shock. Our character's eyebrows are raised in the shocked figure and follow the curve of the upper eye. In this case, however, her eyes are even lower, showing that her eyes are bugging out with surprise. Below them are slightly flushed cheeks. (Have you

figured out yet that adding some "color" to a character's cheeks is a great way to enhance whatever emotion he or she is expressing?)

The mouth is open wide, in this case wider than the very sad mouth, but longer than the furious mouth. It has a mostly oval shape, which, in tandem with the exceedingly wide eyes, contributes to the mood of wide-eyed surprise.

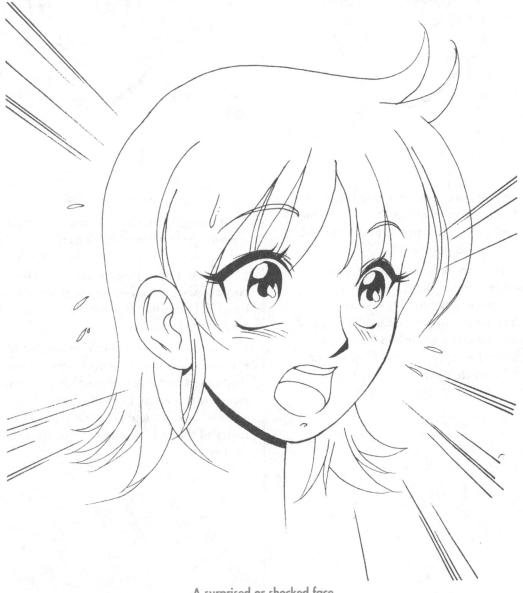

A surprised or shocked face.

A serious face.

The serious face is the face that is least different from our initial control face. The emotion is more internal than previous faces and, therefore, less demonstrative.

The difference between this face and the control face is in the slight adjustments to the eyebrows and mouth. The mouth curves more dramatically in this face, and the line of the mouth follows a single arc. The eyebrows are close to the upper eyes and furrow ever so slightly, which is what gives the face an intensity—and sense of seriousness.

A thoughtful face.

In this face, for the first time, the eyebrows are not symmetrical reflections of each other, but are actually in conflict. The eyebrows sit not too far above the eyes, one following the curve of the eye and ending slightly upward, the other in opposition, its inner corner descending toward the brow.

The mouth is curved downward, but like the eyebrows, it is not symmetric either. That is, the highest curve of the mouth is to one side. Again, this is a face in conflict, wrestling with various thoughts and possibilities, and the asymmetry of the facial features helps convey inner turmoil.

Sketchbook Savvy

Draw some slight variations on the previous figure and see what emotional effects you achieve. Raise the eyebrows a little, open the mouth or make it a bit bigger (but keep the same downward slope),

get rid of the hand to the chin, and add some beads of sweat and motion lines.

Now you know just about everything there is to know about putting emotions and expression on a face. Well, *one* face, anyway. But these tips and tricks apply to all faces. And, as always, keep in mind that mastering the art of faces takes trial and error.

The Least You Need to Know

- The same face can express a multitude of different emotions, which are achieved mostly through variations in the eyes, mouth, and eyebrows.
- You can add to and reinforce the intensity of a character's emotions by adding flushed cheeks, sweat beads, or motion lines.
- Manga characters are not known for subtlety. The characters are often exaggerated in their features, emotions, and reactions. Embrace it; don't resist it.
- ◆ The best way to discover new expressions is through trial and error, taking, for example, the eyes from one expression and putting them together with the mouth from a different expression. You'll end up with a face that's completely new and different.

Character Types

In this part we introduce you to some of the popular archetypes in manga. These are character types that show up again and again in different stories. We discuss these characters' relationships to one another and the role that they often play in a story.

In the following pages we'll introduce you to popular manga heroes and villains, sidekicks, sports figures, bruisers, and best friends. We even explore manga's animal kingdom, dream up fantasy creatures, and take a peek at the things that go bump in the night.

In This Chapter

- Swashbuckling swordfighters
- Hip schoolboys and schoolgirls
- The flyboy with an attitude
- ♦ The antihero or street punk
- The intrepid kid detective

Chapter

Stars of the Show

Now that we've explored how to make different manga bodies and faces, it's time to put that knowledge to good use. The character types in this section are by no means a comprehensive selection, as manga employs a vast (and always expanding) variety of genres and characters.

In this chapter we'll start with the good guys (and gals), the characters that get top billing, and the ones most likely to lead us on an adventure. We'll draw one step-by-step, and then move on to other types.

The Fantasy Swordfighter

Initial line.

We begin, as always, with a line to indicate the basic motion and flow of the character.

Next, we sketch the roughest of pictures, using geometric shapes. From the curve of the spine and tentative step forward of the left foot, we can tell this is a person in a cautious pose—perhaps someone stalking. We also have a small waist on this figure and a hint of flowing hair. If this is a male, it's definitely not a muscular one.

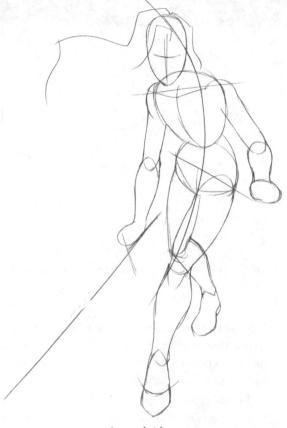

A rough idea.

The flowing hair and the addition of breasts make it clear the following is a female figure. We also get some suggestions of clothing, including a shoulder piece and cape. The face is bisected, in anticipation of laying down facial features.

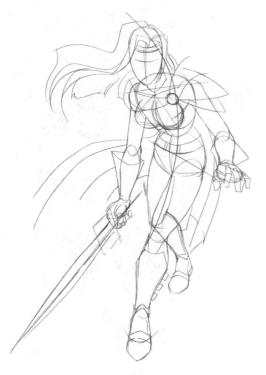

A swordswoman emerges.

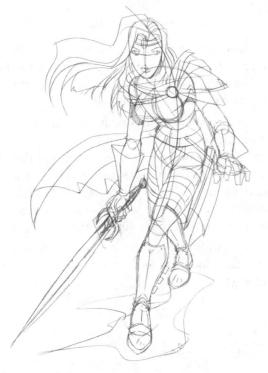

The face in place.

Now we see the actual facial features and more elements of the clothing and accessories. While this figure still needs a lot of work in the way of detail, note that we can already see the expression on the face.

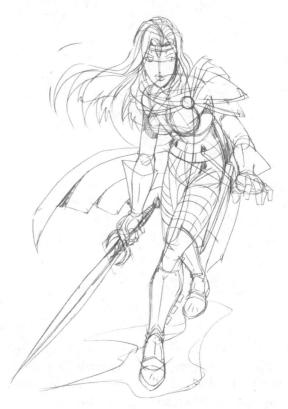

Some light and shadow.

Here David is considering the light source, starting to add suggestions of shadow to give the character added depth.

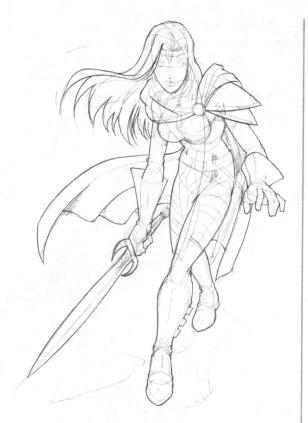

Moving on to ink.

Now satisfied with the drawing, David starts with the most preliminary ink work, laying down a solid line that primarily serves to outline the figure and her clothing. He also sharpens the work in the inking stage—having already mapped the figure out in pencil, he inks a much smoother, confident line.

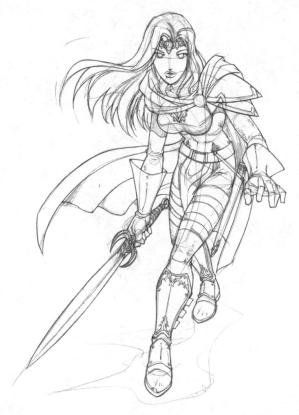

Detail ... and texture.

Further inking allows not just more detail, but also texture. Note the tiny U-shaped marks on the arms, torso, and leg bands, to give the impression of linked chain mail.

Finally we have the completely inked figure of our fantasy heroine. We'll talk more about gear and accourtements for characters in Part 5, but for the moment, note that David has paid particular attention to the character's headpiece, sword piece, and cape brooch, resulting in a more interesting and unique character.

Now, with this step-by-step out of the way, let's take a look at a few other leading role character types.

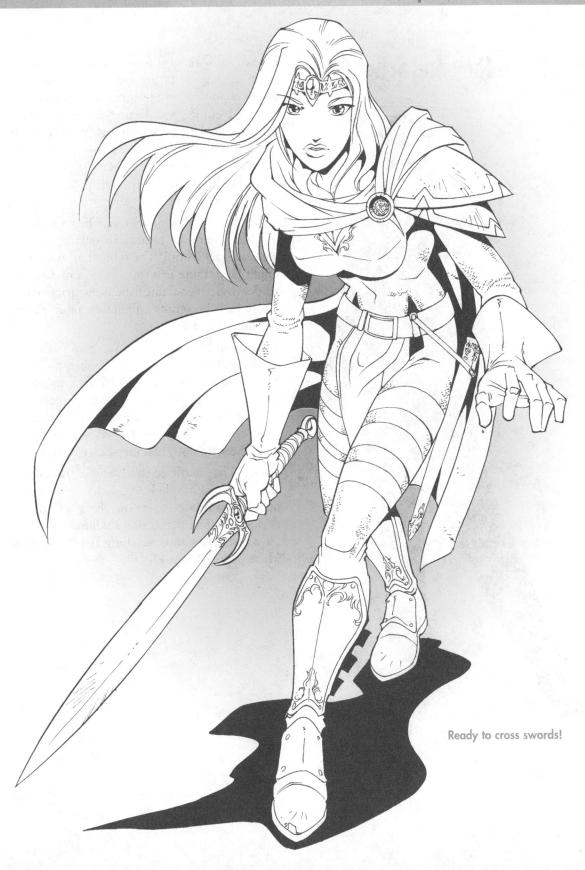

The Schoolboy and Schoolgirl

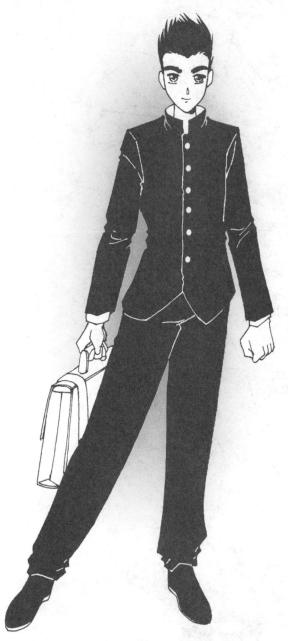

Schoolboy.

One of manga's most common character types is the schoolboy. As we've stated, shonen manga is wildly popular and features stories of excitement, adventure, and derring-do. As it is geared primarily toward boys (although not necessarily enjoyed *just* by boys), many of the stories feature school-aged males. These stories take place in a school setting, at least until the character is swept up into some crazy adventure.

Keep in mind, though, that when we say "school," we're not necessarily talking about a conventional school. The schoolboy archetype might be training in a spy school, a martial arts academy, or even a futuristic deep-space outpost where he is becoming a fighter or pilot who will defend humanity.

In Chapter 3 we showed you how to draw the schoolboy body type. Remember, he doesn't have to be of epic stature or have a muscular body to emerge as the story's hero. In fact, his unexceptionalness is usually one of the points of these escapist stories, as the average boy reader finds the schoolboy archetype easy to relate to.

David has outfitted this particular schoolboy in an outfit of simple black, with a wide and open collar to accentuate the character's thin neck and a shirt that shows a slender body type. He added folds in the clothing and buttons with white ink or White-Out. One of manga's other most popular characters, naturally, is the school*girl*, who is both the love interest in many schoolboy shonen tales and the protagonist of girl-geared shojo books. (Japanese comics also show an extreme fascination with schoolgirls in explicit and adult-oriented hentai manga, but I already *told* you we weren't gonna get into that!)

I should also mention that female leads are by no means exclusive to shojo manga. There are plenty of heroic female leads starring in shonen manga as well, butt-kicking babes who are every bit as formidable and tough as their male counterparts.

David has designed this figure with a teen female body type (see Chapter 4), with big eyes and a small nose and mouth, accentuating her cute aspect. She is in a schoolgirl-type uniform of knee-high socks, a short pleated skirt, and a button-up jacket with a frilly tie.

Sketchbook Savvy

Give your character some easily identifiable clothing or an accessory. Often characters in manga look similar, so something that makes your character unique and identifiable is always helpful. The

accessories the character chooses can also help define his or her personality, from the nerd with the pocket protector to the "cool dude" never seen without a pair of shades—even indoors.

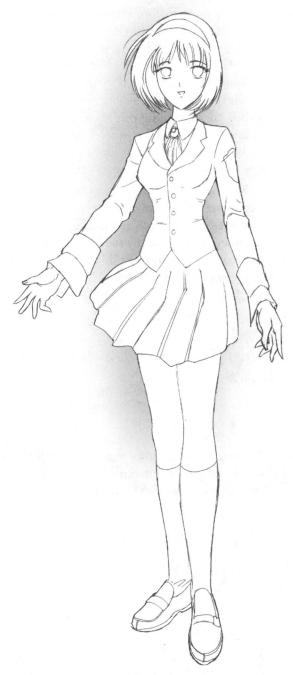

Schoolgirl.

The Pilot

The pilot or soldier is a different type of archetype, usually more mature than the schoolboy. Hence we portray him more as an adult, based on the athletic male body type discussed in Chapter 3. These stories often feature a cocky young adult who learns humility or a rookie who finds the courage to be a hero. While schoolboy tales let young readers imagine themselves as a similarly aged character they would like to be, the tales of young adults present role models to which younger readers can aspire.

In this case, our hero has been outfitted in a high-tech armored uniform or mech, with lots of sleek lines and layers to accentuate the intricacy of the design. *Mech*, by the way, is short for "mechanical," an item we'll be exploring in much greater detail in Chapter 22.

Say What?

A hero is no braver than an ordinary man, but he is braver five minutes longer.

Ralph Waldo Emerson (1803– 1882), American essayist and poet

The next drawing shows our pilot, minus the helmet, looking suddenly much more human and vulnerable, despite the cocksure grin.

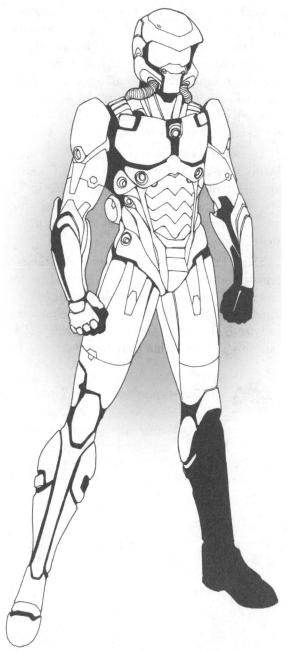

Pilot or soldier.

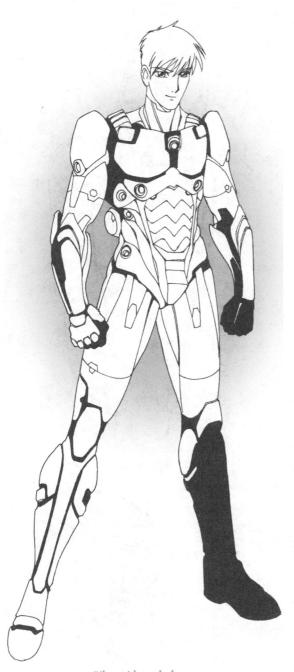

Pilot without helmet.

The Punk

A different sort of hero is the antihero, the punk with an attitude, or the post-apocalyptic protagonist. Here, the character is accessorized with a rag-tag mix of different objects, bandanas, chains, belts, bracelets, and whatever bits of body armor he's been able to beg, borrow, or steal.

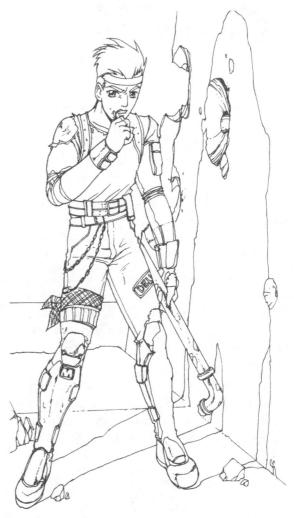

Punk or antihero.

There are plenty of sci-fi manga stories set in a post-apocalyptic or dystopian future, where the heroes are scrappy survivors who have learned to get by in an unfriendly and dangerous world. Often they are rebels fighting an evil government to make the world a better place. And often, in keeping with the bleak settings, these stories have very unhappy or tragic endings.

Manga Meanings

A dystopian future is one in which things have gone terribly wrong, and some or most aspects of this future have made things much worse for humanity. By contrast, a utopian future is one where

everything is better than it is now, perhaps even perfect. Of course, stories set in utopian futures lack the drama of dystopias, so you won't find a lot of those

These antiheroes are the ones who are fighting to make their dark world a better place, even if they have to be ruthless and break a lot of rules (and bones!) to do so.

A piece of body armor outfits our antihero; in this case, it's a knee and shin guard. Military magazines and books are good references for this sort of accessory, particularly magazines on contemporary warfare.

And certainly no punker ensemble is complete without a pair of steel-toed leather hightops. In this case David has added an extra protective plate to the front of the boot to provide maximum butt-kicking damage!

Body armor.

Boot.

The Kid Detective

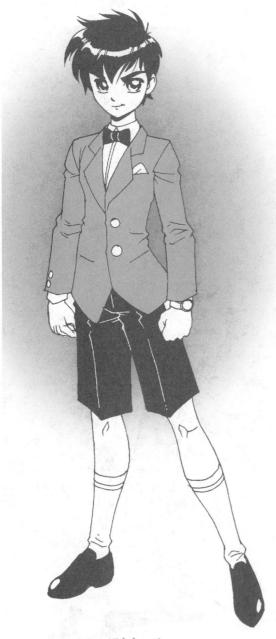

Kid detective.

We've mentioned that there are manga books for *all* ages, and that includes young children. Manga has plenty of young readers, many in their very early teens and often some even younger. And many of these books feature kid heroes, grade-schoolers who are extraordinary or who find themselves in extraordinary circumstances. (And again, this is not to say that these very same books aren't enjoyed by adults and young adults, too, because quite a few of them are.)

So we introduce one final protagonist archetype, the precocious kid detective, child spy, scientist-geek gadgeteer, tech savant, or gamer.

In this figure David has given the intrepid youth short pants and striped socks, which give him a more youthful appearance. The bow tie and handkerchief, which conversely have a more grown-up aspect to them, make it seem like this lil' guy is trying to appear more adult and sophisticated than he actually is.

The Least You Need to Know

- There are a multitude of hero archetypes, designed to appeal to a wide and diverse range of readers.
- Often heroes are people you can relate to in extraordinary circumstances. Other times they are extraordinary people you can aspire to be.
- Accessorize and fashion your hero with things that make him or her unique and easily identifiable.
- What a character wears or carries can speak volumes about the character's personality or the world he or she inhabits.

In This Chapter

- The intimidating second-in-command
- ♦ The best pal
- The goofball sidekick
- The scientist
- The battle-scarred veteran
- ◆ The trainer

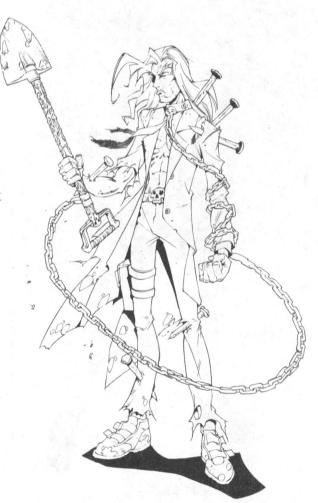

Chapter 3

Support Staff

A supporting cast is by no means unique to manga. In fact, supporting characters are universal to drama, Japanese or English, whether the medium is comics, books, television, or film. Everybody has a friend. And no matter how antisocial a lone-wolf antihero is, there's usually that *one* character to whom they have some attachment or allegiance. Usually even the villain has some sort of second-incommand flunky!

Sometimes these characters need help; sometimes they provide help. Often it's a little of both. Supporting characters are also a valuable way to provide exposition, acting as sounding boards for the ideas or emotions of the main character.

The Second-in-Command

Since bad guys are often more fun visually than good guys, we'll start with a secondary bad guy from a gothic horror story, an enslaved zombie or undead servant of some sort.

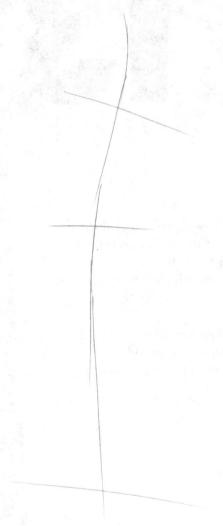

A basic starting line.

Our starting motion line is fairly static and straight in this image, suggesting this figure will not have a lot of dynamic movement.

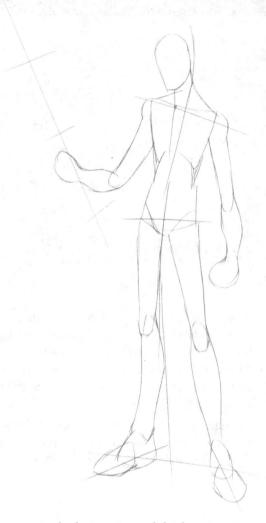

Lanky features in a subdued pose.

The rough figure is standing in place, in a definite non-action pose. Slender and not visibly muscular, the character shows subdued body language.

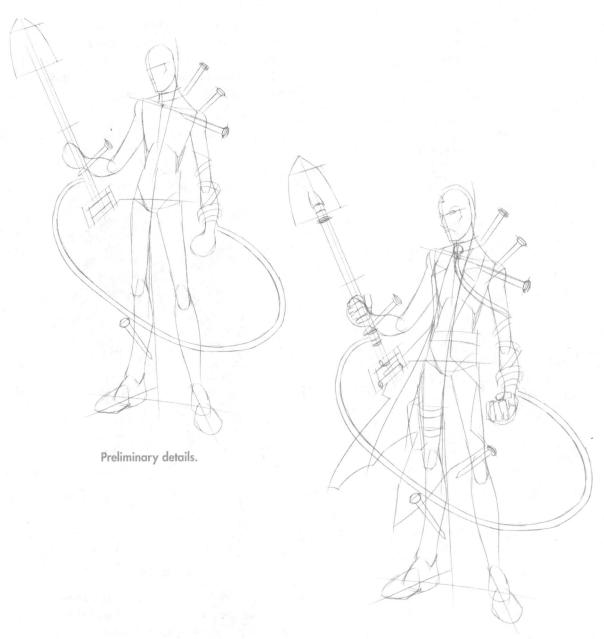

Clothing outline and additional details.

Added, but still preliminary, details are roughed out, including a shovel-shaped object, some sort of rope, and some peculiar spikes.

As more detail is added to the figure, we get a rough idea of both the character's facial

features and his clothing. Of course, anybody with spikes sticking into him like this probably isn't alive by any conventional definition, so we're probably looking at some sort of supernatural being.

Hair is added.

Long hair is added next, along with segments of the ropelike object wrapped around the figure's hands.

Intricate detail and atmosphere.

The detail in this panel adds atmosphere and character to the drawing. In this case, something sinister is taking shape, as a skull-shaped belt buckle and collar are among the most noteworthy additions.

The character is outlined in ink.

Now content with the pencils, David moves into the ink phase. What appeared as segments of a "rope" are now more clearly links in a metal chain.

Chains are not the easiest things to draw, but they would be unconvincing if they'd been left as they were in the previous image. Sure, filling in the details takes a little more time. But some characters and images will always be more involved than others.

The chain is detailed.

Black is now added. Look at the torso: there is lots of detail to the stomach, but the character is not particularly muscular. In the context of the entire figure, we get the impression that there isn't much meat on this character's bones. Take off the shirt, and this member of the living undead would likely be skin and bones—if that!

Shadow and musculature.

In this final drawing, we see David has added some thin, almost scratchy parallel and cross-hatched lines somewhat haphazardly around the figure, giving it a ratty or disheveled appearance. We'll speak of this again, but note that David's decision not to include pupils gives the character a more inhuman aspect.

Now, with this step-by-step out of the way, I'll introduce you to some other types of supporting characters.

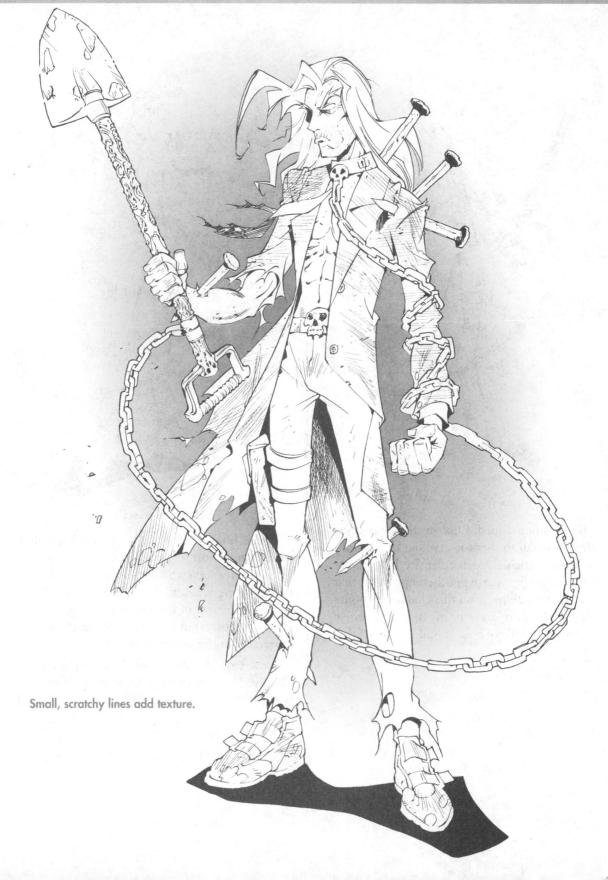

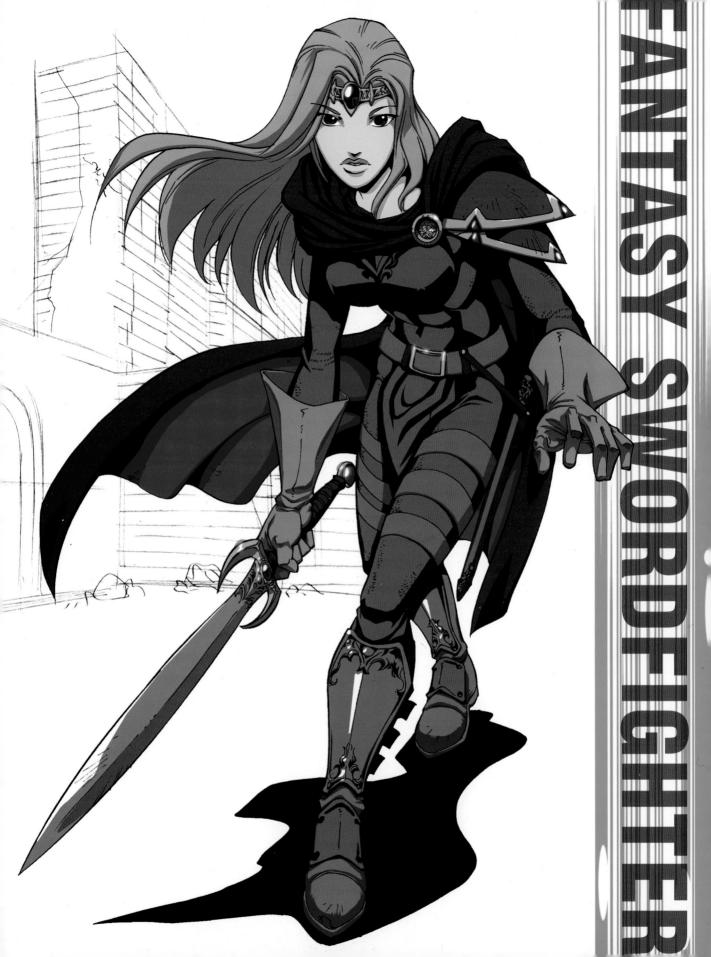

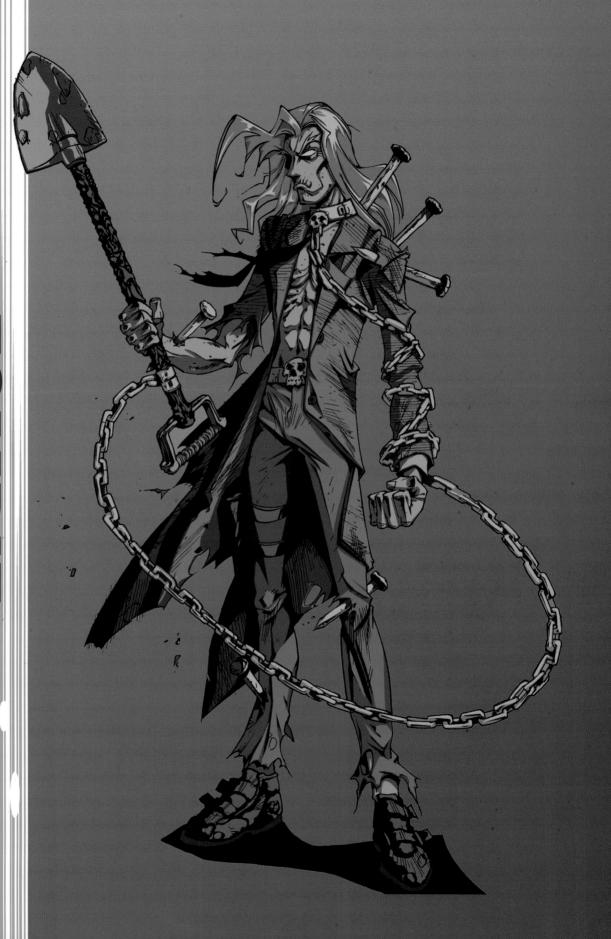

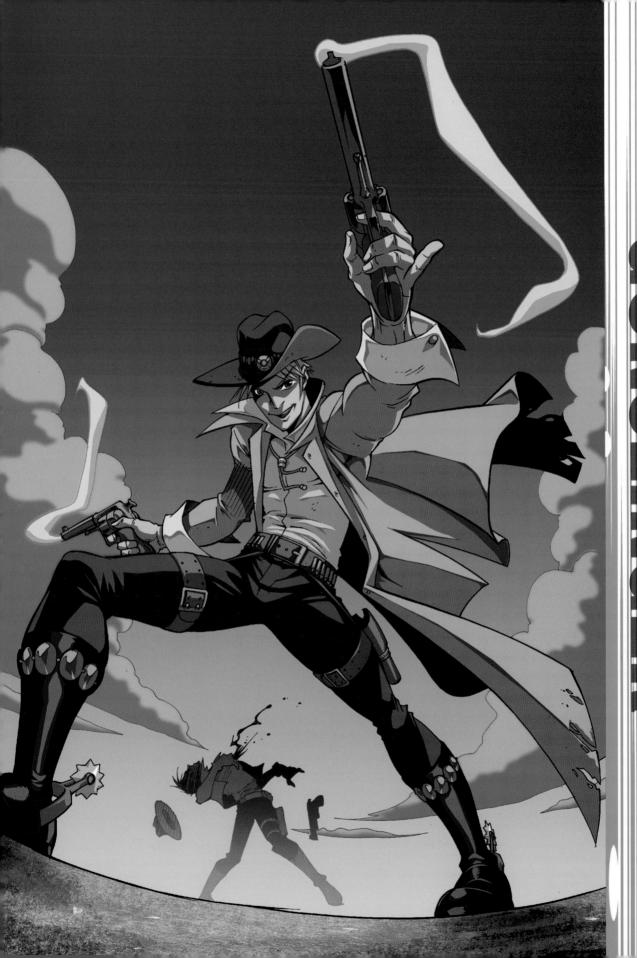

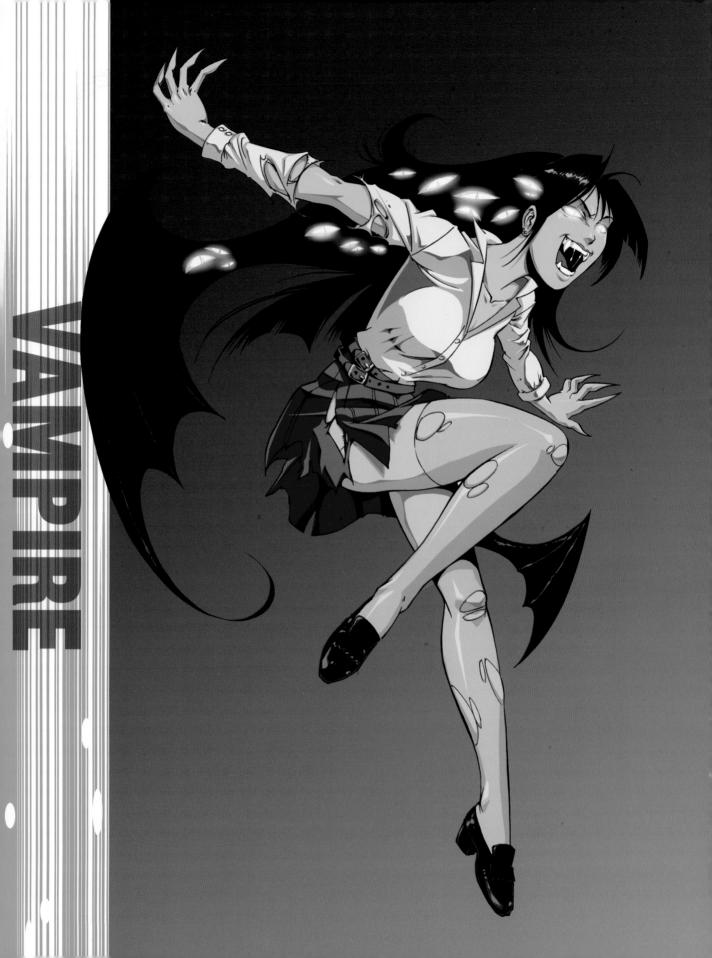

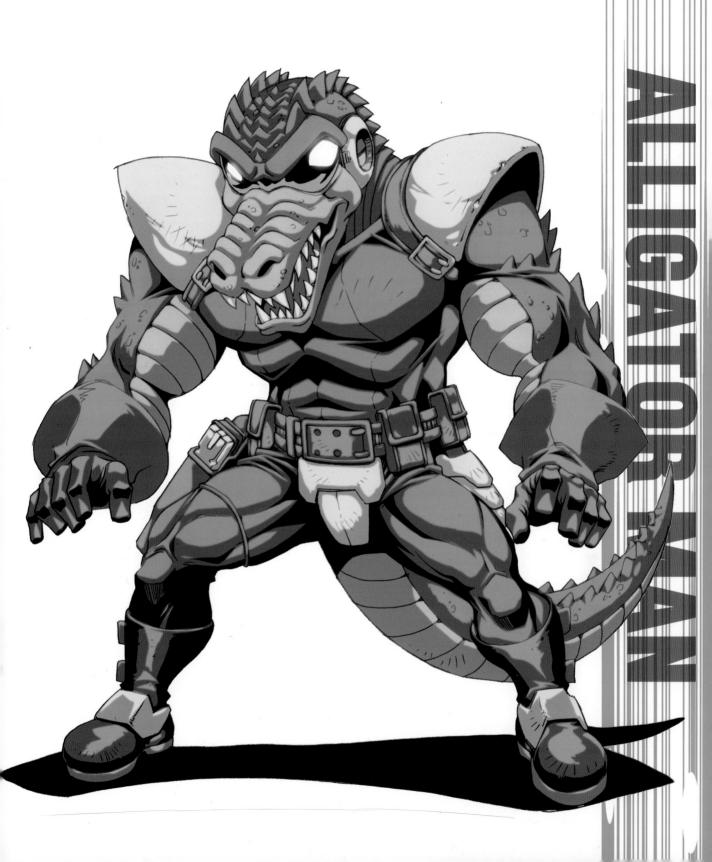

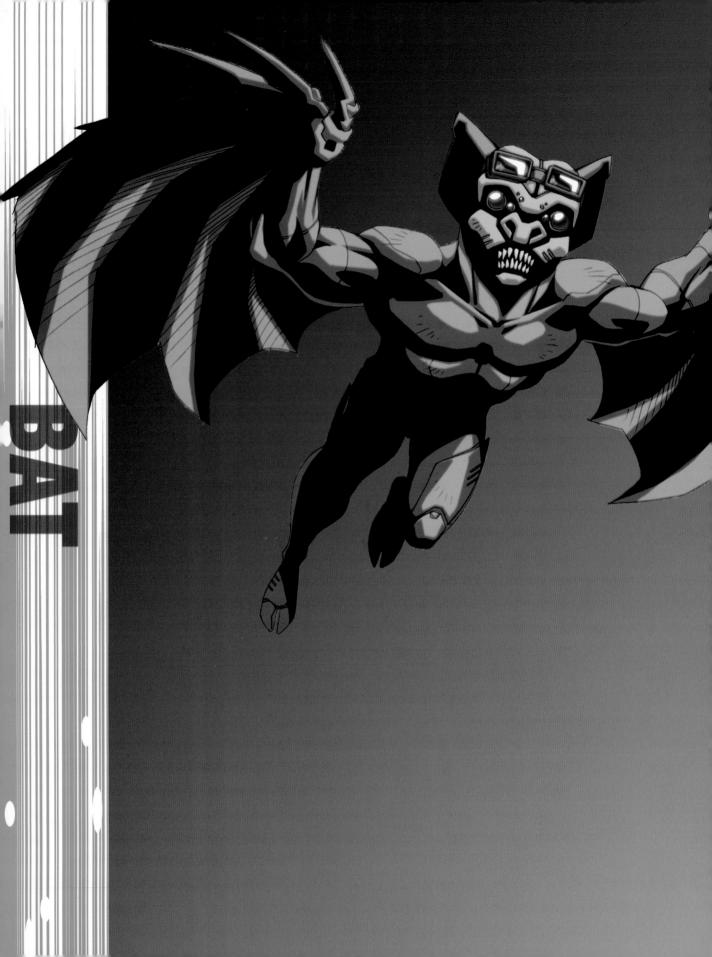

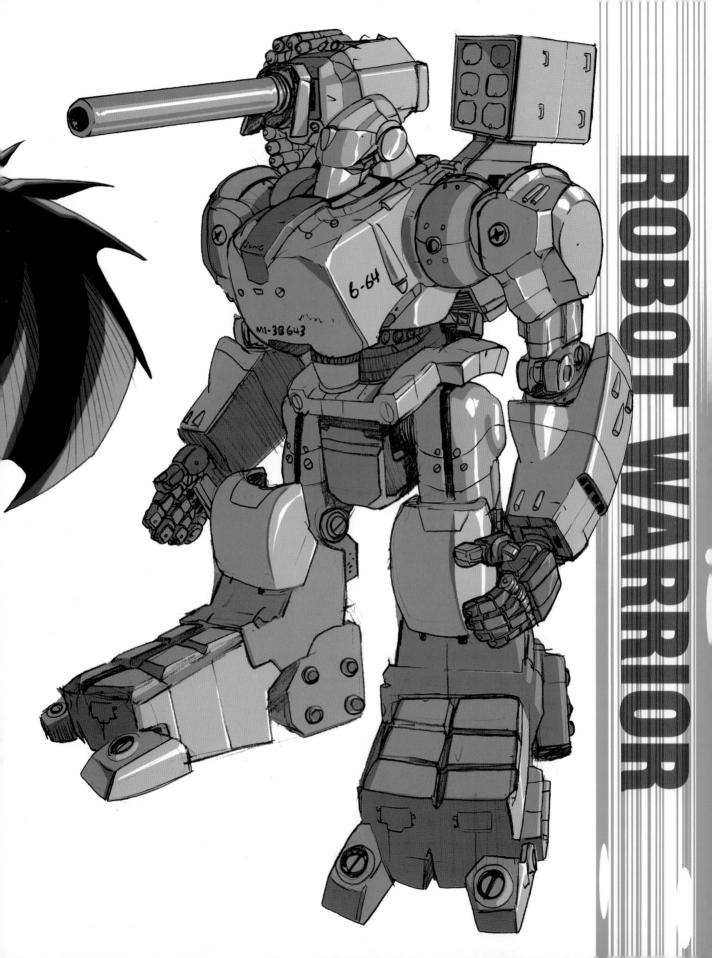

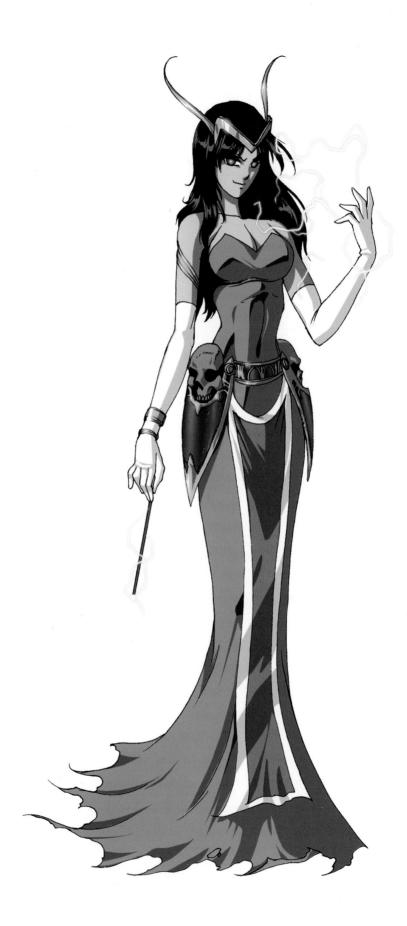

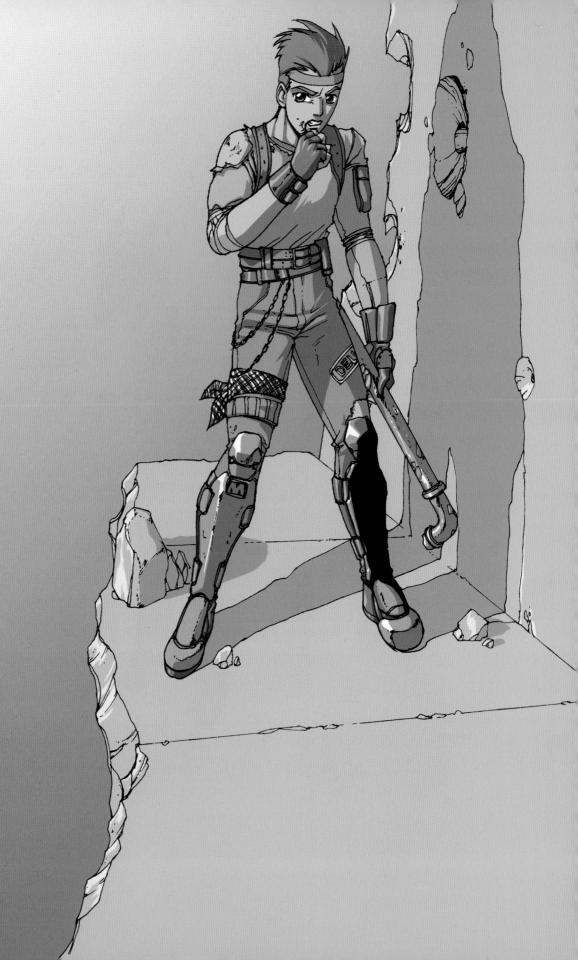

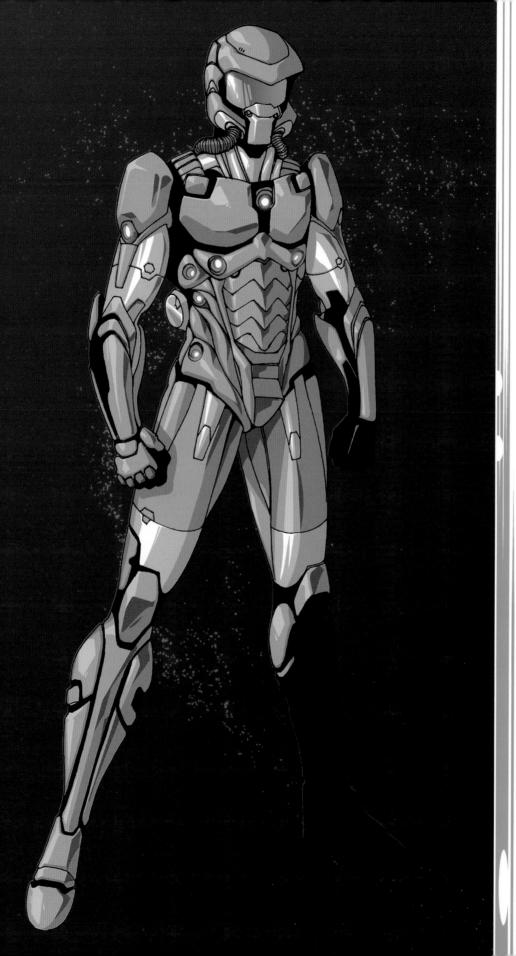

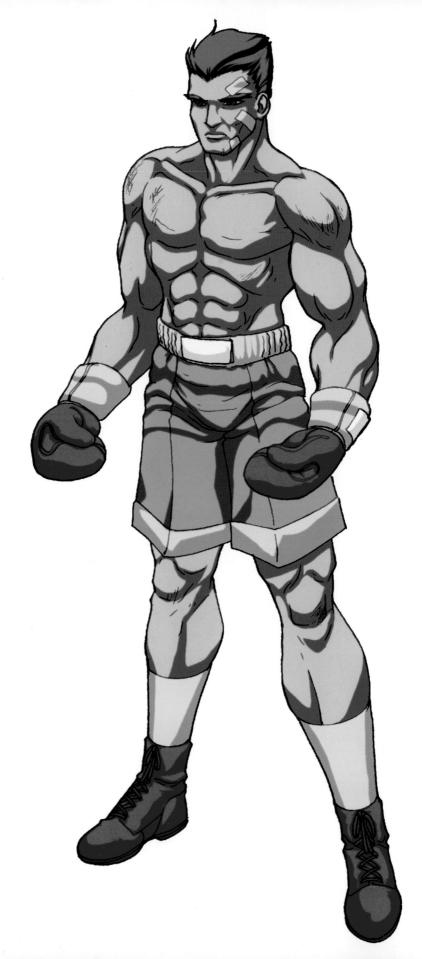

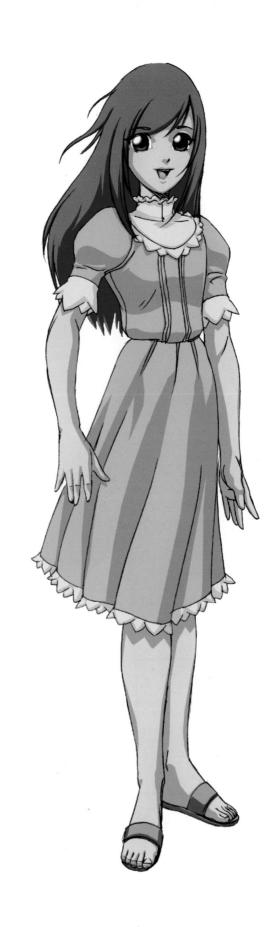

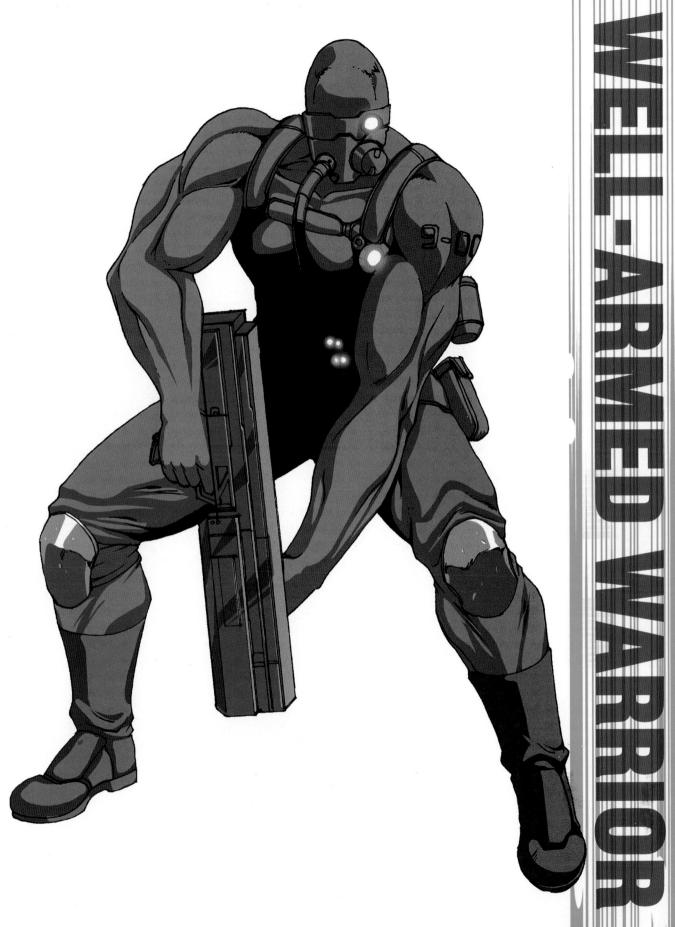

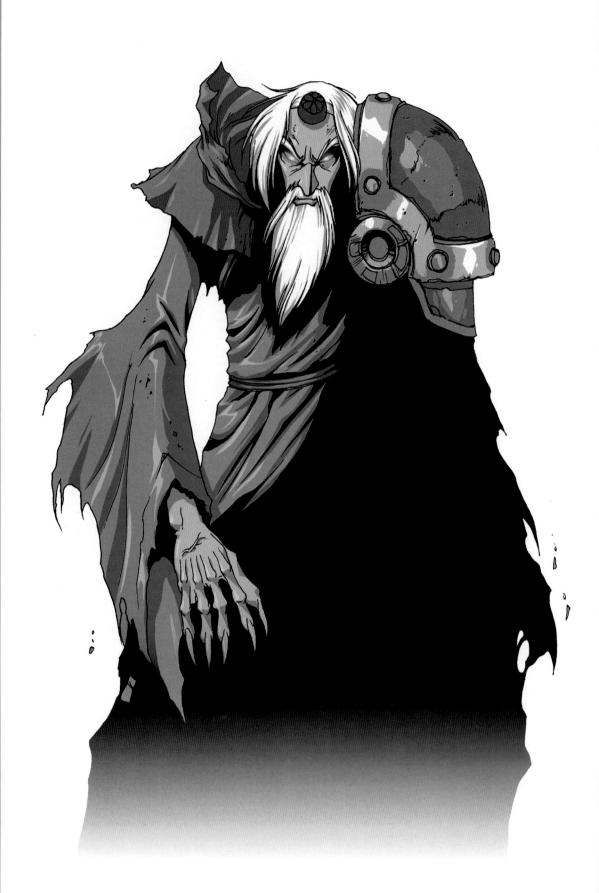

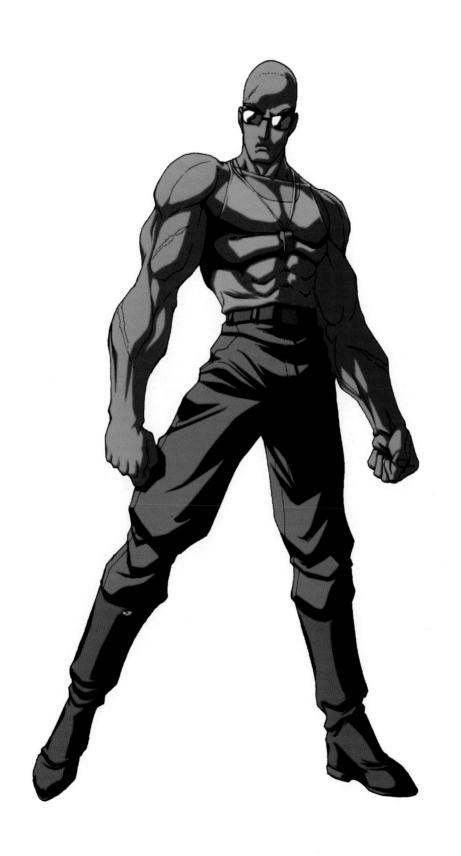

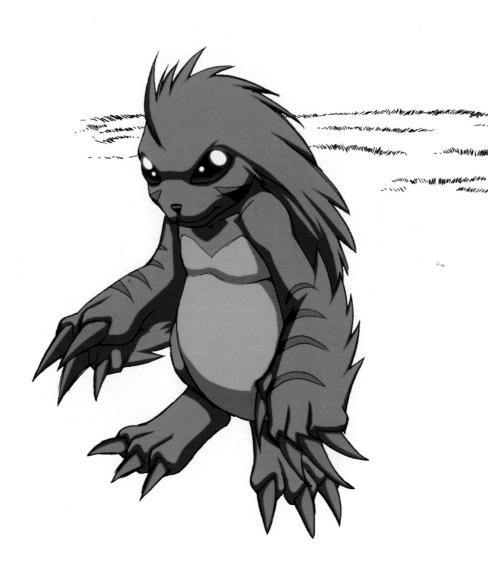

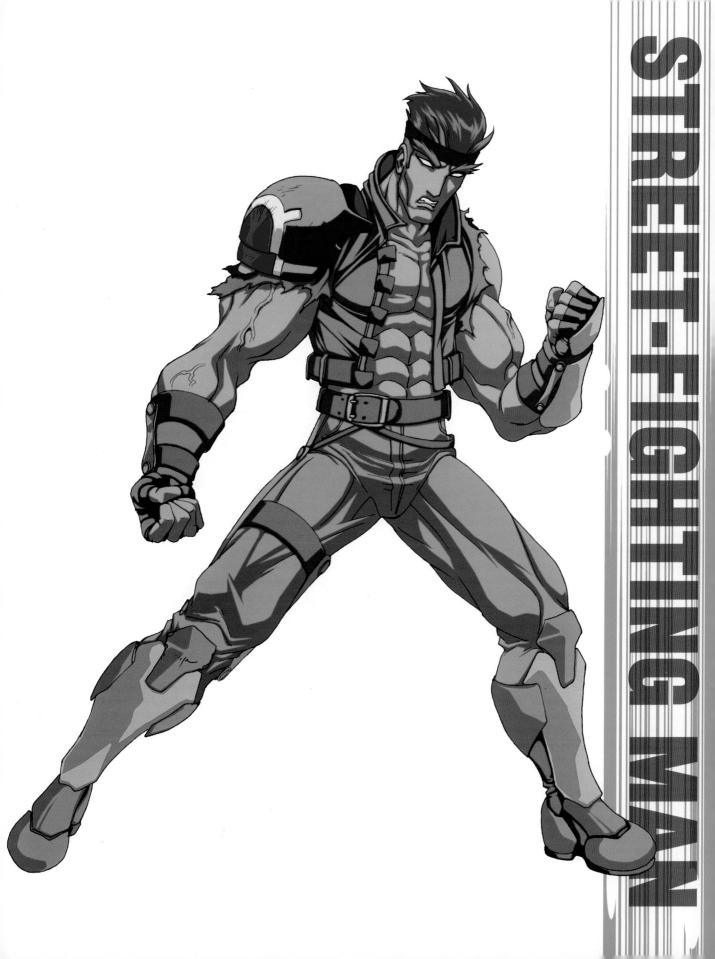

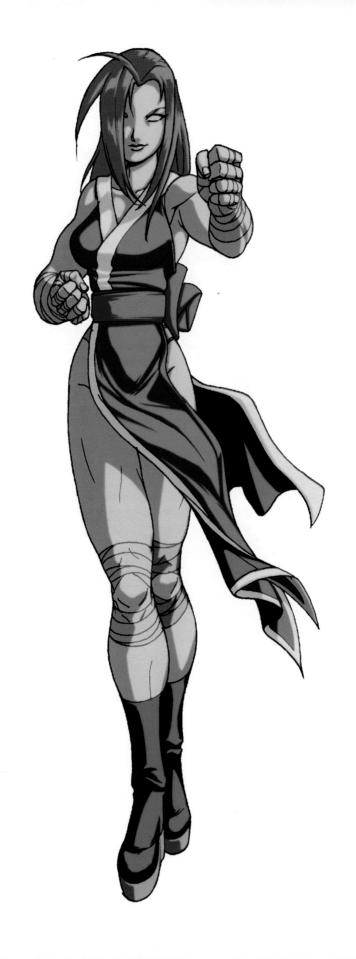

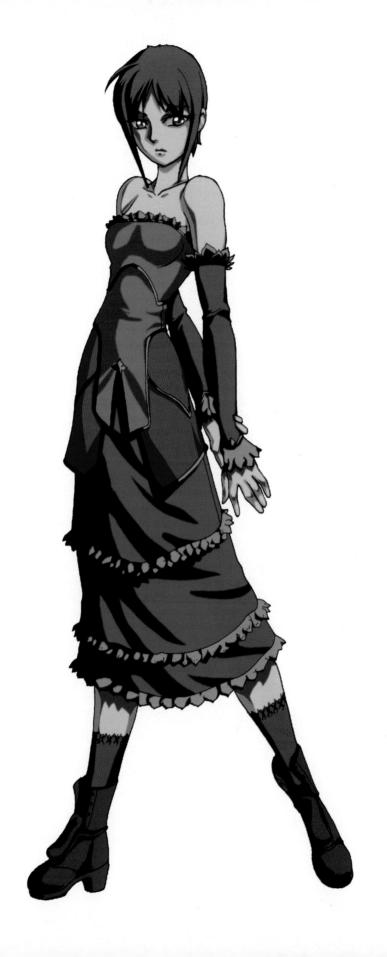

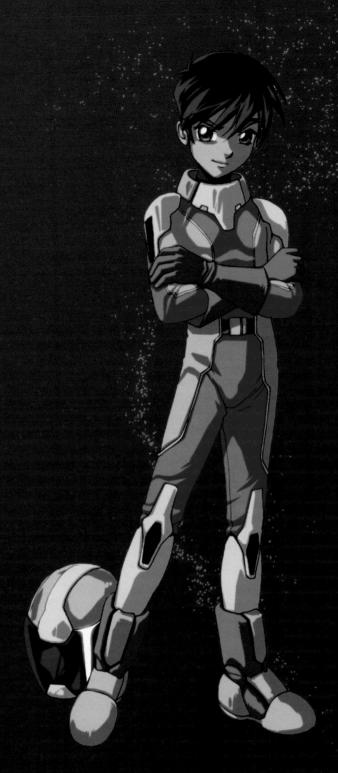

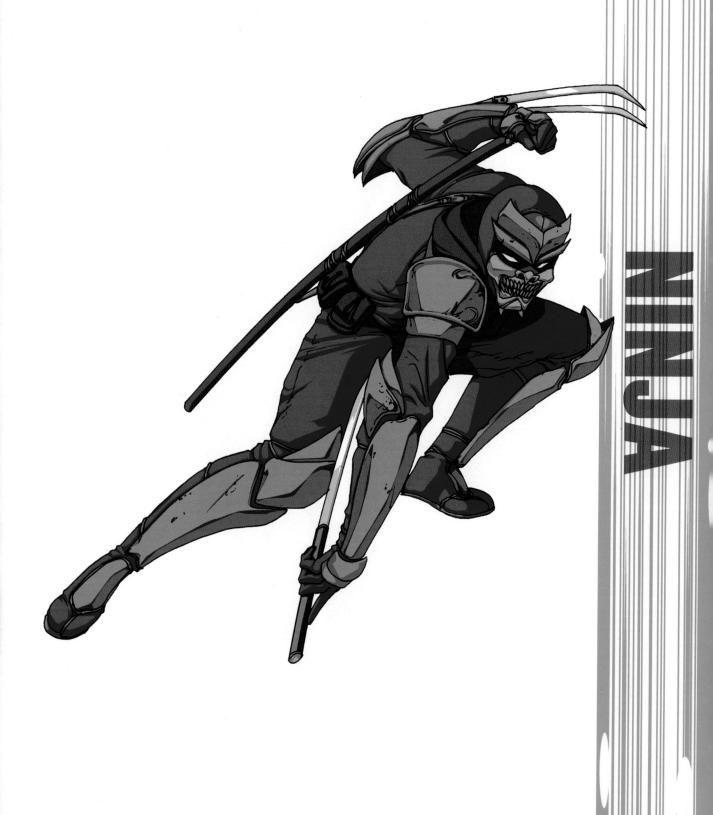

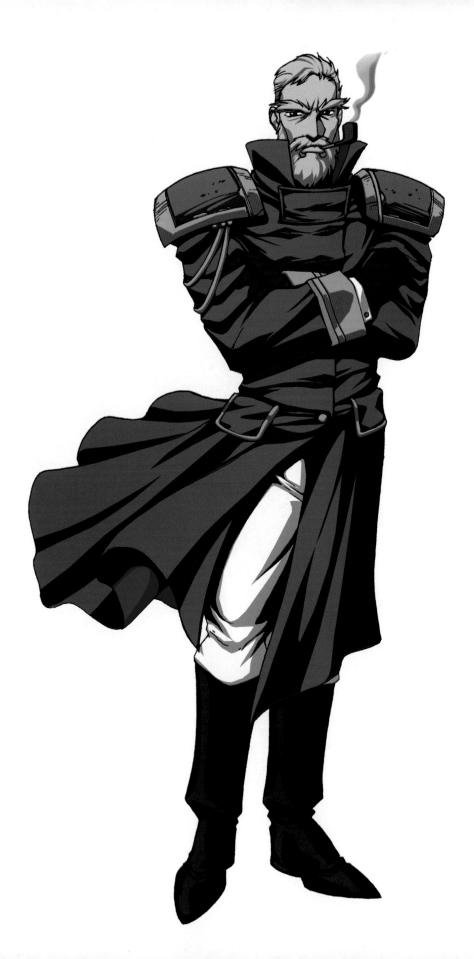

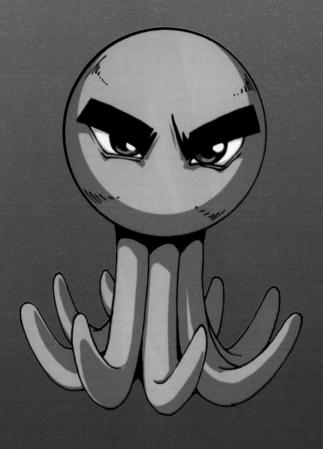

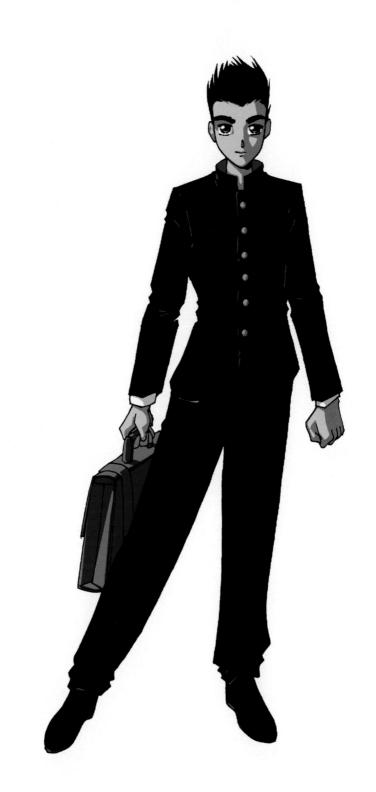

The Best Bud

Nearly everybody has a best pal. And these best pals usually end up playing the role of sidekick, joining the main character on an adventure and assisting along the way.

Say What?

If a man does not make new through life, he will soon find himself left alone; one should keep his

This drawing shows a sidekick who obviously is some sort of techie. The character looks like he is outfitted in some sort of virtual reality gear.

David has equipped this high-tech buddy with headgear and stylish glasses, topped by spiky hair, to give him a bit of a nerdy look, albeit that of a "cool nerd." Stripes on the shirt and one on a pant leg, as well as futuristic boots, round out the ensemble, which is accessorized with a shoulder belt, some miscellaneous round doodads, some strange mech attached to the belt, and a mechanical glove on one hand.

Sketchbook Savvy

are human. Plenty of sidekicks in show you a selection of interesting critters in Chapter 16.)

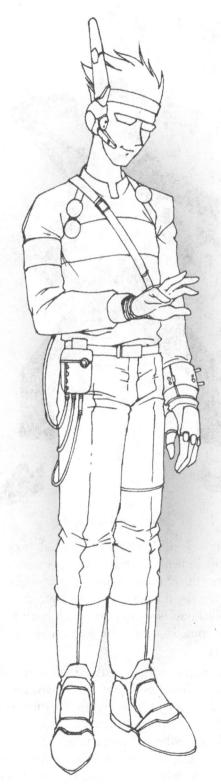

The techie sidekick.

The Goofy Pal

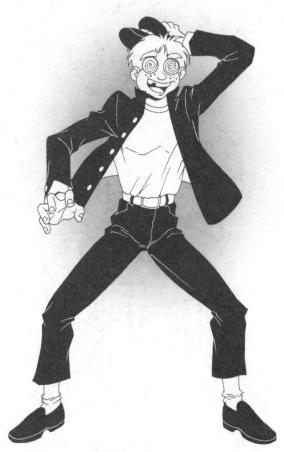

The comic sidekick.

The comic sidekick, on the other hand, is not just goofy in behavior. His goofy appearance reinforces the character's comic aspect. Because manga is a visual medium, much of the character's foolishness is seen in the panels, with broad physical comedy and exaggerated features and reactions.

David accentuates the wacky in this oddball sidekick in almost every way. The character is lanky, tall, and thin, with high-water pants and saggy socks to emphasize the body type. Most sidekicks are either tall and skinny or short and fat (the same applies to comic duos). Again, this is because an odd-looking body type reinforces the notion of an odd character.

The character also has large hands, which make the arms seem longer and skinnier. His face is freckled, he seems to be missing a tooth, and his eyebrows sit comically above pinwheel eyes.

The Science Mentor

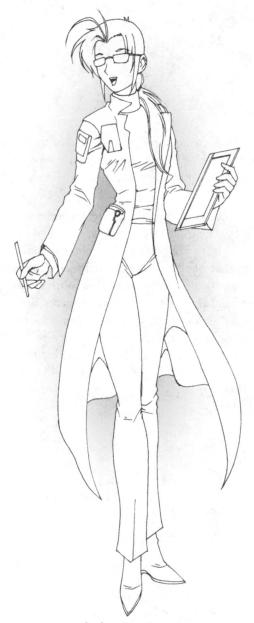

The brainy scientist.

Although some sidekicks are friends along for the adventure, others serve in the role of mentor. They have some experience or knowledge to share with the protagonist and might take the protagonist under their wing to tutor them.

For this character, David has designed a female in glasses and a long, multipocketed lab coat. The character wears a turtleneck, clothing not designed to accentuate the female form. She wears glasses, and her hair is somewhat out of place, implying she is too busy with science and experiments to pay too much attention to style or trying to impress the opposite sex.

The War Horse

The old soldier is a more serious mentor character. This is an authoritative character, with some gravity to his (or her!) bearing.

David has outfitted this figure in a militarystyle outfit, with large shoulder pads, a high collar, a trench coat, and boots. However, unlike some of the more sleek uniforms we've seen on younger characters, these clothes are bulky, suggesting that this character does not have to move around quickly, run, jump, or do battle.

David has also given this character a thick beard and bushy eyebrows, adding to the sense that this character is older (and hence wiser). And, finally, this old fellow is given a pipe as a visual clue to enhance the idea that he is solemn and wise.

Sketchbook Savvy

Young people in manga do not have beards, not even young adults, so a beard is a good visual clue that somebody has been around the block a few times.

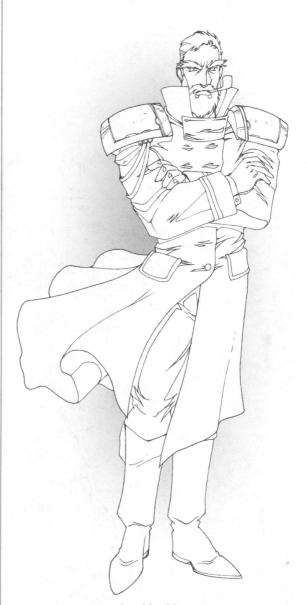

The old soldier.

The Coach or Trainer

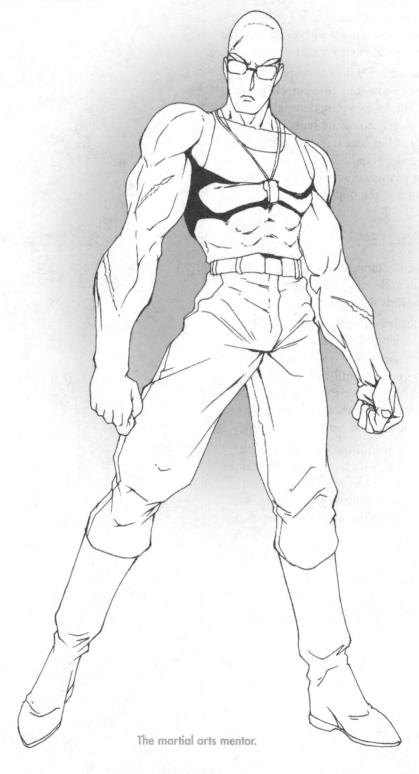

A similar figure to the old soldier, serious, but more active and action-oriented, is the coach or trainer.

The coach/trainer archetype might be a monk, a martial arts expert, or somebody raised to fight dirty on the streets. He might even be a coach or trainer! This is a character who, for whatever reason, takes the protagonist under his (or her!) wing and shows that character the ropes ... even if it means giving the hero a few black eyes or bruises. Invariably, the hero not only learns from this figure but exceeds his training and expectations. And, almost always in these sorts of dramas, toward the end the student becomes the master.

This character is younger than the old soldier but still older than the protagonist. He or she is muscular and in shape enough to still kick a little tail.

The Least You Need to Know

- Supporting characters are sometimes serious or frightening and sometimes serve as comic relief. But they almost always help the protagonist of the story when the chips are down.
- Comic sidekicks tend to have a goofy appearance and use lots of physical comedy and exaggeration.
- Supporting characters are sometimes friends tagging along on an adventure and offering some manner of expertise.
- Other supporting characters are mentors, imparting their wisdom or experience to the lead character.

In This Chapter

- Action in manga
- The rootin' tootin' gunslinger
- ♦ The blue-collar tough guy
- ♦ The martial arts fighter
- The sports figure
- ◆ The femme fatale

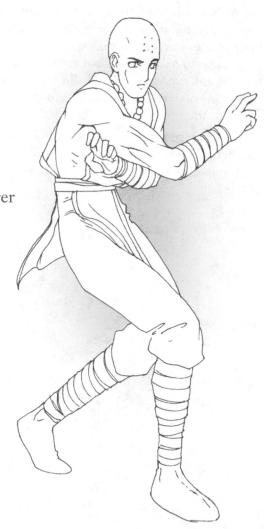

Chapter

Rough and Tumble

Many of the characters featured in this chapter might fit just as well in the protagonist chapter or make an appearance as one of the supporting cast. However, since action plays such a huge role in manga, we thought we would take the time for a separate look at the action archetype.

Bruisin' and Brawlin'

Make no mistake about it: manga is action-oriented, particularly the very popular shonen manga geared toward young males. Fight scenes are well choreographed, and a particularly nasty brawl might unfold over a dozen pages or more of fighting and punching, taking punches, and then getting up for more. The same goes for chases or gunfights. In American comics this is called *decompressed storytelling*. In manga, this technique has been used for decades.

Manga Meanings

Decompressed storytelling takes what might be a short event and stretches it out into a longer scene for dramatic effect.

The drawings that follow feature some of the more popular action-oriented characters. Whether these figures turn out to be heroes or villains is entirely up to you.

The Gunslinger

While Western characters are more at home in American literature, I hope I have made it abundantly clear that manga features a multitude of genres and characters. So if you have a hankering to make a rootin' tootin' cowboy character, go on ahead, pardner.

Basic flow.

We begin this drawing with two simple lines to capture the basic motion and flow of the character. The two curves are very pronounced, suggesting the action will be exaggerated.

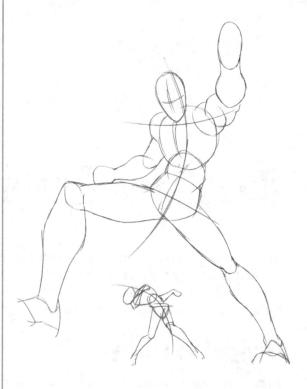

Adding geometric shapes to form the body.

Following the flow, geometric shapes are added to give us a better sense of the body. This body is lanky and not overly muscular, and the legs are separated to give the character a leaping motion. David has also bisected the face, to show us roughly where he intends to place the facial features.

Note that there is also a smaller figure in the lower section of the image, designed in geometric shapes, just like this figure. As we will learn in Chapter 17, this is a trick of perspective, to make a character appear in the distance.

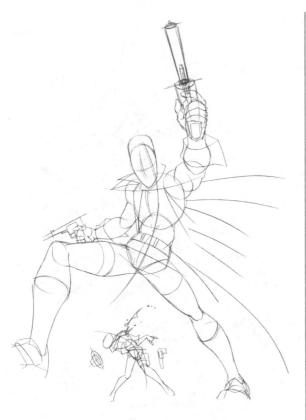

Weapon in hand.

Now the character comes into better focus, as geometric shapes are added to suggest pistols and the clothing is roughed in. Here, we can see the outline of a belt and the collar and billowing piece of cloth behind the character, suggesting a cape (or, in this case, a long jacket).

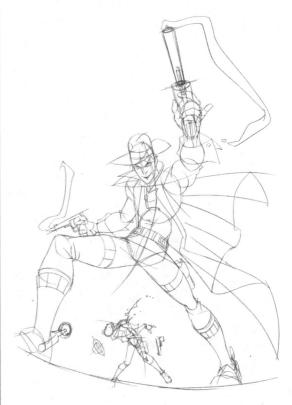

Adding the face and other details.

Here, facial features are placed. We see more definition to the clothing, including the billowing overcoat, shirt, collar, and cuffs. We also see additional flourishes, such as spurs, a hat, and smoke from the pistol (not to mention the same sort of details on the background figure).

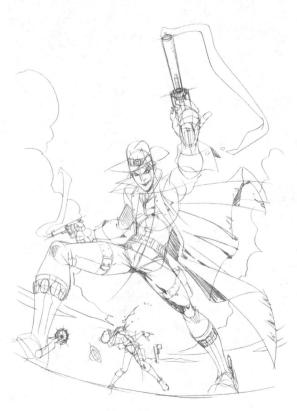

Adding a light source.

Now, with the picture firmly established, David continues to work out the particulars, considering a light source and shading. The details emerge at this phase of the drawing, and we see more of the hat and belt. We see the buttons of the shirt and a side holster thrown in for good measure—even the spurs have a jagged quality now.

Before you begin inking, make sure you are satisfied with your character, because there is no turning back now!

David continues to embellish his work in ink. Note that certain features are given more depth from the pencil stage of the previous figure to this one. The bullets on the gunfighter's belt, which are roughly approximated in the previous figure, are given more depth and detail here. A less confident and experienced artist than David might want to perfect the figure in pencil before moving to ink.

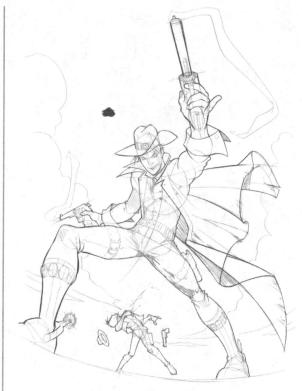

An outline in ink.

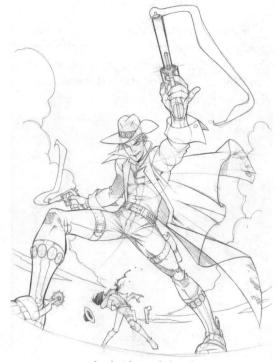

Ink, depth, and detail.

And now, the final figure, with the black added in, giving the figure its rich finish. You'll note that some of the black was added to places we had no idea would be black, such as the boots. Some artists, prior to "spotting the blacks," use little x's to remind themselves which areas are to be pure black (or perhaps to remind the inker, if it's a separate person).

And now that we've taken a step-by-step look at a classic tough-guy archetype, here's a look at a few other character types cut from the same rugged cloth.

Ready for the gunfight!

The Tough Guy

There is no more basic tough guy archetype than ... the tough guy. In this picture David used the muscular male body type, with a tight tank top accentuating the pronounced musculature. A few bandages show that this fellow is no stranger to trouble or to pain. This is reinforced by the rip in his shirt. David has accessorized him with a broken pool cue. What better weapon to bust heads in some dingy dive bar while on a late-night quest for justice? The bruiser.

The Martial Artist

Like the tough guy, the monk/martial artist figure could just as easily be a bad guy or a good guy. The martial artist is a very popular character type in manga, particularly in books set in the past.

The martial artist is drawn with the muscular male adult frame. David has garbed him in wraps and lightweight pants, to protect his arms and legs while allowing maximum maneuverability. The character wears a necklace of round beads and has some markings on the forehead

of his otherwise bald pate, which make the character more distinct, fearsome, and unique.

Mangled Manga

Don't let the label "monk" fool you. While many people think of monks as men of peace, in manga (as well as in Asian cinema) they are usually competent if not extraordinary fighters, char

acters who are often devoted to quiet study and contemplation, but also more than able to defend against villainy and threats against their society or the master they serve.

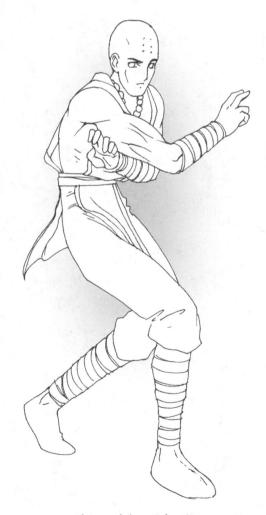

The monk/martial artist.

The Sports Hero

If this next fellow looks familiar, it's because we watched him being designed top-to-bottom in Chapter 3.

The sports hero archetype might initially seem strange to an American audience. We venerate our sports heroes in real life and enjoy sports films such as *Rocky*, but comics following the exploits of athletes are quite uncommon in the United States. Not so in Japan, where, as we have said, a sportsman rags-to-riches or chumpto-champion tale is a popular genre of manga.

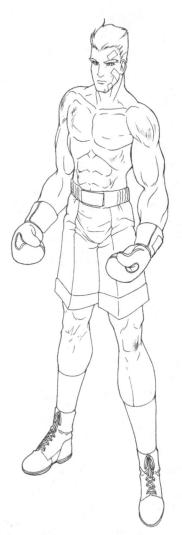

The athlete.

Say What?

Champions aren't made in gyms. Champions are made from something they have deep inside them: a desire, a dream, a vision. They have to have last-minute stamina,

they have to be a little faster, they have to have the skill and the will. But the will must be stronger than the skill.

-Muhammad Ali, boxer

The Beautiful Spy

The sexy spy.

Close-up of face.

The sexy-but-deadly female is a familiar archetype in both Japanese and English comics—as well as all other storytelling mediums. Manga is rife with tales of bewitching lady spies, double agents, femme fatales, and beautiful killers.

This penciled figure is one of an athletic female body type, in a short body-sculpting striped outfit. The character is equipped with a firearm holstered on her upper thigh, as well as a long sword. Glasses on the character's face lend her an innocent aspect.

Let's move in closer on our beautiful spy, for a penciled face shot. In this neck-up shot, out of context from our previous shot, this female could very well be a schoolteacher, a college student, or a librarian.

The Least You Need to Know

- Action is a very popular genre of manga and is populated by many action archetypes, both good and bad.
- A popular storytelling device in manga is decompression, in which a short event is stretched out into a longer scene for dramatic effect.
- The majority of action archetypes are built using the muscular or athletic body types.
- Female action archetypes are less muscular than their male counterparts. Invariably, they are beautiful and not above using sex appeal to achieve their goals.

In This Chapter

- The bloodthirsty vampire
- The soldier archetype
- ♦ The evil mage
- The seductive sorceress
- The corrupt businessman

Chapter

Heavies

Villains play a crucial role in any drama, and good villains are almost always more interesting than their heroic counterparts. And they are usually more fun to write and draw, as well. These are the archetypes that give a story its flair and panache, and you should always strive to make your villains as unforgettable and cool as possible.

The Vampire

Initial motion, and an abrupt curve.

Our opening motion line here suggests a strange sort of movement, given the abruptness of the curvature toward the bottom.

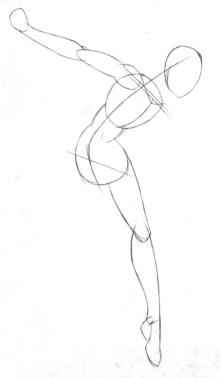

Shapes reveal a body in midair.

The strange curve of the previous figure begins to make sense here, as shapes are added to the initial motion line. From the outstretched foot and arm pulled back, we can tell this is a character leaping in midair.

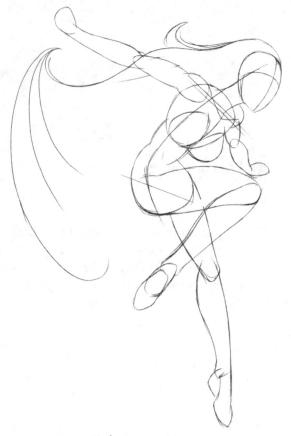

Limbs in opposition.

A second leg is added, oppositely positioned in reaction to the first. Adding the second arm gives a better sense of perspective to the character, while the long, wild hair suggests a character in some sort of *unnatural* flight. This is also, as evident from the breasts and small waist, clearly a female.

The face is added, and just from the rough we can see the character is wearing a sinister expression. Note the character's claws and hair that is reminiscent of bat wings. This is not just a character in unnatural flight, this is likely a character in *supernatural* flight.

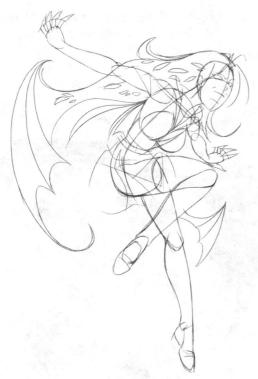

Face and rough features.

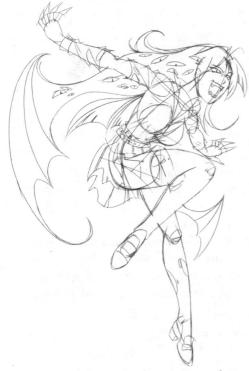

Details suggest the supernatural.

This is David's detail pass over the pencils. The facial expression becomes more clear, and sharp teeth are an obvious tip-off that this is a vampiric character. The outline of an outfit is apparent: a tattered skirt and sleeves, paired with ripped leggings and sandals. The eyeballs in the hair are a fantastical flourish David has added to make this character even more otherworldly.

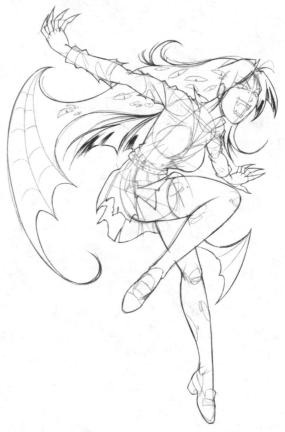

The initial ink line.

David begins the ink phase. You can see that particular care is being paid to the hair of this character, with lots of thin lines and details adding to a sense of "wildness."

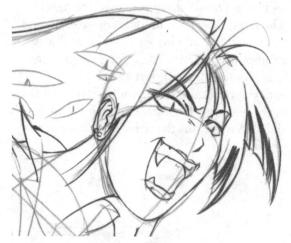

Fangs on a face.

Details are added to the face, with small lines around the eyes and nose accentuating a sinister expression.

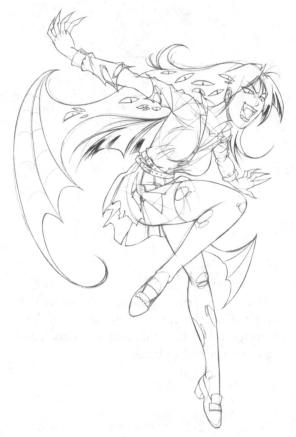

Clothing in tatters.

Having outlined the character in ink, David moves to the interior, embellishing the character's tattered clothing.

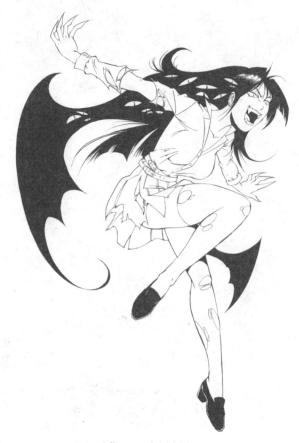

Filling in the blacks.

Blacks are added. The eyeballs in the hair lend this villainess a particularly creepy aspect.

This time, David did not stop with the blacks, but went in with white ink and added details to the shoes and accents to the "bat wings." The previous figure was perfectly acceptable, but note how much more effective the following figure is with the white accents. Sometimes, it's the small extra efforts that bump your figures up to the next level of quality.

Now, here's a rogue gallery of *other* dastardly manga villains.

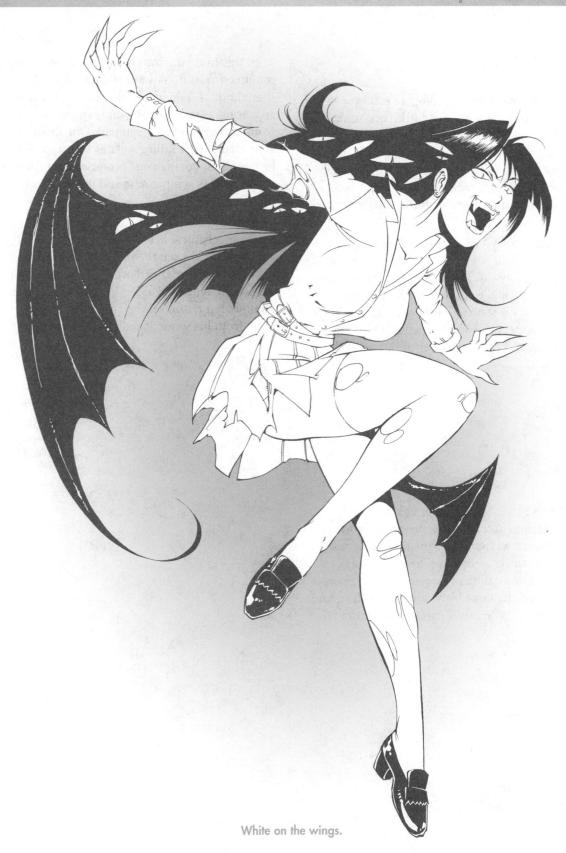

The Soldier

Whether your hero is battling an evil race of alien marauders, Yakuza cutthroats, ninja assassins, or intergalactic shock troopers, your character is almost certainly going to be pitted against this archetype. He or she will probably go toe-to-toe with them multiple times before the ultimate showdown with the story's primary villain.

When we say "soldier archetype," we don't necessary mean *just* a soldier. Not in the military sense, anyway. We mean minions, henchmen, and people employed by the bad guy or working in his service. These are almost always nameless, faceless goons, expendable for story purposes, and cannon fodder to put up against your hero.

Say What?

The more successful the villain, the more successful the picture.

-Alfred Hitchcock (1899–1980), film director

The key to a good soldier character is a good design. You need a memorable uniform, costume, or weapon and something that easily identifies the character as a bad guy. This can be as simple as all the characters wearing sunglasses and the same black suit, white shirt, and black tie, as in certain Yakuza gangster dramas.

In this case you don't want to vary the design too much. You don't want these characters to be thought of as individuals. By keeping them from appearing as individuals, you keep the reader from having too much sympathy for them. If your character is killing villains who appear to be people, suddenly your protagonist becomes a whole lot less sympathetic and less easy to relate to.

In this picture David has designed a soldier with a mechanical headpiece (to preserve his anonymity). We see the musculature, particularly in the well-defined arms, of the muscular male body type. David has given this character a numbered tattoo on the arm, again, to take away from his sense of individuality.

Sketchbook Savvy

Villains should be as unique and unforgettable as possible. Their minions should be well designed but have no real identity beyond serving their masters' designs and desires

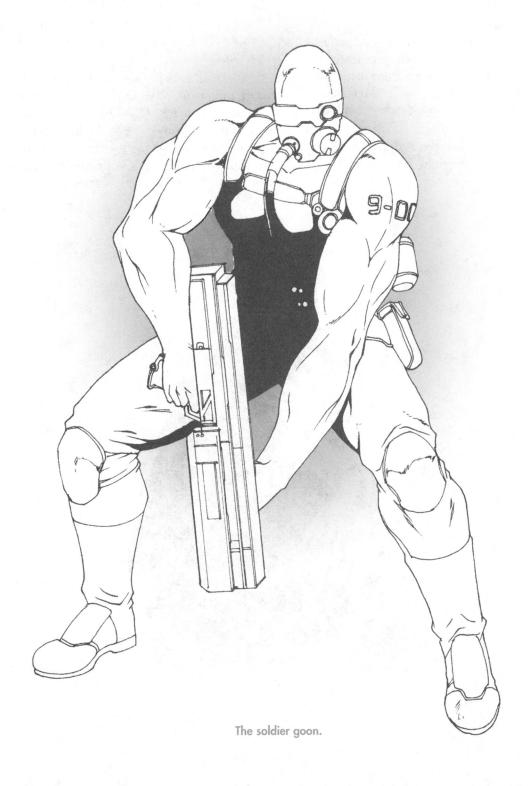

The Mage

Fantasy—stories of characters who exist in or are transported to magical lands—is a popular genre in manga. Many of these tales feature some power-mad magical wizard, a mage (short for "magician" or "magic-user") who is determined to rule the land using tyranny and dark magic.

Our evil mage character is drawn in long, flowing robes. He has long hair and a beard, a

sign that the wizard is old, if not ancient. His face is lined with wrinkles and his brow is dark and furrowed. He has no pupils, which dehumanizes him, as pupils are such an expressive part of the face.

The character has a claw-like, skeletal hand, with long nails, pronounced knuckles, and some veins on his hands. David has added a black-to-white graduated tone to the bottom of the character's robe, giving the character an otherworldly aura, as if he is just materializing out of thin air or is perhaps only semi-tangible.

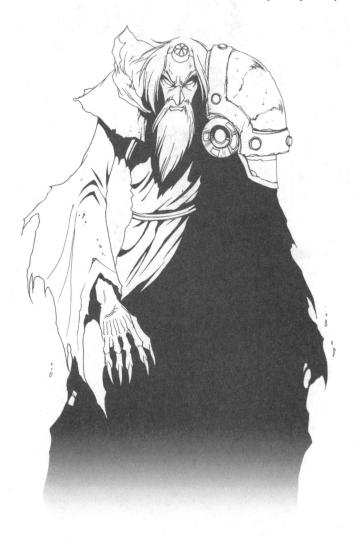

The mad magic user.

The Sorceress

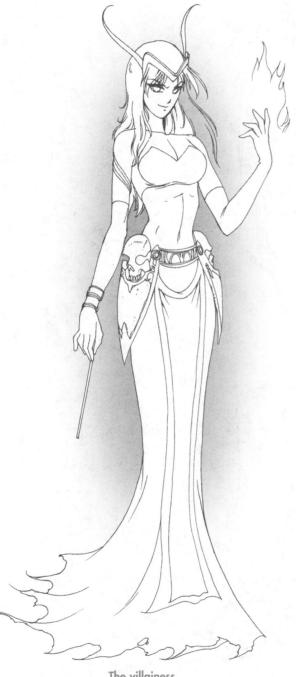

The villainess.

The sorceress is a twist on the evil mage, generally playing the same role, although the sorceress is younger and obviously has more sex appeal. These characters are usually more interesting to draw than their male counterparts, who tend to favor boring flowing robes.

This fetching figure is designed with a unique headpiece, as well as bracelets that adorn the wrists and upper arms. She wears a long skirt, enhanced by an ornate and decorative belt (skulls on a character's costume are usually a tip-off that you are dealing with one of the bad guys-or gals, in this case). This character's expression is a mixture of scorn (in the brow and eyes) and amusement (in the slight upturn of the mouth).

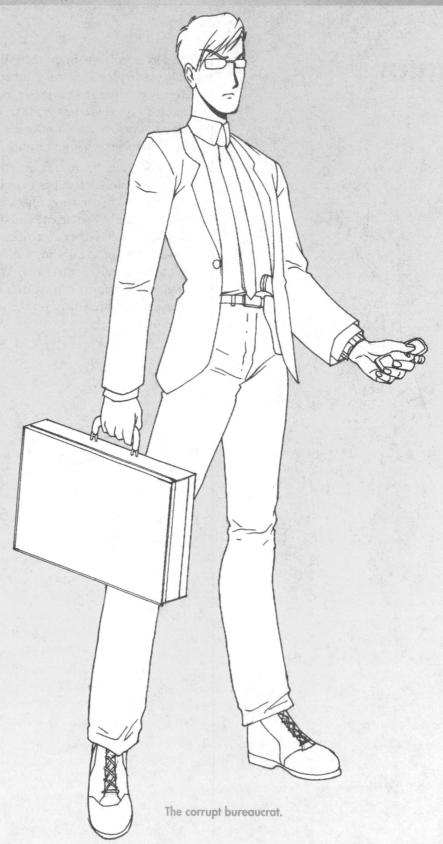

The Corrupt Businessman/ Government Agent

This sort of character is popular in contemporary stories, since tackling an evil corporation or an unjust government seems to be very fashionable in modern society.

Here David tackles one of the bureaucratic baddies. A stylish suit covers a tall, thin, athletic male body type. The character is accessorized with a briefcase, an expensive watch, and a cell phone.

The hair is short, and bangs hang to one side over the face. Dark glasses keep us from seeing the eyes, the brow is in a perpetual severe furrow, and the lips are pursed disapprovingly.

Mangled Manga

Just because corporations and governments tend to be nameless entities doesn't mean your corporate or government villain has to be. Make your villain interesting, in appearance and personality, and your story will be more memorable as a result.

The Least You Need to Know

- The actions and decisions of villains drive the action of most stories. The hero generally has to thwart someone or something as a result of a villain's machinations.
- ◆ A villain's minions should be well designed but not have a lot of individuality.
- A hero will take on many faceless minions or soldiers before his ultimate confrontation with the primary villain.
- Interesting villains make for interesting stories. Generic villains make for forgettable stories.

♦ Animals in manga

Fictitious zoology

Four-legged friends and foes

Birds, insects, and fish

 How to anthropomorphize animals—and why

Chapter

Weird and Wild

Manga shows a tremendous diversity in genre, content, and setting. There are stories set in alien worlds, stories set in the past, stories set in the far-flung future, and stories set in some contemporary reality populated by strange and fantastic creatures.

Simply put, we can't talk about manga without exploring the weird and wild zoology found within its pages. These animal characters could be the protagonist's loyal friend, sidekick, or steed, or could be creatures the hero has to catch or collect. And in many cases, despite the characters' harmless appearances, these creatures can be very dangerous—even deadly!

Crafting Critters

When drawing an animal, whether it is based on a real animal or an invention of your imagination, the approach is basically the same as the one you would take to draw a human. It's best to begin with a stick figure outline, just to make sure you have the basic shape you want. Next, give the outline more form, using shapes such as circles and cylinders, before fleshing it out. Then, finally, add inks and tones and any small details you think will help complete your beastie.

The crucial difference, however, is that beastie shapes are different than human shapes, sometimes radically different. You can't draw them based on an upright chest and midsection, a head, a neck, and four limbs. Your character may have all these features, but the shape is likely to be very different, as is the center of gravity. There are man-shaped creatures, of course, like monkeys or bears standing on their haunches, but there are many more four-legged animals and animals with wings or fins—or whatever!

And because animals are so different from one species to the next, there is no one approach to designing them. Each one is different, and you'll have to build them differently from the stick figure outline on up.

Sketchbook Savvy

Even fictitious animals take some inspiration from real ones. A trip to the zoo is a great way to be inspired, as you'll often discover creatures you didn't even know existed. Nature magazines and

educational TV channels are also good ways to discover new and wondrous creatures.

So for this chapter, we'll explore a bunch of different critters and show how David went about designing them.

Amphibian in Armor

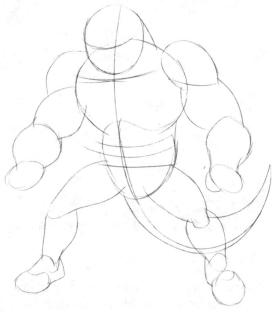

Bulky biped with tail.

Even when drawing distinctly nonhuman characters, the rules we have learned still apply. This figure is built in the same way as the bulky or tough male, and the only thing tipping us off that it's not an ordinary human is the fact that a tail has been added.

For this figure of an alligator man, David blends the familiar with the unfamiliar. The arms and hands and feet are roughly the same as those of a muscular humanoid, though the stance is much wider than that of a normal (nontailed) human.

With the basic shaped roughed out, details are added. Scales, ridges, and bumps have been added to give the skin a rougher, alligator-like texture.

Our final figure has been inked. Of course, as we will see in the rest of this chapter, critters come in all shapes and sizes. However, you will find that even when drawing nonhumans, a strong knowledge of bipedal form comes in handy.

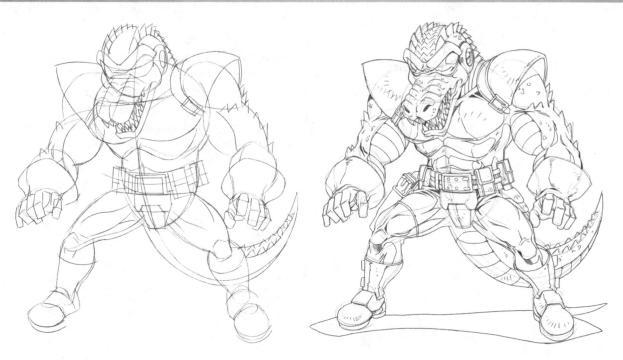

The rough alligator man.

Details are added.

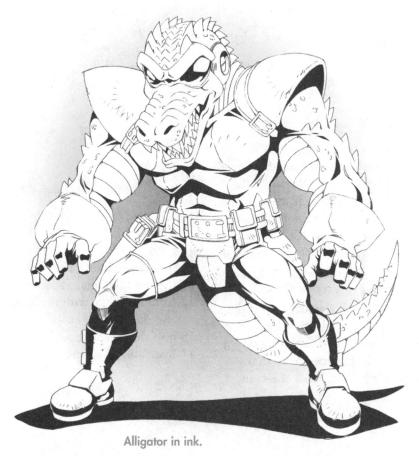

The Bront Beast of Burden

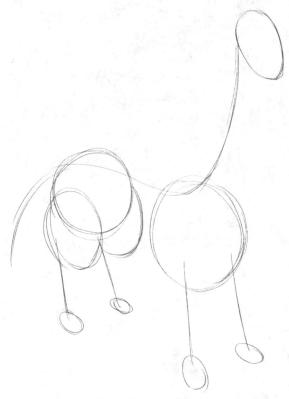

Rough sketch of a horselike creature.

Just as our human stick figures gave us a rough idea of the characters' sizes, or even their personalities, based on their body language, this rough outline shows us we are clearly not dealing with a human. This is some sort of four-legged animal, and it looks almost horselike in this drawing, albeit with a very long neck.

The central line of this character is literally its backbone, sort of a backward S-shape that runs the length of the animal's tail and up its back, then curves upward into a long neck, topped by an oval head. Two circles represent the figure's body: a larger one, lower to the ground, representing the critter's chest, and a

smaller one for the hindquarters. We have two more circles reinforcing the back legs, so immediately we can tell this is a largish critter, one that could possibly support a human rider. And the figure is complete with four lines representing legs, each with an oval to represent the foot.

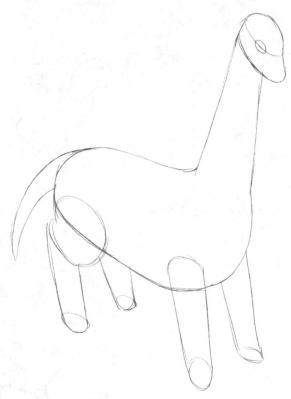

The figure comes into better view.

David connects the chest and hindsection together and adds dimension to the neck, tail, head, and feet. The legs of this creature are basically cylinders, and we see that the shape of the head has changed from an oval into a more complex shape with the appearance of a nose and skull. David placed the eye about halfway into the face, although that placement changes from animal to animal.

Sketchbook Savvy

Reference books are just as important for drawing animals as they are for drawing humans, perhaps even more important. It's a good idea to invest in an animal encyclopedia and books that specialize

in the anatomy of insects, fish, dinosaurs, and even mythological beasties.

The figure comes to life here, with just a few added details.

Isn't it amazing how a pupil in the center of an eyeball can go such a long way toward making your character seem alive? Other details are added in the ears and some bumps are added along the neck, and we are left with ... well, it's not exactly a brontosaurus, and it certainly has horselike aspects.

Animals and beasties in manga tend not to be very realistic, whether they are based in reality or are purely fantasy creatures. So you have a lot of leeway to create cool and fanciful creatures.

Here is the final figure of this brontosaurus creature. David did not add a tremendous amount of detail between this and the previous figure, or even between this and the *second* figure. A gray tone adds some dimension to the figure and suggests an overhead light source, and David has added some highlights to the creature's eyes.

Finished figure.

Winged Wonder

Rough sketch of a birdlike creature.

David tackles a very different sort of animal here. And it should be clear just from the outline that we are not dealing with a *quadruped* or a *biped*, but some *avian* creature.

Manga Meanings

Quadrupeds walk on all fours. Humans are bipeds, which mean they walk on two legs. Avian creatures are birds (or have the characteristics of birds). The body shape is upright, unlike our four-legged brontosaurus critter, but it's not upright like a human. The body is squat and largest in its cone-shaped lower body. This creature's head is bigger than its chest, and we see lines that denote arms (wings) and feet, as well as joints attaching the arms and feet. The two curved lines rising outward from the lower "arms" suggest the creature's wingspan.

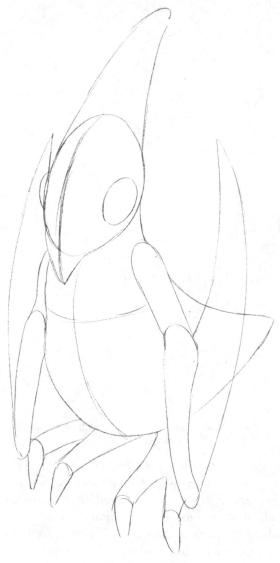

More details are filled in.

With the basic figure now captured satisfactorily, more details are added, including big round eyes, a beak, and a long, cone-shaped back of the head. Also, the limbs have been fleshed out, and we see the shape of the creature's wings. They appear to be folded back behind the body while this little bird guy is at rest.

The creature takes on a more birdlike appearance.

David adds more details here, including a pupil to the eye and some markings on the chest. We also see a line behind the arm, which represents the fold of the creature's wing.

Here's the final figure, with the eye penciled in and a highlight added to the eye. A fully rendered and realized eye really helps your character or creature achieve a more lifelike aspect.

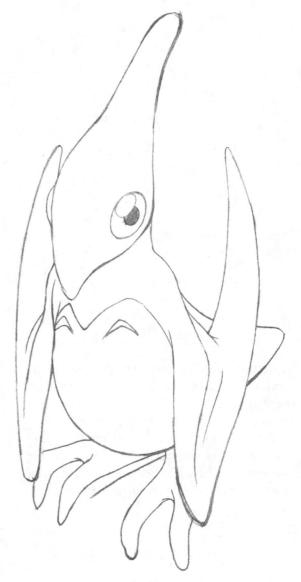

Finished figure.

Claw Critter

This fanciful character is roughly based on a badger, with the body type of a turtle—that is, a turtle who walks upright.

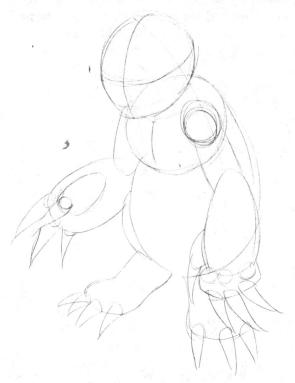

Rough sketch of a more fanciful creature.

In this figure we have a small, squat biped, with short feet and large forearms. It's also evident even in this rough outline that this character has dangerous-looking claws on its hands and feet. In all likelihood, the large forearms are partially to emphasize the large claws, as if the forearms have had to compensate in size to carry those extraordinary clawed hands.

Sketchbook Savvy

Want to invent a critter but stumped on how to start? Try mixing and matching aspects of one creature with another. Perhaps combine two very different creatures, such as an elephant and a parakeet.

More definition added.

More details are added to this figure, such as definition to fingers and toes, as well as a nose, a mouth, and eyes. In this case, the simple triangle nose over the stretched-out W-shaped mouth gives the lower face a bit of a feline aspect. The thick brow area makes the eyes seem sunken and sinister. Already, with just the rough of the face and the claws, we can tell that this critter is not exactly cute and cuddly.

And yet, once David adds large eyes and a line to indicate a slight smile, this fellow does seem cute. But judging from the spiky fur added to the back of the head, down the back, and on the back of the arms, this is probably a creature who is best kept cute from a distance.

More details define the creature.

Note that the character's eyes have changed considerably from the previous figure. Gone is the large brow area that gave the eyes the sunken aspect. The eyeballs are slightly bigger in this finished figure, too.

Here's the finished figure, colored in grayscale, and given some cool stripes on its face and arms. David left the stomach area of this creature white, because contrast between black and white, or other colors, often makes characters' appearances more interesting. David completes the figure with a graduated tone to the eves, as well as white highlights.

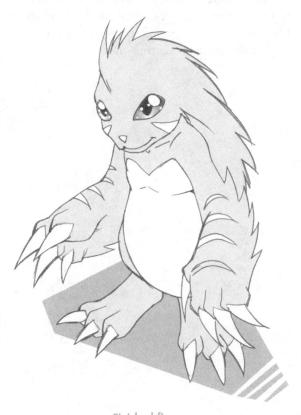

Finished figure.

Mangled Manga

things simple with just white,

Two Tails

Another crazy critter is up, and this time we have the character in an action shot. This is a figure jumping, and not only that, it's a figure with two tails.

In the next rough figure, a line represents the spine, determining the flow and movement of the character. Circles represent the head and body, and lines indicate limbs, feet, and the two tails of this strange creature-to-be.

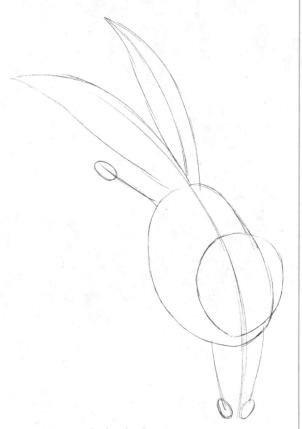

Rough sketch of critter in action.

Our figure suddenly makes a lot more sense in the next picture. The limbs and tails are more clearly defined, and we see a rough outline of the almond-shaped eyes and the triangle-shaped ears. David has also seen fit to add what appears to be a horn on this crazy-lookin' varmint.

Some other things to notice are the way the ears are placed so they are pulling toward the back of the head, the hind legs are bent back, and the front arms are coming together, following the slope of the spine we saw in the previous figure.

More details are added to the figure, most noticeably stripes on its back, on its tails, and on its front legs. We also see the pads of the back feet of this critter, pupils, and a line that more clearly defines the shape of the ears.

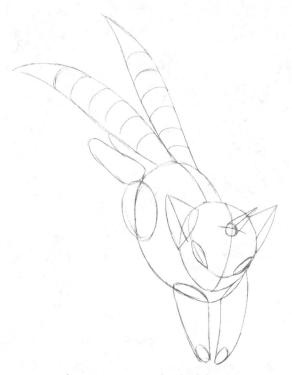

The critter is more clearly defined.

In the final version, just a few details are added. The horn of the creature was embellished with some detail. There is a slight shadow between the chest and the lower right paw, and another curved line within the ear gives it more depth and dimension. The pupils have been darkened, and highlights have been added to the eyes.

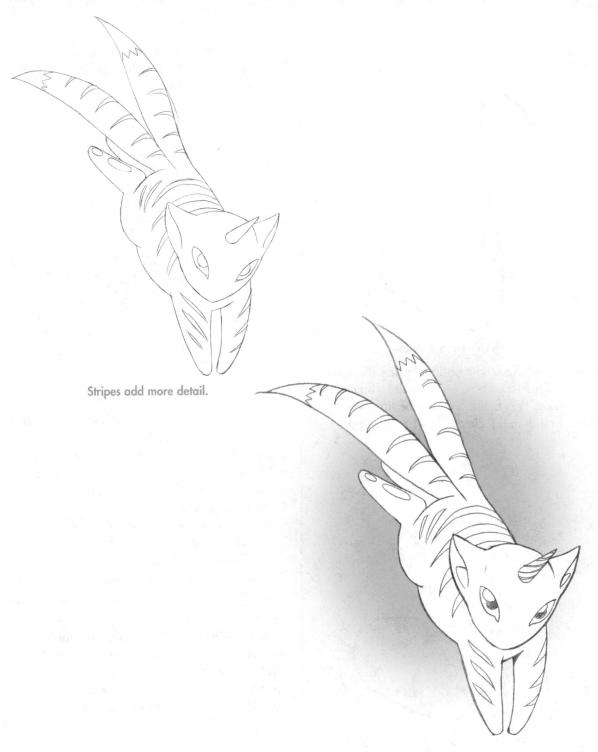

Finished figure.

Snake-Eyed

Rough shape of a snake.

Not everything can be outlined using shapes or circles. Or at least here's one animal who can't: the snake. This figure seems to be little more than a random doodle or scrawl at this point.

Arrows help indicate position.

Here David adds a triangular head and extends the tail. The rough shape from the previous image is highlighted.

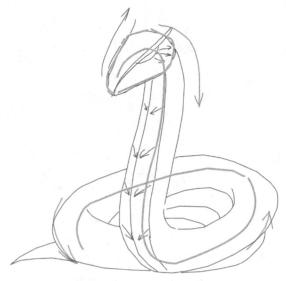

The snake comes to life.

And here we finally get a better sense of what we are looking at. The base of the snake looks like a rolled-up hose, with a curved triangular tail peeking out at one end. Up the neck we see some arrows indicating the direction of the lower body scales. The eyes have been drawn at a threatening angle, and David has added some lines above the eyes to make the snake look more sinister and sleek.

In our final figure we see scales not only along the body, but on the lower part of the tail and around the eyes.

Note that David drew a thick line under the eye but did not add a pupil or highlights. Eyeballs tend to humanize figures, whether they are human or not. For some reason, characters without eyeballs are very difficult to empathize with.

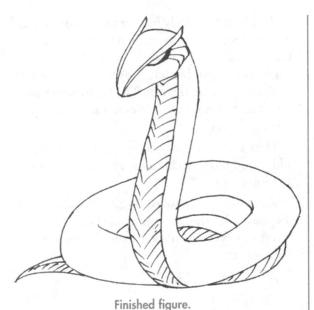

Ant-Art-Trick

The beginnings of an ant shape.

David tackles the insect world in this series of figures. Insects aren't particularly easy to relate to. They don't share features with humans that other animals do (two eyes, a nose, two ears), which makes them difficult to *anthropomorphize*. They are not easily drawn from memory (unless you are some sort of insect expert or enthusiast), so it's good to have an insect reference on hand.

Manga Meanings

To anthropomorphize an object is to ascribe human characteristics to it. We do it all the time to our pets, and artists often do it to nonhuman characters to make them more likable or sympathetic.

Multiple limbs added.

Now we see this creature's multiple limbs.

The ant takes shape.

And here we finally see our ant taking shape, with various-size ovals and circles representing the segments of the insect's body. The head is a half oval, given big buggy eyes and adorned with antennae on the top. The limbs aren't even remotely human, but a series of long, thin, spiky objects.

Here's our finished ant figure, with a neck added and more details added to his antennae and joints.

Remember our discussion about eyeballs and the snake? It's the same principle here: David leaves out eyeballs to accentuate the creature's alien aspect.

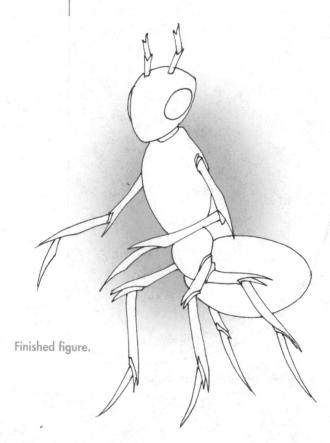

A Whale for Your Tale

A single line depicts the whale's back.

Fish and their aquatic relatives are another very different type of animal to draw, since they are neither quadrupeds nor bipeds. Fish are generally sleeker, with a body shape that is little more than an oval that comes to two points.

Sketchbook Savvy

A reference alternative: For the artist on the go who doesn't have the time or desire to head to the library or bookstore, there's always the World Wide Web. Google image searches can find the refer-

ence you need in seconds. (That is, provided you have a computer and web access.)

Fins and tail come next.

The next step in this figure is to add fins and a tail, or, at least, to mark where these parts are going to be.

The whale takes shape.

From our rough body outline, our whale takes shape in this figure, as we see its body, tail, fins, eyeball, and underside. A line above its head marks the whale's blowhole.

Even a whale, which is more complex than the typical fish, is still basically a long almondshaped oval with fins and a tail.

Here's our finished figure, with no added detail, just the removal of the guides, which were erased after David committed the figure to ink.

Introducing Mr. Octopus

Here is a picture of an anthropomorphized octopus. Where David drew a realistic creature in the previous picture, here he chooses a more fanciful approach. A realistic octopus seems strange and alien and unfathomable. But by adding some human features, the octopus becomes less difficult to relate to, even oddly likeable. We begin this upright figure with a simple straight line.

A perfect circle captures the head of this creature, and two horizontal ovals outline what will be this beastie's many legs.

The character takes shape, with eyes in the center of the face and upturned tentacles coming down from the head and facing outward all around the creature.

Circles define the shape.

The creature takes on an octopus shape.

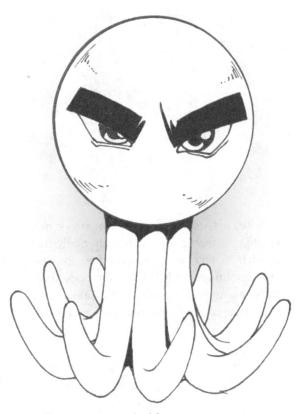

Finished figure.

In the final figure, David adds some shadows below the head and underneath the legs. However, what is surely most noticeable is the addition of the pupils and highlights to the eyes, as well as the thick eyebrows.

This is a good example of how, by keeping the design of the creature simple (in this case, for example, the perfectly round head) and adding humanlike facial features, you soften what could potentially be a very unfriendly looking creature into something less dangerous and alien.

Fierce Flyer

We'll start with a fairly conventional creature. In this case, it's obviously a bipedal humanoid, but with some sort of wings or cape. At this point, this could just as well be a flying caped superhero as a bloodthirsty monster.

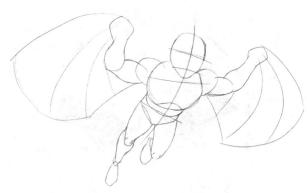

A rough winged figure.

As details are added to the roughed figure, we see that the figure is definitely nonhuman. The hands, face, ears, and even feet are strange and nonhuman. Only the bipedal body shape gives any suggestion of humanity, along with the corresponding human facial features (two

eyes, a nose, and a mouth, all roughly placed where they would be on a human face). You'll note David also considers the light source in the drawing, denoting with an "X" where he intends light to fall on the figure.

Not only are details added, but David indicates which areas he intends to be solid black. This is helpful in the inking phase of a drawing, even more so if the penciler and inker are separate people. As in the previous drawing, he denotes with an "X" where he intends light to fall.

And here is the final image, the first in our menagerie of uglies. Just as in noir and horror films, the heavy shadows here tend to accentuate the sinister or mysterious aspect of a person or thing.

The Least You Need to Know

- Because animal characters have radically different anatomy than humans, and have radically different anatomy than one another, a different drawing approach applies.
- You'll need to take differences in anatomy into account when designing your animal characters. Having a visual reference on hand is highly recommended.
- Anthropomorphize animals and other creatures by giving them human characteristics, both in their facial features and their body language. This can be done most easily by giving them large and expressive eyes.
- Conversely, you can make a creature seem more alien, unknowable, and unapproachable by leaving the eyes blank and giving the creature no pupils.

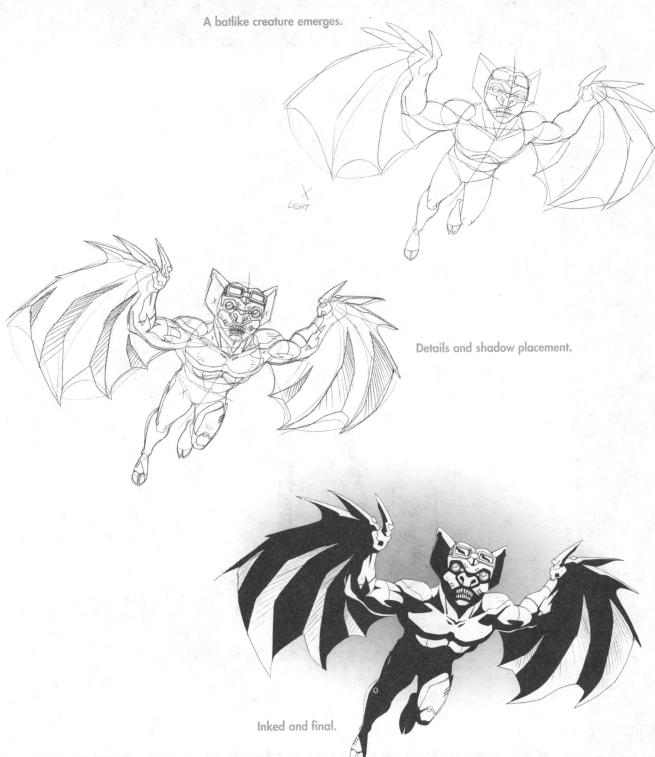

Manga Nuts and Bolts

Manga is more than just drawing characters. After you've got a handle on drawing people, you're going to want to put them into a story. In this part, we show you some of the more technical aspects of enhancing your story. We explore ways to make your pictures appear three-dimensional, and other ways to give your drawings realism. We look at light and sound, angles and approaches, words and pictures, and the peculiar, unique, and ubiquitous manga storytelling element known as the speed line.

Remember, your goal is to make a comic that you can be proud of and that people will want to read. Some of the advice we give you in this part is universal to all comics, and some of it is specific to manga. In either case, learn these techniques, and your comic—and your artistry—will grow stronger as a result.

- The importance of perspective
- Perspective and scale
- Vanishing points and the horizon line
- Points of perspective
- Useful perspective tips

Chapter

Put It into Perspective

Fair warning: you're going to need a ruler for this chapter! I've given you a good starting point and reference for creating dynamic characters, so now it's time to talk about how they interact with their worlds.

What Is Perspective?

Capturing the proper *perspective* can make pictures and panels in your manga more believable and real.

Manga Meanings

Perspective is the technique for representing three-dimensional objects to produce the impression of distance and relative size as perceived by the human eye.

Perspective is the way to show distance in your comics. It's a way to give a two-dimensional drawing the illusion of depth. It's a way to make your pages appear to contain three-dimensional space.

Look into the distance. An object near you appears larger than an object farther away from you, even two things you know to be of equal size.

Points of Perspective

Simple one-point perspective.

This figure is an example of one-point perspective. What is the point of this, you ask? It's to give a square dimension, so we see it as a cube. If we were staring at it straight on, it would simply be a square. But from this perspective, it is a cube. It is a structure rather then just a shape. It has three-dimensional space to it.

To do this, David started with a *horizon line*, a straight horizontal line running the width of the panel. Below it, he drew a square and then assigned a *vanishing point* to the square, a

place where the parallel lines of each corner of the square recede into the horizon. A second, smaller square is added behind the first square, and its corners fall along the same path as the parallel lines on their way to the vanishing point.

Manga Meanings

The horizon line is the line where the ground and sky appear to meet. The vanishing point, in a perspective drawing, is where parallel lines appear to converge on the horizon line

While the previous drawing was an example of a single object in one-point perspective, we see in the following figure that you can also draw multiple objects in one-point perspective. The receding lines of all the objects converge on a single point.

Note, too, that objects can be above or below the horizon line, and they can be very differently shaped. This perspective might come in handy if you were following vehicles racing down a highway. Or, with objects above and below the horizon line, it could be a dramatic shot of a group of spaceships all headed toward a single destination, hundreds of light-years away.

A one-point perspective is the most basic sort of perspective, the most limited way to give an object dimension. But it still makes for a more dynamic angle on a scene than staring at a boring old square head-on.

The next figure is an example of two-point perspective. As you might have guessed from its name, there are two vanishing points where two different sets of parallel lines converge.

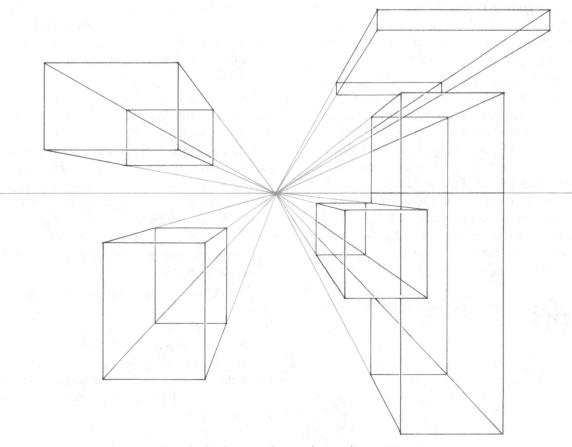

Multiple objects with a single vanishing point.

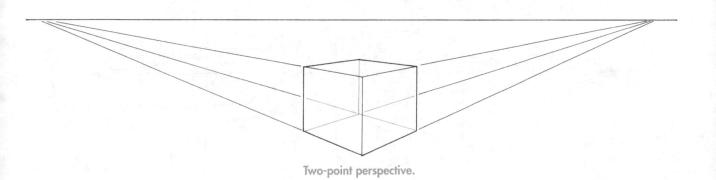

Two-point perspective gives an object even more dimension. While in one-point perspective we saw the front and top of a cube, here we see the top as well as two sides.

Two-point perspective is particularly good for cities and vehicles. If you draw every building from the same two-point perspective, however, your drawing won't appear entirely lifelike, because buildings and city streets are rarely completely uniform. A better alternative would be to draw several of the buildings from one two-point perspective and several others from a different two-point perspective. It's more work and will involve erasing lots of different vanishing points, but it's the best way to achieve a realistic cityscape.

Sketchbook Savvy

Horizon lines do not need to be perfectly horizontal. You might try putting your horizon line at an angle. It might even be vertical, depending on what you are drawing. Shown below are multiple objects, this time in a two-point perspective. In this case, the various rectangles are solid, rather than "seethrough," to give us some idea of how this might look using objects with form.

On the next page is our last type of perspective, three-point. In this case, we have our two points, one on each side of the horizon line, and have added a third vanishing point going straight into the ground. This gives the figure an additional level of dimensionality. It appears we are looking down at the figure from above. Naturally, this perspective would be ideal to show a city, object, or character from a high vantage point, such as from a plane, from a helicopter, or flying through the sky.

You could also draw a scene in which the third vanishing point extends into the sky. That would change the perspective from looking down to looking up and might be most effective for a child's point of view, a small character in a large world, or someone entering a great forest or looking up at a mass of impressive skyscrapers.

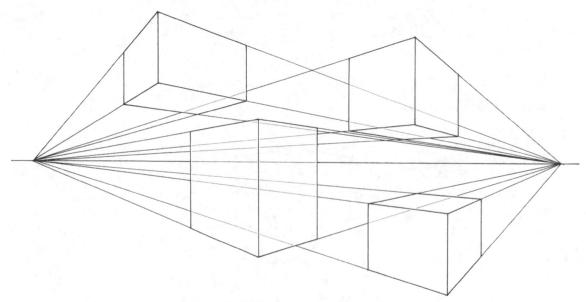

Multiple objects in two-point perspective.

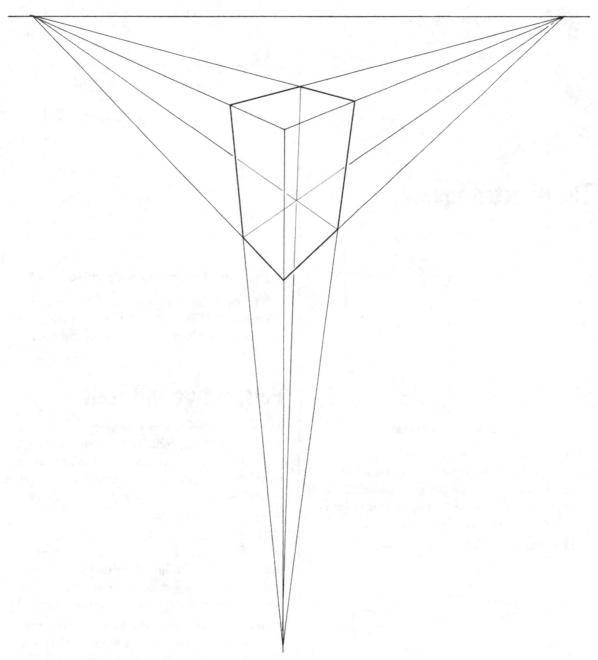

Three-point perspective.

Mangled Manga

Although it is technically possible to draw things in four- and five-point perspective (or with even more points than that), there is no need to. We exist in a reality of three dimensions: height, width,

and depth. Adding other points of perspective will add nothing to your drawing.

The Bisected Square

Three-dimensional cube.

Now we'll show you some helpful ways to accurately determine scale and illustrate how a different perspective can change a shape. Both examples require you to "cut up" a square into pieces, so we'll illustrate that first.

Here we begin with a standard threedimensional cube.

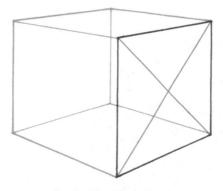

First, diagonally bisect the square.

The first thing to do is diagonally bisect the square, drawing two straight lines from one corner to its opposite corner. It will look like you are drawing a big X on one side of the cube.

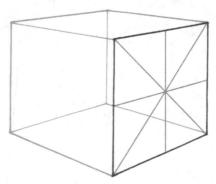

Then bisect the square vertically and horizontally.

The next step is to bisect it vertically and horizontally. This will look like a plus sign laid on top of your X, with all the lines intersecting in the middle.

Perspective and Scale

As we said, objects appear smaller as they move farther away from you. Here's a trick that will help you maintain scale and keep things proportionally in perspective. We begin with a bisected square, heading off to a one-point vanishing point on the far right.

Here we add a new line. This line begins at the far corner of the square. It intersects with the horizontal line, bisecting the square, and then continues outside the square, until it intersects with the top vanishing point line.

See the point where the new line now intersects with the top vanishing point line? If you draw a vertical line from that point, you will have a new square, perfectly in perspective and proportion with the first square.

After you've made the second square, you can follow the same step and make others. Note that each square is getting shorter and thinner, as the vertical lines are closer together the farther away the square is.

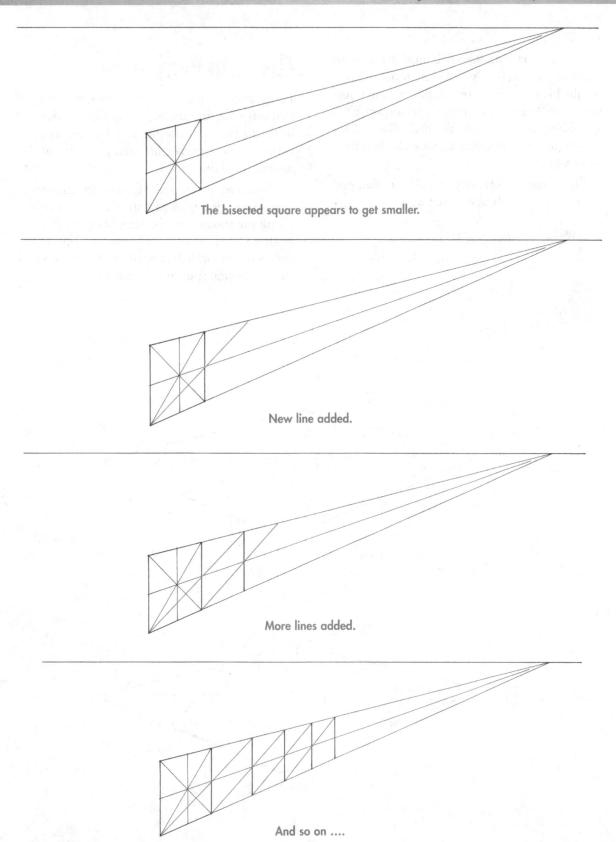

You can continue this trick until the lines are so small you can barely make them out. This is valuable to know if you are doing something repetitive, like making uniform windows on a building, or if you want the back wheel of a vehicle to be in perspective and scale with the front wheel.

Of course, wheels are generally circular, not square, so we'll talk about that next.

Mangled Manga

Don't draw your perspective lines too dark. They are just guides and will eventually be erased.

Circles in Perspective

Perspective does not just alter scale, it alters shape as well, and the following figures illustrate this point. We begin with a square in a two-point perspective, bisected vertically, horizontally, and diagonally.

Circles are often tricky to draw in perspective, so here is a trick to draw them accurately. Using the square and the lines bisecting it as guides, David draws a circle, the outermost curves of the circle intersecting with the vertical and horizontal split in the square.

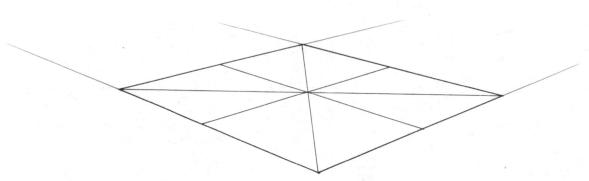

Begin with a square in two-point perspective.

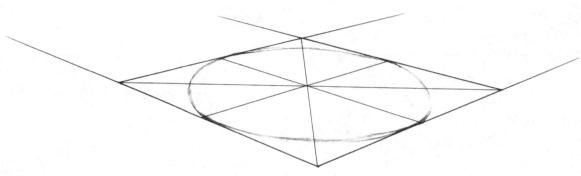

Add a circle in the square.

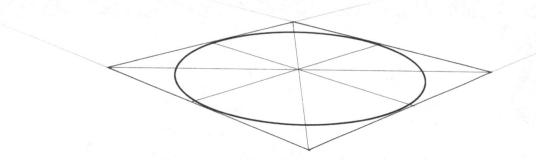

Circle emphasized.

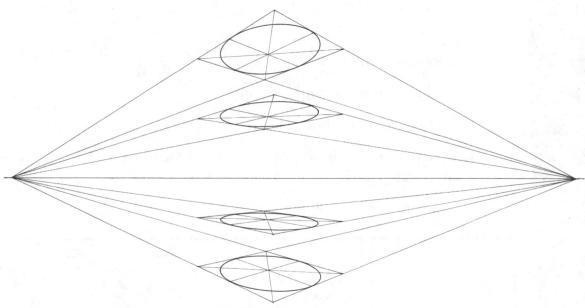

Multiple circles and squares.

In the first figure, the circle is emphasized to create a better idea of its shape. Of course, a circle in this perspective is more of an ellipse, a circle that is stretched, with slightly longer, flatter sides.

The next figure better illustrates how circles and squares change shape based on their perspective. This figure features a variety of squares, and circles within, drawn from a two-point perspective.

Note that the closer to the horizon line and the flatter the squares appear, the skinnier and less circular the ellipses.

The Least You Need to Know

- One-, two-, or three-point perspective adds dimension and realism to your work.
- Vanishing lines converge on a horizon line, sometimes at multiple points.
- Objects farther away from the viewer appear smaller.
- Objects appear to change shape based on the direction from which you are looking at them.

In This Chapter

- Choosing your shot
- Medium, close-up, and long shots
- The establishing shot
- Dynamic angles: bird's-eye view, worm's-eye view, and rotated angle
- Dramatic foreshortening

Chapter

All the Angles

One of the primary benefits to drawing a comic is that you are in total control of your story. So in this chapter, you're going to put on your filmmaker's cap and settle into the director's chair. It's time to explore shots in manga and to see how to choose the most effective shot for your scene.

Three Basic Shots

There are three crucial types of shots in comics, just as in movies: the *wide-angle* (or *long*) shot, the *medium* shot, and the *close-up*. All have different strengths and purposes, but each is a crucial part of your overall drama.

Manga Meanings

A wide-angle or long shot is one that takes in a lot of space and shows a lot of area. A medium shot moves the "camera" in on the character, so we get a better look at him or her. It still maintains some

distance, usually showing the character from the waist or chest up. A **close-up** is a tight shot of a character, usually just the face.

A comic book panel will most likely be one of these three shots. The majority will be medium shots and close-ups, so we'll discuss and contrast them first.

A medium shot.

This is a good example of a medium shot. We are close enough that we see two characters. We aren't so close that we can't see what the figures are wearing or how they are standing or moving in relation to each other. However, we're also not so far that we can't see the expressions on the characters' faces.

This is a great type of panel if you want to show two or more characters interacting with each other or speaking to each other, as this type of panel generally leaves plenty of empty space for dialogue balloons for each character.

A close-up.

And here is an example of a close-up, as the "camera" moves in from the previous shot. We find ourselves face-to-face with the injured boy from the previous panel.

Close-ups most often center on just one character. The close-up is an effective shot to spotlight a character, to focus on him or her delivering some crucial bit of dialogue or having a pivotal reaction.

Obviously, since this is the closest we see a character, this shot shows the most of the character's features and gives the reader the best sense of the character's emotions. The close-up is the shot with the most intensity and immediacy.

Sketchbook Savvy

A close-up does not need to be a face. You can focus on any object or body part in a close-up. A nervous hand inching toward a gun. A valuable book on a table. Maybe even some feminine curves that a lustful character can't keep his eyes off.

Here's another example of the medium shot. This one is more wide than tall (comic shorthand for this is *widescreen*, another term lifted from moviemaking).

In this case, this widescreen medium shot allows us to see several characters placed more or less side-by-side. There is also plenty of room for dialogue balloons, in case this crew is feeling chatty.

On the next page is a second example of a close-up. This time, it does not focus on a single character. We move in on the entire group, instead. This allows us to get a much better look at the characters' faces and hence a better sense of what they are thinking and feeling.

Mangled Manga

When designing a panel, always take the amount of dialogue in that panel into consideration. If you don't leave enough room for the dialogue, you'll end up with dialogue balloons covering your art when the book is lettered.

A widescreen medium shot.

A group close-up.

Getting Extreme

There's one last type of close-up we haven't mentioned, and that's the extreme close-up.

As the name suggests, this shot moves in very tightly on a character. The shot is so tight and so close that you see only one aspect of the character's face, such as the eyes or the mouth.

An extreme close-up.

Going Long

A wide-angle shot allows us to take in a character's entire body or multiple characters, as well as the surroundings. In this example we see three characters, the entire bodies of two of them and three-fourths of the third, with plenty of room in the panel for lots of dialogue and a good idea of what is around the characters. (Of course, if you cover the panel with dialogue you will lose the surroundings, so pick which is more important in this particular panel or find some middle ground.)

As the next figure illustrates, a wide-angle shot is also an ideal way to convey a sense of scale to the reader. Depending on the story, these soldiers are either leading the injured kid through a very big door or all three characters have somehow been shrunk very small.

In the next wide-angle shot, we pull back even farther to show our three characters, who seem very small against the gigantic door of this humungous building. Again, this shot definitely shows the three characters in relation to their surroundings. The downside to such a wide shot is that the characters are very small and hard to make out, but sometimes that's the intention.

Wide-angle shots are especially good for an establishing shot, which shows you the exterior of the building or place where the action occurs before moving inside. This puts the scene into context for the reader and is a great way to avoid confusion.

Mangled Manga

An establishing shot of a building or place may seem boring, but if you don't specify where your characters are from one scene to the next, you may end up with a muddled and confused story. It's

a good idea to have an establishing shot at or near the beginning of every new scene.

A wide-angle shot.

Another example of a wide-angle shot.

Rotating the same image slightly.

The bottom image here is not radically different from the top one. However, you'll note that the image has been rotated to the side slightly, and we're looking at it from a lower perspective. We'll talk about that next, but for now, compare the two previous panels and notice how these subtle changes make the giant building appear more interesting, as well as more sinister and foreboding.

New Views for You

Beyond wide, medium, and close-up shots, there are other ways to keep your shots interesting and dynamic. Here are a few more angles that can give your visuals a fresh perspective.

The following shot is what's known as the bird's-eye view. As the name suggests, this is an overhead shot, looking down from above. This particular shot is a medium shot, but bird's-eye views are often wide-angle shots that convey a sense of scope and size—but from a highly dramatic point of view. These sorts of angles also come with a sense of detachment, as well as some *omniscience*, as if we are stepping away from the scene to take it in from a more impartial perspective.

Manga Meanings

The omniscient narrator is all-knowing, getting into characters' heads and knowing their thoughts and feelings. An omniscient viewpoint shows us an angle that cannot be seen by the characters or shows us something the characters cannot know or see.

The opposite of the bird's-eye view is the worm's-eye view, which is a shot from the ground, looking up. In a panel like this, one can look up to a medium or wide-angle shot and get a sense of the scale of skyscrapers, tall trees, or mountains. This is a more personal type of shot, as we see things not from an omniscient point of view, but more as an everyman.

Another dynamic shot type is the rotated angle. This wide-angle shot is slightly off-kilter or tilted and helps emphasize the chaotic movement in a fight scene or a chase.

Mangled Manga

Dynamic angles such as the bird'seye view, the worm's-eye view, and the rotated angle should not be overused. Employed too frequently, these unusual angles will lose their impact.

A bird's-eye view.

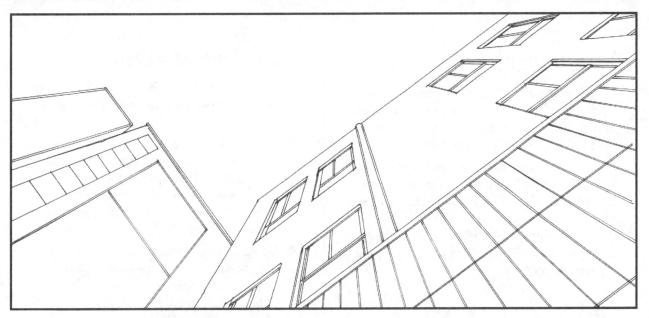

A worm's-eye view.

A rotated angle shot.

Foreshortening

Foreshortening is another device that can make a panel very dynamic and exciting. It is a trick of perspective, in which the part of a figure or object closest to you is drawn larger.

In the following figure we look up at a character who is leaping away from us (or possibly leaping toward us). Her foot and leg are closest to us and appear very large, and the rest of the figure gets thinner and smaller toward the head, giving us the sense that that part of the figure is the farthest away.

Mangled Manga

Foreshortening can be tricky and requires a lot of practice, as well as an understanding of perspective. Get it wrong, and your character will simply appear to have grossly disproportional limbs.

Again, this technique will lose its effectiveness if you use it too often.

The next example of foreshortening takes a bird's-eye view of the scene. In this case the fingers, hand, and forearm are much larger than the rest of the body, and the lower body gets progressively smaller, appearing to be the farthest away from us.

The Least You Need to Know

- Varying the type of shot you choose is crucial to keeping your story visually interesting.
- Medium shots are an ideal way to show several characters interacting. Close-ups and extreme close-ups are good ways to convey the intensity of a character's emotions. Wide-angle shots create a sense of place and scale.
- Using an establishing shot at the beginning of each scene helps keep the story clear to the reader.
- Dynamic angles such as rotated shots, bird's-eye views, and worm's-eye views can be extremely dramatically effective, but are best used sparingly.
- Foreshortening is tricky and requires knowledge of perspective, but is another great way to make your panels different and exciting.

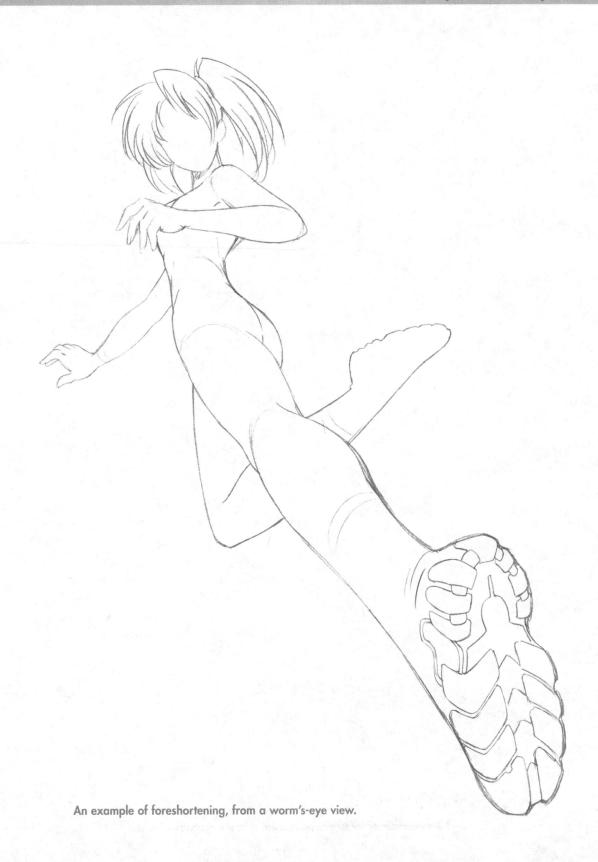

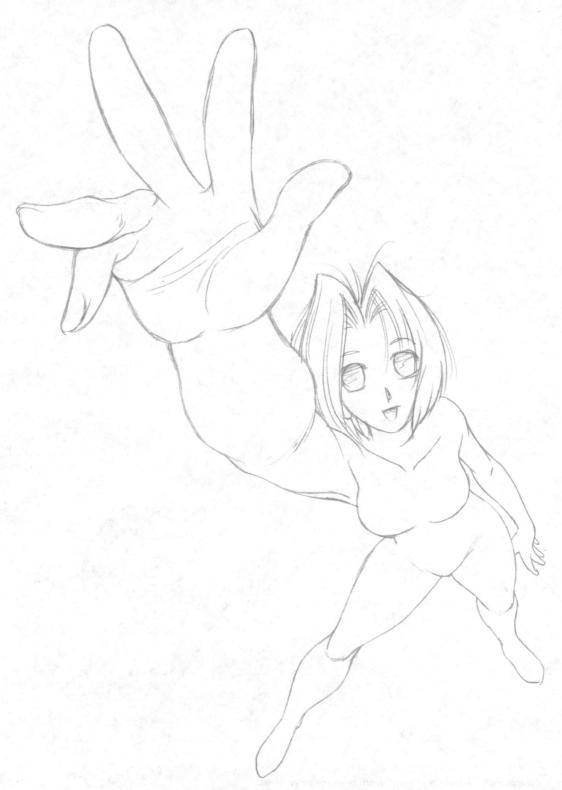

An example of foreshortening, from a bird's-eye view.

In This Chapter

- How speed lines add intensity to a drawing
- Radial and straight speed lines
- How to make speed lines
- Special techniques to convey motion and energy

Chapter

Need for Speed

There are few stylistic devices more unique to manga (and anime) than speed lines. Speed lines in manga are not only used to show movement; they are also used to express emotion or intensity. Speed lines often have nothing to do with speed and have no single definitive meaning. They do, however, help give your panels and pictures intensity and pizzazz.

To Speed or Not to Speed?

Here's an example of a panel without speed lines. Clearly, we are viewing a tense situation, and we are either in the middle of a deadly firefight or a standoff that might lead to one.

Next we see the same panel, but with speed lines added. In this case, they are *radial* speed lines, spreading out circularly from a point centered behind the three gunmen, whose predicament is the primary focus of the panel.

The speed lines have the effect of a visual exclamation point, adding intensity and

immediacy to the shot. In this case, the speed lines reinforce the tension of the situation. Speed lines can make an action sequence more exciting, but as we will see, they can also be used to emphasize internal drama. The style of a speed line—whether it's a radial or *straight* speed line—is a purely subjective choice of the artist.

Manga Meanings

Radial speed lines extend outward from a point. Straight speed lines are, well, straight.

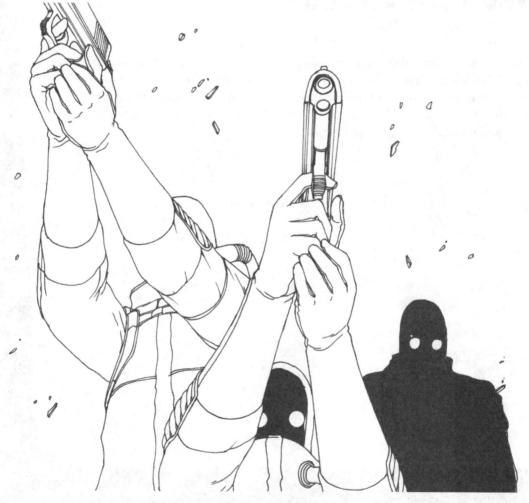

A panel without speed lines.

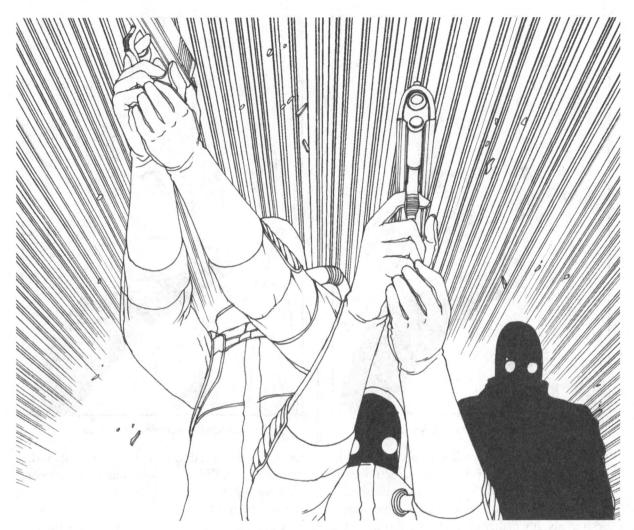

The same panel with speed lines.

On the following page is another panel without speed lines, although this panel is not so much action-oriented as simply dramatic.

Next we present the same panel, but with speed lines added. In this case, the lines are straight (as opposed to radial). They are vertical and heaviest and most numerous as they head away from the character.

In this case, the lines add dramatic emphasis to whatever this character is doing or saying, letting you know that whatever is going on in this panel is more important than the average panel or throwaway line of dialogue.

A panel without speed lines.

We'll show you other types of speed lines and their effects throughout this chapter, then they're yours to do with as you want. It's your decision: there aren't any firm rules about speed line usage or even about whether or not to use them.

Sketchbook Savvy

Don't worry about overusing speed lines. Some artists use speed lines on nearly every page, while others use them sparingly to emphasize very dramatic moments. How often you use them is a matter of per-

sonal preference, as is whether you choose to use them at all.

In the next figure, we see a plain panel and a reaction shot of a character.

Next we see the same panel with speed lines. They intensify the dramatic effect. David has

The same panel with speed lines.

chosen radial speed lines that emanate outward from the face. (The face, remember, is the most expressive part of the body, and hence the focal point for emotion.)

You might note that these radial speed lines are only a half circle and that they radiate outward farther from the character than the radial speed lines around the men with guns. Again, this is a stylistic decision, partially determined by a desire to leave more blank space around the face. It's also determined by the shape of the panel, which has less *negative space* around the upper panel and left panel than the picture of the men with guns.

Manga Meanings

Negative space is exactly what it sounds like: space in a panel either filled completely black, with a tone, or completely white.

A plain panel without speed lines.

Speed lines give this panel more intensity.

The same panel with different speed lines.

Here is another take on the same panel, this time with a different approach to speed lines. The lines are still radial, extending circularly out from a point behind the character. Only this time, the lines are curved and fill more of the initial panel's negative space.

Another panel with speed lines.

Taking the previous panel out of context, we have no idea whether the character is reacting to a literal threat, person, or event, or whether this is simply an emotional response. In this case, David chose straight speed lines, extending from a center point clearly below the girl and off-panel.

Manga Meanings

Something off-panel happens outside of the comic panel.

Sometimes it is dialogue coming from a character not featured in a panel. Sometimes it is an action that is intentionally left unseen.

Now here's the same panel, with a different approach taken to the speed lines. These lines are curved and less concentrated, with a center point closer to the face. And because it's closer to the face, your character's emotive center, it's likely that this is a more emotional response, a response based on internal fear or worry.

The same panel with different speed lines.

Speed lines don't have to be as thick or concentrated as we've seen in the previous examples. Sometimes, as in the case of this extreme close-up, art takes up the majority of the panel, and you won't want to cover it up.

In this panel, however, we get another look at our intense friend whom we met when discussing extreme close-ups in the last chapter. With just a few lines, you can dramatically intensify the atmosphere without covering or adversely affecting the art. In this case, just a few strategically placed straight speed lines coming from the center point of the face make our featured character seem to be focusing intently on something or someone. The action could be external or internal.

It should be noted that speed lines are not just for people; they also can be used for things. Specifically, vehicles in motion.

In the next figure, David has given us a bird's-eye view of a vehicle. However, nothing in this figure indicates that the vehicle is in motion.

Close-up without speed lines.

Close-up with speed lines.

To achieve an effect that won't become clear until the next panel, David has added some parallel lines to denote the shadow underneath the car.

And in the final shot, David adds straight parallel lines to the rest of the panel's negative space. The speed lines overlap the lines of the shadow, making the shadow stand out as darker than the rest; otherwise the shadow would be lost in the figure. Another option would have been to ink the shadow solid black, but I think this is a cooler visual effect.

With speed lines added, this panel now conveys the idea that this car is racing at a furious speed and turning at a breakneck pace.

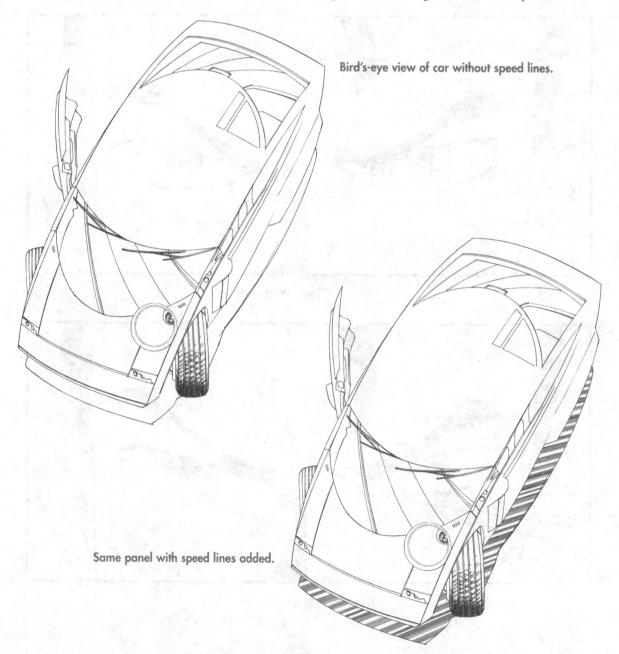

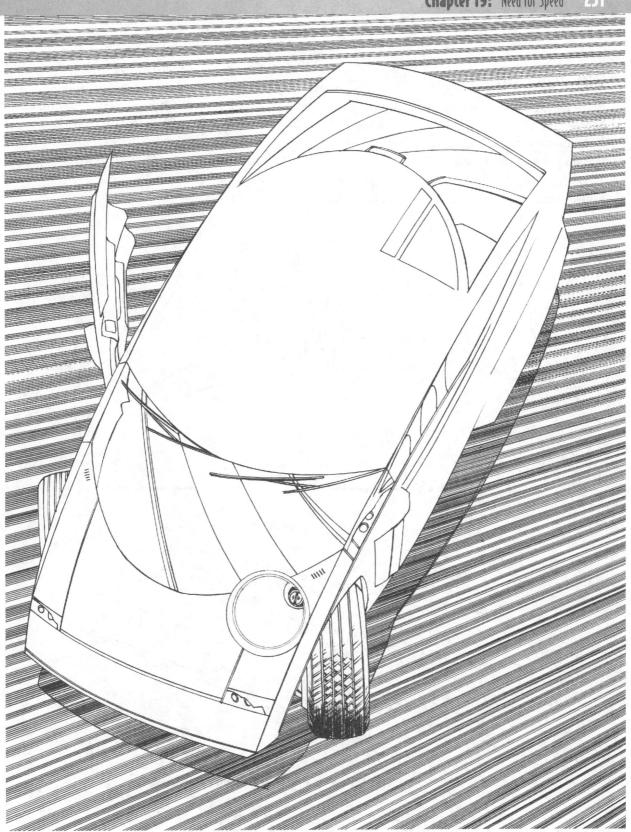

More speed lines added to convey motion.

Speed It Up

Here David offers his technique for making speed lines. David goes straight to ink for speed lines; no messing with pencils. (Although you certainly *can*, if you want.)

David keeps the lines straight, anticipating his desired length ... and then he flicks his wrist

backward at the end of the stroke to give the line the effect of tapering away into nothingness. Your lines will not be perfectly consistent, but that's okay. As you see from the previous speed line examples, speed lines are all different lengths, shapes, and thicknesses, even within the same panel.

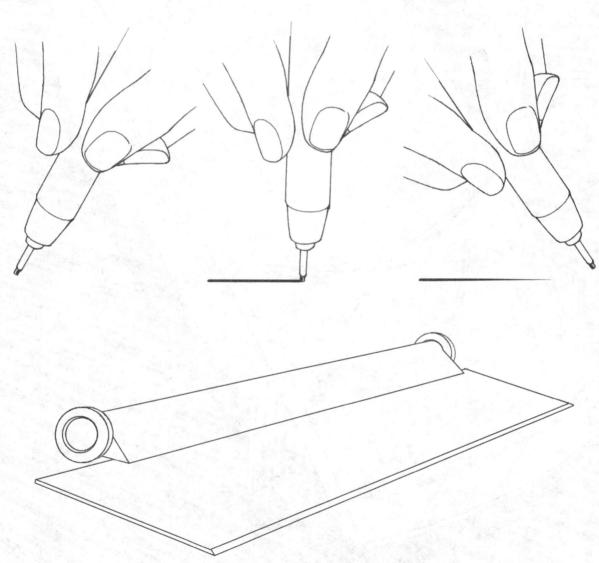

Using a rolling ruler allows you to keep your lines parallel.

Walking the Fine Line

Horizontal speed lines.

Horizontal speed lines are good for conveying movement, particularly if a character or vehicle is in motion from one side of the panel or the other.

As we said, speed lines can be a variety of thicknesses and concentrations. In this case, the lines are the same thickness, although spaced at different distances from each other. Keeping them the same distance apart would be too difficult and might take away from the spontaneity of the effect.

Next are the same lines, adding the tapering effect we just learned. Again, there is no right or wrong way to do these; however, the tapering of the lines creates a blurred quality that suggests even higher speeds than the previous figure.

The same lines, but tapered.

The same lines with white spots added.

David takes the previous figure and adds some small, random dollops of white ink or White-Out. This is a nice effect to use when a character is speeding through an urban area, as it suggests the character zipping past city lights at a furious speed.

Burst of Energy

X marks the spot.

Here David walks us through the steps of making radial speed lines. We start with an X. Easy enough, right?

Draw a circle around the X.

Next, a circle is made around the X. It doesn't have to be a perfect circle. It can be any circular shape you desire, taking into account where you want to place it in relation to the particular figure and panel you're working on.

In the next step, we are not asking you to draw a thumbtack. A handy trick for radial speed lines is to grab a thumbtack from your desk drawer or bulletin board and put it in the center of your X. The thumbtack is simply a tool to keep the lines centered.

Add a thumbtack.

Swivel around the thumbtack.

Using the thumbtack as an anchor, swivel your ruler around and make lines that all extend outward from a single and consistent center point.

The inked speed line figure.

These speed lines are thick and dense, each line tapering off toward the center. (This tapering effect can also be done with a brush instead of a pen, although it requires some skill with a brush and ink.)

The final speed line effect.

David fills the remainder of his figure with ink. That's because this particular speed line

drawing is very dense. Whether you choose to do this will depend on what your lines look like and what effect you are trying to achieve. This particular speed line effect does not mean one particular thing. While it could indicate a burst of physical energy, it could also be an outburst of emotional energy. It all depends on the context of the drawing the lines are put in.

Last Line

So now that you know about speed lines and how to make them, try photocopying a panel and trying different types of speed lines: straight and curved, thick and thin, horizontal and vertical, radial and parallel. Some choices might work better than others, depending on the shape and composition of the figure or panel, but you're not going to figure out what you like best until you give it a try.

The Least You Need to Know

- Speed lines are an effective device to add intensity to an action scene, as well as an emotional scene.
- Speed lines are not always used to show speed. They are often for dramatic emphasis, both external and internal.
- Some speed lines are straight; some are curved. Some are parallel; others extend radially from a point. Which ones to use depends on personal preference.
- The face is the focal point of a character's expressions and emotions. Radial speed lines around the face often signal a character's internal emotional turmoil.
- Making speed lines is an imprecise science.
 The lines will vary in size and length, and that's okay.
- Horizontal speed lines are ideal for conveying motion, while radial speed lines are best for indicating physical and emotional energy—both bursts and outbursts.

In This Chapter

Light and shadows as mood enhancers

Consider the (light) source

Lots of lighting examples

Silhouette techniques

Chapter 2

Light Up Your Life

Light and shadows are valuable tools to add realism, as well as dimension and atmosphere, to your manga. The proper lighting effect can, for example, make a character appear more mysterious or sinister. Light and shadow give your manga a more realistic aspect and make the figures and the world you have created seem more three-dimensional.

Source, of Course

When you are dealing with light or shadow, the first and most fundamental thing to consider is your light source. What is it? Light differs between times, places, and circumstances, and so do shadows, which grow longer and shorter (and even lighter and darker) and fall in every direction.

Illuminating Illumination

A shadowless shot.

We begin with a control shot, a three-quarter view of a girl with no shadows on her. Keep in mind as you read this chapter that nobody says you are required to draw shadows!

Also note that David left the eyes hollow, with no detail or highlights added to the pupils. He did this so he could experiment with different lighting effects on the eyes as he does the variations of shadows falling across the girl. No one effect is correct; his variations merely offer options and alternatives.

Lit from the side.

In this figure David has added a tone to the parts of the face where shadows will fall. Looking at this picture, and the subsequent ones, we'll identify where the primary light source is, as well as sources of other light and ambient light.

In the case of this figure, the light source is coming from the right side, which casts a shadow on the other side of the girl's face, as well as behind her hair and on various parts of her braids that are not facing the light source.

In this image David colored the eyes the same tone as the shadow. He will add black to the pupils and add highlights in the next image. These choices are subjective on David's part, just a matter of personal preference.

Sketchbook Savvy

Don't just consider one light source, consider whether there are multiple light sources. A particular place often has more than one.

Midday sun or a brightly lit room.

There are not a lot of shadows falling across this figure's face, so it is safe to assume it is a relatively bright day out (or she is in a relatively bright room). Shadows fall beneath the character's hair, nose, and mouth. The sun (or other light source) is likely high in the sky overhead.

Sunset or a dimly lit room.

Here is a figure lit by a dimmer light source, possibly a sunset, judging by the soft edges between the light and the shadow. David achieved this effect in Photoshop.

Light source from above.

We'll explore shadows on a different image now, this time a frontal close-up shot of a young girl. This is another image where the light source comes from above and a little to the left (our left, the girl's right). We can tell that the light source is not directly overhead by the shadows falling across the lower left side of the girl's face, in addition to the shadows caused by her hair, nose, and chin. As well, her left ear has more shadows across it than her right ear.

Say What?

Where there is much light, the shadow is deep.

-Johann Wolfgang von Goethe (1749–1832), German poet and dramatist

More side lighting.

Here's another example of a light source coming from one side. In this figure, David does not strive for complete accuracy. If we were tackling this realistically, the right ear would likely be completely in shadow. David was concerned that the ear would get lost in the shadow, however, so he added some highlights to help bring it out.

There is only a slight difference between the next figure and the figure above. In the next figure, David has added some additional tones: a darker tone in the right ear, the left eyebrow, and under and to the side of the nose. The second tone gives the figure a bit more dimensionality and complexity.

Additional tones added.

Following is a character with *backlighting*—and an original hairstyle! Backlighting can be a very effective dramatic device. It is often used to introduce a character and keep him or her slightly mysterious, or perhaps to create sinister connotations.

On the backlit character, the shadow falls across almost the entire figure, except for some bits of light *around* the character (known as *rim lighting*). That bit of light comes from behind the character, around the shadow falling across the front of the character; hence the term "backlighting."

Manga Meanings

A backlit figure is a figure with a light source emanating from behind it. Rim lighting is the depiction of light on the side, on multiple sides, or all around the outside of a figure.

Second tone added.

Here is the same figure with a second tone added. This second tone is under the hair, in the ears, and to one side of the nose. Again, this second tone gives the figure more dimension, as it suggests there are some areas, even within shadow, that are still darker than others.

Here is another example of backlighting and rim lighting, a figure who is primarily in shadows, except around his outer shoulder, his back, the side of his face, and around his neck. Sometimes, as in the case of this character's neck, lighting can be used to sculpt a figure or highlight his or her features and musculature.

Rim lighting.

Lit from the front.

Here is another figure lit from the front. He is heavily shadowed, including the front of his face, where there is still a light source, just not a particularly strong one. Perhaps this character is in a darkened room, in front of a flickering TV screen or computer monitor.

Again, this is a case where lighting helps dramatically accentuate the curves and lines of the character's face.

Lit from the back.

Here is the same figure, lit from the back and a bit to the side. On the back of the head, notice David has used light and shadow to add definition to the character's hair.

Under-lit.

This figure is severely under-lit. Again, this may be a character in a darkened room looking at a monitor, but it is even more dramatic than the previous front-lit image. In this case,

lighting is just used to provide highlights to the character's face and clothing. It makes for a very dramatic and possibly ominous look.

Silhouetiquette

Silhouettes can make very compelling and dramatic images. Most often they are full-figure shots, allowing the body language of an ink-covered figure, rather than a facial expression, to tell the story.

Manga Meanings

A **silhouette** is an outline of some-body or something usually—but not always—filled in with black.

Silhouettes are also very effective when you want to take the focus off the silhouetted character and draw the reader's attention to something in the background or *around* the character. In this panel, we see a figure approaching in the background. The use of a silhouette tells us that this character's approach might ultimately be more important to the story than the character in the foreground.

Figure in silhouette.

Rim-lit silhouette.

The previous figure is a silhouette with rim lighting, which adds a new and dramatic dynamic to the image. Of course, drawing this is a little more time-consuming than a simple black silhouette. But it certainly adds flair to the image. And in this particular image, with the bright lights of the city in the background, it also adds a certain realism.

As always, the decision of when and whether to use silhouettes is totally yours.

Sketchbook Savvy

Experiment with your silhouettes, filling them in with gray tones or graduated tones, or even leaving the insides of your silhouettes white. There's no reason to do them just in black, and differ-

ently toned silhouettes can be equally effective depending on their surroundings and circum-

The Least You Need to Know

- Lighting and shadow—or the absence of lighting and shadow—can affect the atmosphere of a comic, making it more dramatic, scary, moody, or tense.
- Always take into account your light source. Sometimes there will be multiple light sources.
- Silhouettes are an effective dramatic device and sometimes a timesaver. You don't necessarily have to make silhouettes only in black, either.
- If you use a silhouette, the body language of the character is important, because you cannot see your character's facial expression.

In This Chapter

- Translation and localization
- Word balloons in manga
- Balloon shapes
- Balloon placement and flow
- Sound effects
- Icons and exaggeration

Chapter

Words and Pictures

In this chapter we'll look at methods of incorporating words with your pictures in ways that enhance the reading experience without distracting from the art.

Exported Manga

To produce a comic from Japan for an American audience is quite easy. The Japanese text is removed, the content is *translated* and *localized* to sound like colloquial English, and the American text is added back in. There are also more and more comics created in a manga style by native English speakers, eliminating the translation process. After all, isn't that why *you* bought this book?

Manga Meanings

Translation takes the words of one language and puts them into another, though the result does not always sound natural. Localization takes the rough translation and finesses the language to make it sound natural and native.

Talking About Talking

We've tried in this book to give you the knowledge and skills to make the most authentic manga you can. You can make a judgment call and decide whether you want to arrange your pages so your books can be read left to right or right to left, but if you try to arrange your words and characters in the same way as the Japanese do, you will end up with an unreadable mess.

So we're going to look at word balloons in this chapter, as well as some other visual effects, but, for the sake of clarity, we're going to approach these American manga–style, reading pages (and word balloons) from left to right.

Shaping Your Balloons

Typical manga word balloon.

This is the shape of a typical manga word balloon. Because Japanese characters are read vertically, these balloons are usually long and thin. They also have a more organic and imperfectly circular shape, which, as you will see, differs from the typical American balloon.

The problem with these balloons is that when you translate the text to English, the balloons are too narrow for American words and paragraphs.

The next balloon is designed to fit more dialogue. A typical balloon has room for only a sentence or a very short paragraph. But when a character has more to say, you need to give that character a larger balloon (or more balloons) to say it all. Authentic Japanese manga books tend to squish two tall, thin balloons together, as you see in this panel.

Double balloon in manga.

Again, it is difficult to fit typical English sentences into the double balloon, because the balloons are simply too narrow.

Typical balloon for English-language comics.

The typical balloon for an English-language comic, as seen here, is shorter, fatter, and more perfectly rounded. It is shorter and fatter out of necessity, because our words and sentences read horizontally, rather than vertically. It is also more perfectly rounded, which is an aesthetic difference between American and Japanese comics.

Double balloon for English-language comics.

And here is the English-language equivalent of a verbose balloon, to allow multiple sentences and short paragraphs. The balloons again are shorter and fatter and more circular, and unlike the Japanese balloons, they are clearly separated from one another.

However much you might want to make an authentic manga comic, balloon shape is one compromise you will have to make. Unless you want your characters to speak in three-word sentences and monosyllables, the tall, thin balloons simply do not work for English words and sentences.

A happy medium?

We offer this balloon as a happy medium, taller and thin, but not quite so thin as the Japanese balloons, to allow for the placement of English text.

Making this balloon perfectly round was simply David's choice. However, if you prefer the rougher, more imperfect balloon shape, go for it.

Balloon Effects

Sometimes words are not enough. Everybody has a different voice, and often a person takes a different tone based on his or her feelings. Comics, both manga and others, have invented certain visual cues and tricks that help differentiate different types of voices.

One way to do this is by varying *fonts*. Much of today's comic book lettering is done by computer (Adobe Illustrator being the preferred program). Different styles of fonts can be purchased (or built from scratch, although that is a completely different discussion).

Manga Meanings

A font is an electronic typeface, used in comics when creating dialogue or sound effects on a computer. If you have a word processing program on your home computer, it likely has a set of different styles of fonts.

Another way to do it is by altering your balloon shapes. In the following pictures we will show you a few examples. Keep in mind that these balloons are created in a tall and narrow Japanese style. To work better for Englishlanguage comics, they might be slightly shorter and fatter.

A balloon that is wobbly and unsteady is a good effect for either a spooky villain, such as a ghost, demon, or other supernatural creepy-crawler. It works equally effectively as a "scared" effect, for a quavering, cowardly, or frightened character.

Scared or spooky effect.

Mechanized voice effect.

A balloon like this, with sharp lines and angles, suggests a geometric precision, something you might associate with a robot speaker or some other synthesized voice. This is also a good "electronic" balloon, for use when a character is hearing something from a phone or walkie-talkie or even a television or radio.

Balloon burst.

This balloon is known as a burst and is used to express extreme emotion, such as fear, excitement, or anger. When drawing a burst like this, it's often advisable to make the words inside the balloons bigger, **bolder**, or *bold italic*. Since the burst is an expression of excitement, and the character is usually yelling, enlarged text reinforces the idea of a shout.

Every Balloon in Place

The science of balloon placement is one that many people, particularly inexperienced artists, neglect taking into account when creating a comic. Balloon placement is very, very important and can make the difference between a book that is clear and readable and one that is a muddled mess.

Panel 1 shows an example of a page on which the balloons are placed properly and flow properly. Readers of English will naturally read the top panel first and then drop down to the tall second panel, just as they would read the next line of a paragraph. The reading order is quite clear, as is the sequence of the panels. Comic letterers often say that it is their job to do work that goes unnoticed. This is because it's only when balloons are placed poorly that their placement is noticed—and that's often when confusion results.

As we have said, native Japanese manga books are read right to left, and hence the pages are flipped and the balloon flow is reversed. This can be *very* hard for the English-speaking manga reader to get used to. Because we're not planning to make manga in native Japanese, we're simply going to pass over this issue.

Panel 2 shows improper balloon placement. That is to say, this is the *wrong* way to do it. The first major difference is the placement of Balloon 1 in the two panels. In Panel 1, we put the balloon in the mostly empty space to the right of the character. In Panel 2, it's to the character's left, where it covers some of the character's cloak. Now, sometimes you have no choice but to cover art with a balloon, but here we do. If you can avoid covering art with your balloons, that is always preferable.

In Panel 2, note how Balloon 2 jumps out of the border. There is nothing fundamentally wrong with having a balloon halfway in one panel and halfway in another, as long as that other panel is the next panel, and there are no other balloons in the first panel.

Imagine this page without numbering in the balloons. In this example, it would be very difficult to tell whether you are supposed to read Balloon 2 and then Balloon 5 or Balloon 2 and then Balloon 3. And because of the way Balloons 5 and 6 are placed, there would be still more confusion about how Balloon 6 fits into the reading order.

Mangled Manga

Try not to cover art with word balloons. Balloons over hands and feet are a particular no-no.

Panel 3 serves as another good example. It shows a situation in which it is perfectly fine for a balloon to be between one panel and the next, because it leads the reader's eye the way it is supposed to move.

Balloons 4 through 7 feature two characters, each with dialogue (one talking more than the other). In this case, Balloons 4 and 6 were connected, and three of the four balloons sit in the panel's negative space, showing as much of the characters' silhouettes as possible. The last balloon is placed over a character's legs, but as unobtrusively as possible.

Panel 4 is another example of what *not* to do. In this panel, two balloons break the panel border between the first and second panels. However, because we read left to right, we're likely to read Balloon 2 first. If you must break the panel borders here, better to put Balloon 1 in the place of Balloons 2 and 3, and Balloons 2 and 3 behind the hooded guy's shoulder in Panel 2.

Another problem with Panel 4 is Balloons 4 through 7. The balloons belong to the same speakers as the previous panel, and it is clear who is talking and in what order. However, because of the placement, much more of the silhouettes are obscured. We've already learned from the previous example that it can be done a better way.

Much of balloon placement is trial and error, and you need to be willing to experiment to find the best way to make your page clear and readable while sacrificing as little art as possible.

Panel 1: Well-placed word balloons help "steer" the reader's eye to what the reader should read next.

Panel 2: The same panel with poorly placed balloons.

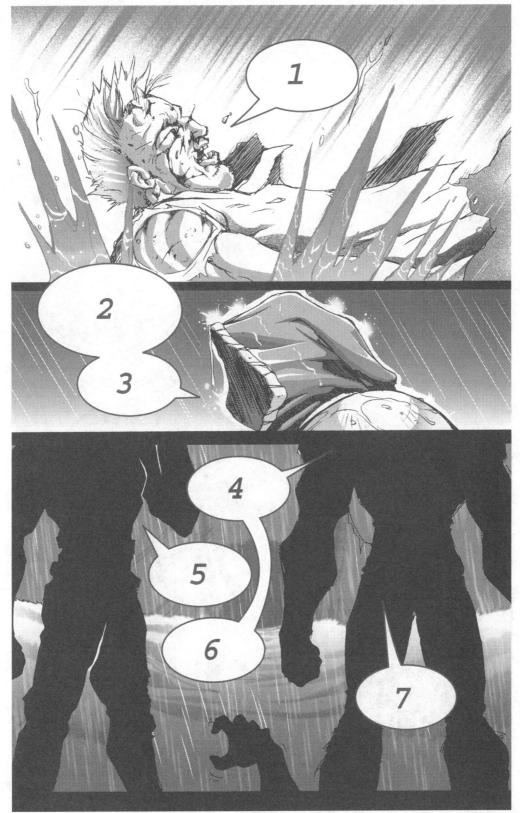

Panel 3: Another example of proper balloon placement.

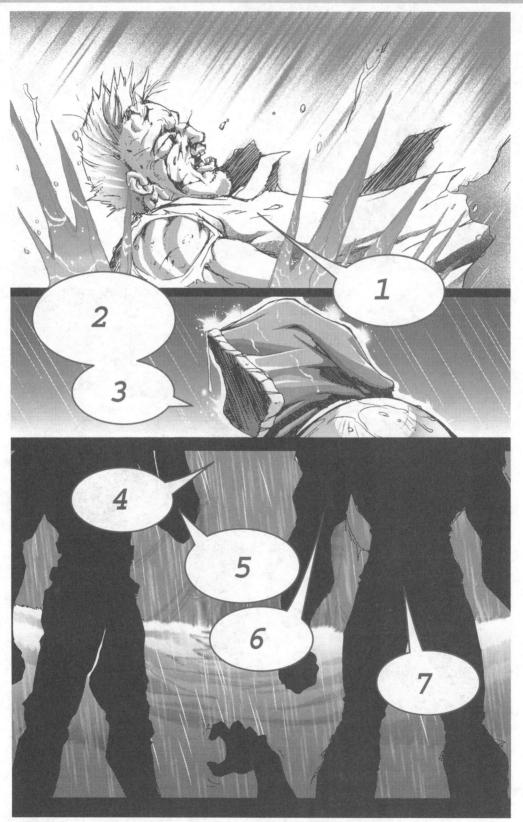

Panel 4: The same panel with poorly placed balloons.

Sound Off

Sound effects are popular in both Japanese and American comics. Because many manga books have sound effects included in the art, it is difficult, if not impossible, to remove them for English-language translation (as opposed to text in balloons, which can easily be removed with a computer without compromising the art). In translated manga, American readers often have a Japanese sound effect with its English equivalent nearby in the same panel.

Manga Meanings

A sound effect is a word or words communicated in dialogue or nar-

Of course, in this book we are talking about drawing manga in English from scratch, so we don't need to talk about Japanese sound effects. We'll skip straight to English.

A typical sound effect.

Sound effects are popular in fight scenes or action sequences including explosions or gunfire. But they can be used to convey an almost limitless number of sounds—a phone ringing, a door knocking, even a breeze blowing.

Splash effect.

There is an art to making sound effects, just as there is to most other aspects of making comic books. One method used in lettering is to make a sound effect that looks like the sound it describes. In this case, the "splish" is drawn to look like drops of water.

Explosion effect.

Again, this is an effect drawn to look like the sound it represents—an explosion. The effect grows larger in the center, suggesting that the sound grows louder, while visually suggesting an outward expansion, perhaps the burgeoning cloud of smoke and flame and debris you would encounter in an explosion.

Rumble effect.

In this effect, David gave each letter a drop shadow, as well as drawing each character irregularly, to give the balloon a shaky, unsteady aspect.

Mangled Manga

Keep in mind that there is no definitive way to make a given sound effect. Sound effects—and even the spelling of sound effects—are purely the invention and the prerogative of the artist.

Another explosion effect.

Here is another effect, possibly for an explosion, possibly for a fight scene. Notice how the effect grows in size, to indicate its increasing force and decibel level. It is also tilted slightly, which expresses movement.

The sound of a tire going flat.

Not all effects are for great, ear-splitting noises. This could be a "quiet" sound effect, to show the air being let out of a tire or a snake hissing. Balloons often depend on the context they are shown in: a sound effect placed in one panel could have a completely different meaning if put in a different panel.

Sketchbook Savvy

In general, the larger the sound effect, the louder the noise.

A nonsense effect.

In this case, we want to show you that the words do not necessarily matter. This effect is nonsensical, but we emphasize how much design and presentation can add to an effect. Of course, ideally, your words or sounds would work in tandem with the design of your effects.

Visual Effects

Thus far, we've spent the chapter talking about the relationship between words and pictures. Now, suddenly, we are going to talk about pictures *without* words. But this is not as abrupt a transition as you would think. Manga, in particular, excels at visual shorthand. Things which might take a long time to explain otherwise are summed up very quickly in one picture.

Often this is done with exaggeration. As we will see, most of the visual effects seen here are not to be taken literally. A character who is in love may not literally have stars in her eyes, but these sorts of exaggerated visuals help a manga reader quickly ascertain the mindset of a character.

Starry-eyed.

This is a popular manga effect for a character, most often a female, who is love-struck, in awe, or extraordinarily happy. Not only does the character have stars for pupils over a background that looks like a starry night sky, but there are also a few little stars floating around the character's head.

This face is an angry one, with a throbbing temple and beads of sweat jumping hotly from the character's brow. Keep in mind that the character might only appear like this for one panel, to show that he or she is reacting intensely. In the panel before or after this one, the character might be perfectly fine. Again, this is a case in which readers are willing to suspend disbelief and accept something that is not completely realistic to quickly understand the intense emotion, reaction, or mood of the character.

This sad character appears to be literally crying buckets. Of course, it's ridiculous to assume the character is actually doing this, even though that's what the picture shows.

Crying buckets.

An enraged effect.

A nice effect for an enraged character is a flat, slightly downturned mouth and a flushed upper face. The eyes are the focus of this panel, large with thick black circles around them. Remember when we talked about a lack of pupils giving a character a less human aspect? In this picture, the character is so angry that she takes on an unhuman aspect, as if her sole focus is rage or vengeance.

The comic faint.

Sometimes it's most effective to not show your character's face at all. In this case, we have a curlicue line and a foot. To show a reaction of surprise or shock, the character appears to faint dead away. This is more of a lighthearted reaction: perhaps that of a schoolboy who just got asked to a dance by the girl of his dreams or somebody who just found out he won the lottery.

Mind blown.

Here's an exaggerated visual of someone's mind being blown. Again, this is not to be taken literally. Neither the manga readers nor the other manga characters will think this character suddenly has pinwheels for eyes and is being hit by a giant mallet. This could mean a multitude of things within the context of your story. Like sound effects, visual effects have several uses and meanings and depend on the story's context.

The Least You Need to Know

- Native Japanese comics are translated and then "localized" to sound like conversational English. Since you will create your own comics, no translation or localization will be necessary.
- Word balloons are differently shaped in Japanese and American comics, because the words and characters are read differently.
- Correct placement of balloons is important. If you place your balloons incorrectly, your story will become muddled and unclear.
- Sound effects are a great way to add atmosphere to a panel, and there are many ways to craft an effective balloon.
- Manga often exaggerates visuals to cartoon effect to convey a character's intense emotion, but these effects are not to be taken literally.

Round Out Your World

Manga is a vast and multifaceted universe, and in our final part we are going to explore the corners of this universe, looking at the objects and environments that help make your story complete. Often this means finding the correct background, giving your characters the right wheels, or equipping them with what they need to defend themselves.

We'll look at objects that are natural and objects that are man-made, focusing on manga's fascination with all things mechanical and technological. By the end of this part, you'll have all the tools you need to dream up a vast and multifaceted manga universe of your own.

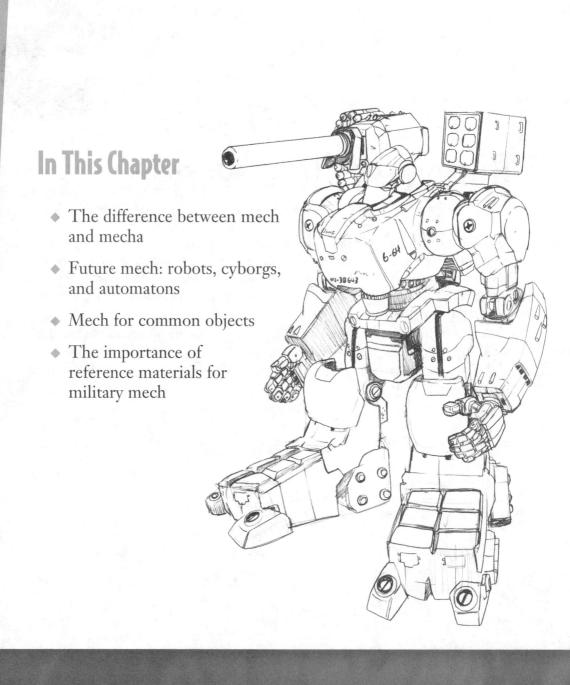

Chapter

Make It Mech

Now we're going to explore ways to round out your world. And because mech plays such a large role in manga, we'll start there first.

Mech vs. Mecha

Mech should not be confused with *mecha*, although some people use the terms interchangeably. Mecha, as we use the term here, refers to the very popular giant robot genre of anime and manga. Mech, on the other hand, refers to anything mechanical.

Manga Meanings

The term mech pertains to all things that are mechanical. In contrast, mecha pertains specifically to giant robots.

The Marvelous Mechanical World of Manga

Mech has a huge presence in manga. Unless your characters are H-bombed back to the stone age, your sci-fi tales will be overrun by mech, as mech includes robots, androids, cyborgs, computers, virtual reality, spaceships, starfighters, laser pistols, laser swords ... the list is literally endless, limited only by your imagination.

Robo-Babe

Here David has roughed out a mech-based character. For now, we see a sketch of a young adult female figure. We also see outlines for parts of the character's costume. We'll get a better idea of exactly what we're seeing as David tightens up the pencils.

Next the figure is honed. We get a much clearer look at the character's shape. We also see clearly defined lines on the character's limbs and torso, although it's unclear exactly what these lines will be.

More details emerge as David continues to work on the character. We see more lines on the character's limbs, and their smooth, sharpangled geometric shapes suggest that this character is wearing some sort of mech—perhaps a high-tech futuristic bodysuit.

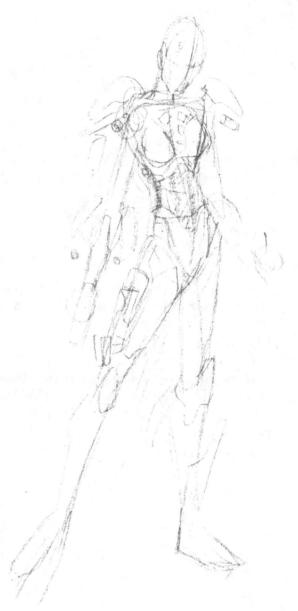

A rough sketch of a mech character.

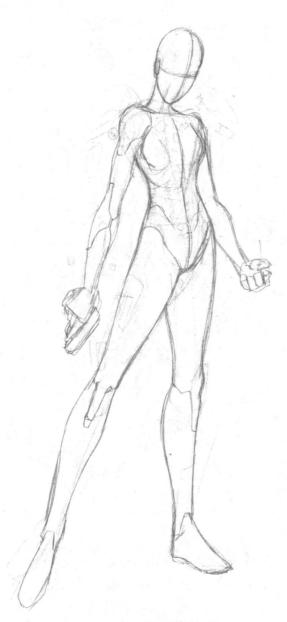

More details are added to the figure.

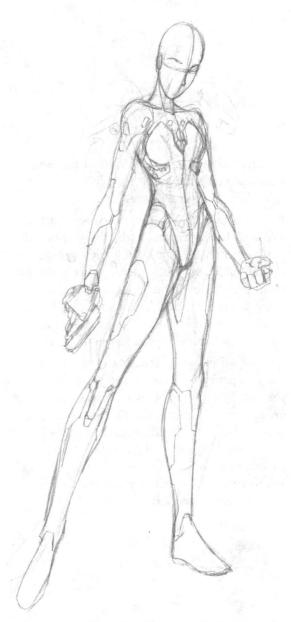

The figure is finessed, with even more detail added.

Close-up of a human female face.

David details the face now, to all appearances a normal human female drawn, in the manga style, in a three-quarter view.

And here is the figure with even more detail. We see what appears to be the finished penciled drawing of an attractive young girl-with-gun in a futuristic, form-fitting outfit. As we noted previously, the lines on the limbs suggest that the outfit has some mech elements to it, as do the small squares around the chest and shoulders, which look like they could be microchips.

Now we see what David was getting at in the first panel—what those rough outlines in the first figure were all about. The lines we saw are not actually part of the character's suit, but parts of her *body*, which extend and transform to show various mechanical parts. On the figure's calves are what look like tiny jets; the left arm is a weapon; and within her shoulder is what appears to be some sort of camera.

Manga Meanings

Character turnarounds are different shots of a character that can be used for reference later. They usually include three full-body shots of a character in costume, front, back, and profile, as well as a couple of close-up head shots.

The finished futuristic female.

Some mech surprises are hidden up her sleeve.

David planned ahead when he was designing this figure, intending to first show us a figure that looked like a normal girl, which we could later compare against this mech version. If David was doing *character turnarounds*, he would definitely keep these side by side, so he could reference the character each of the ways she appears, in her fully human and partially robotic form.

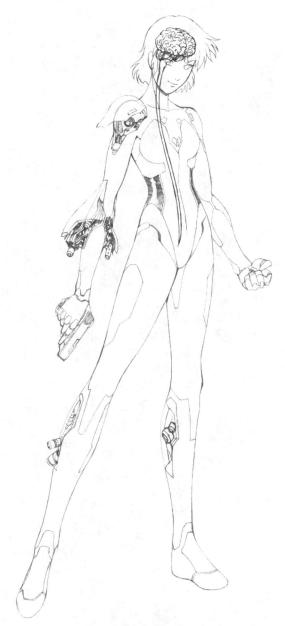

Cyborg with human brain.

Obviously David had a plan up his sleeve when he designed this character. She would appear human until the time was right, and then all sorts of mech contraptions would pop out of her body, revealing that she was not human at all.

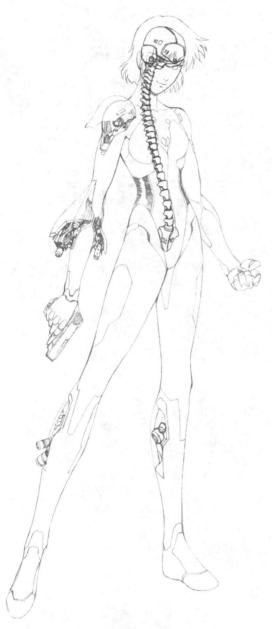

Robot in a human shell.

Here David adds another design element, taking things a bit further. Here we see the character with a robotic brain. This is not a partially human cyborg; it's pure robot. Ideally, he would surprise the reader with this even further into a story. Perhaps the readers think the character is a girl until they see her robotic parts.

Mecha Man

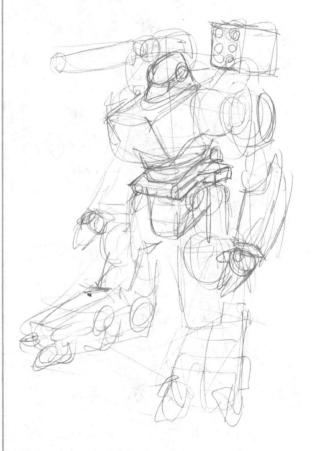

Rough sketch of a monstrous mech.

Here is a rough of a more obviously mechanical creation. For this figure, the shapes are not circles and cylinders (other than the circular joints), but rather squared, rectangular, and blockish.

Here is the finished figure, a formidable piece of mech as anyone can see.

Say What?

One machine can do the work of fifty ordinary men. No machine can do the work of one extraordinary man.

—Elbert Hubbard (1856–1915), American author

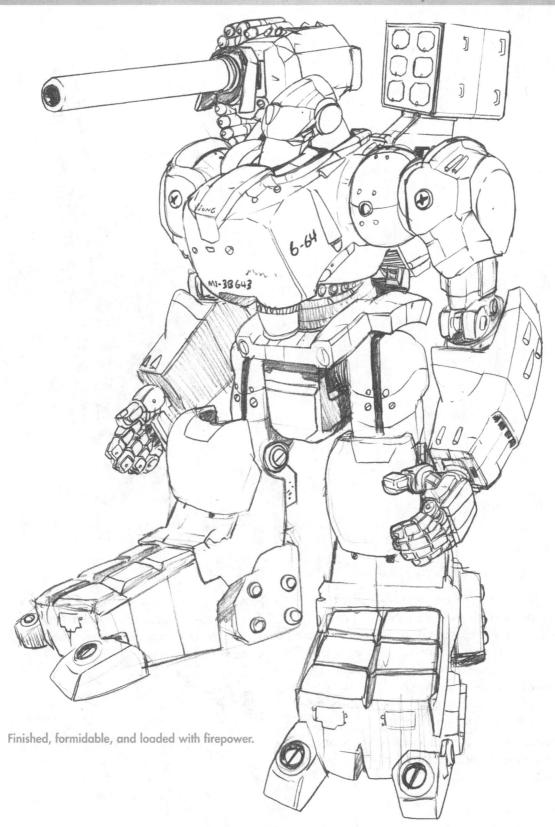

Common Mech

Close-up of a futuristic communicator.

Not all bits of mech are as intricate as female androids and battle-armored mech. Some are as mundane and commonplace as a cell phone. Of course, it's always a good idea to try to make your mech a little more interesting than the standard cell phone, especially if your story takes place in the future, when technology styles most certainly will have changed.

Some gray tones were added to the phone to give it more dimension. Highlights were added as well.

Gray tones give this tool a metallic appearance.

Military Mech

Not all mech is fictitious, and sometimes you'll want to make your mech as accurate as possible. To capture the details of military mech, find some good references on military history.

Sketchbook Savvy

A visual dictionary, which shows pictures of objects along with some terminology relating to the objects' components, is an invaluable reference for a writer or artist. Visual dictionaries don't go into a tremen-

dous amount of detail, but they're a good way to get a quick look at a great many things.

Rough sketch of a piece of modern mech.

Finished contemporary tank.

Unless you are an expert at tanks, there is no way to draw something like this from memory. You'll need to dig up some reference materials if you want it to appear remotely realistic.

The Least You Need to Know

 Mech is verbal shorthand for "mechanical." The possibilities for mech are limited only by your imagination.

- Mech is prevalent in manga, no matter what setting you choose, but it is especially crucial in stories set in the future.
- Mecha, which features giant robots, is a popular genre of manga and anime.
- Twists and surprises planned into your story will keep your readers interested.
- Books on military history are a great reference for real-world mech, as well as a starting point and inspiration for your own futuristic mech creations.

In This Chapter

Weapons, characters, and story

Chapter 3

Draw Arms!

If you're creating a manga story with action, chances are it's going to have weapons. If you want to tell a story with action and conflict, you'll have to be prepared to draw weapons.

Finger on the Trigger

Approach drawing guns the same way you approach drawing mech. Construct the weapon roughly with shapes. In this case, a lot of circles, rectangles, and cylinders make up this amazing-looking chain gun.

Say What?

He will win who knows when to fight and when not to fight.

—Sun Tzu (approx. 400 B.C.E), ancient Chinese military tactician

The finished weapon has lots of crisp lines and clean detail to give it a mechanical look.

Your character's choice of weapon can often reflect the type of character he or she is.

Say What?

Nothing in life is so exhilarating as to be shot at without result.

—Sir Winston Churchill (1874–1965), British statesman

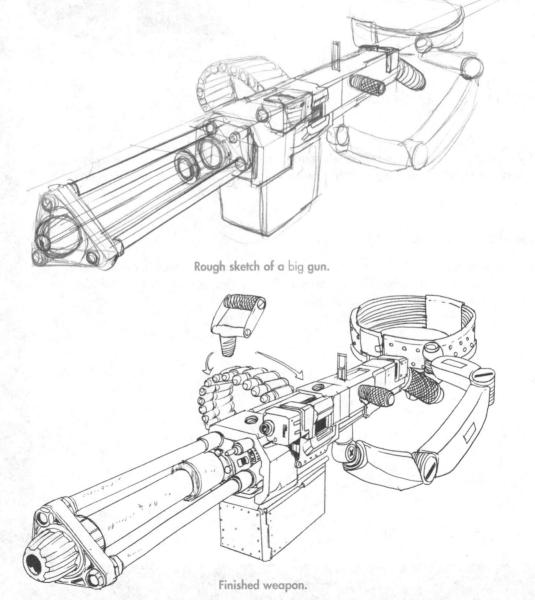

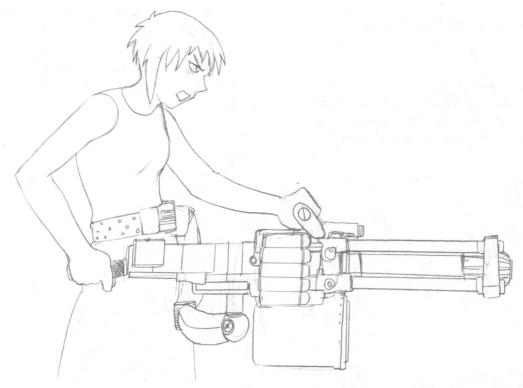

Gunfighter.

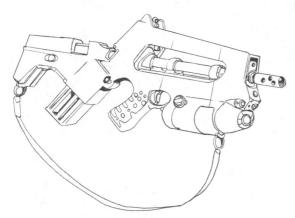

Another big gun.

Here's a different finished figure of a big gun. There are plenty of gun references out there, from Guns & Ammo type magazines to books on military history and contemporary warfare. Science fiction movies and television are also terrific sources of inspiration for futuristic weapons.

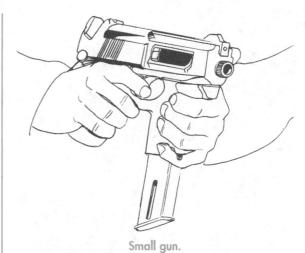

Pistols and small guns are even easier to invent than larger guns. As long as what you draw has a handle, a barrel, and a trigger, it will look like a gun, so you can go nuts coming up with cool and futuristic designs. Again, base your design on a pre-existing gun model and then experiment with tweaking the design.

Close-Quarter Combat Weapons

Of course, not all weapons are ranged weapons or sophisticated pieces of mech. Some stories call for hand-to-hand weapons, so let's spend a bit of time talking about *mêlée weapons*.

Manga Meanings

As any experienced gamer or roleplaying game (RPG) participant can tell you, mêlée weapons are handheld, nonranged weapons, such as swords, knives, bats, and clubs.

Rough sketch of a sword.

Here is a rough of what might be the most fundamental of handheld weapons, the sword. Obviously, these types of weapons are less complex than guns and easier to draw. The figure is basically T-shaped, coming to a point at the bottom.

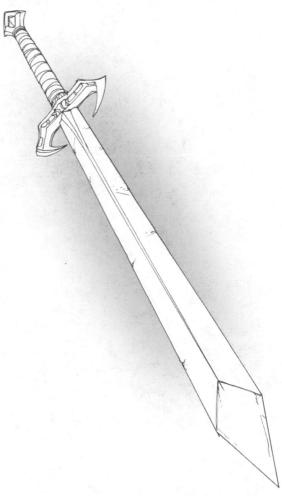

Finished weapon.

The finished figure isn't much different from the rough. It is a simple object, with fewer components than a gun and, hence, less detail.

David roughs out a scimitar here. This figure is little more than the rough shape of the blade.

Scimitar rough.

Scimitar with details penciled in.

David adds detail to the figure in pencil, including the hilt and some decorative rings on the dull side of the blade.

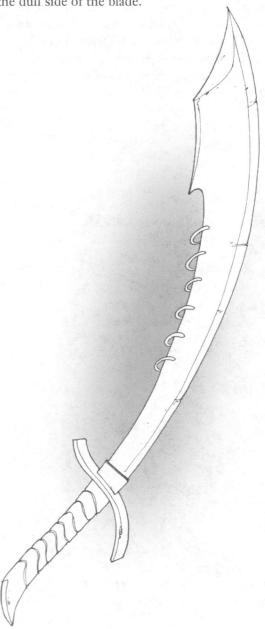

Finished weapon.

The inked figure looks similar to the finished pencil drawing, with a line inside the blade giving the edge the appearance of sharpness. The rings are purely decorative, to make this weapon more memorable and unique.

Oddball Armaments

Often a unique weapon makes for an effective plot-driving device known as a *MacGuffin*, an object that the characters are trying to find, control, or maintain. An example would be a magical sword in a fantasy story that everybody is trying to get ahold of.

Manga Meanings

A film term coined by British film director Alfred Hitchcock, a MacGuffin is an object, artifact, or weapon that is being pursued, something that creates motivation or drive for the characters. Often it

is something that both the heroes and the villains are racing to find first or control.

Rough sketch of a sickle.

Finished weapon.

Consider equipping your figure with an odd or uncommon weapon, something to make that character stand out from all the others. Plenty of books cover handheld mêlée weapons, and it's not difficult to come up with something that's visually a little more off the beaten path.

Here is a finished sickle. In the ink phase, David added a long highlight to the black handle, making the staff appear sleek and shiny. Two groups of thin lines on the sickle suggest a metallic sheen to the blade.

The Least You Need to Know

- Complex weapons are built using a combination of shapes, just like figures and mechanical constructs.
- Exaggerate your weapon for dramatic effect, particularly in futuristic war or scifi stories.
- A character's choice of weapon might reflect that character's personality or situation.
- Consider your character's relationship with his or her weapon. Some characters will be forever associated with their weapons.
- A weapon makes for a good MacGuffin, a plot-driving object after which the characters are chasing.

In This Chapter

- How different vehicles help define your characters
- Four-wheeled wonders
- Road hogs

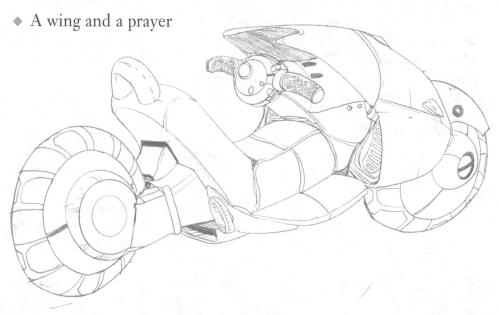

Chapter

Manga's Driving Force

Vehicles play an important role in manga, more so than in American comics. Manga's fascination with all things mechanical extends to mech to ride, mech to drive, and mech that breaks speed limits and sound barriers.

Hot Wheels

David picks his perspective, then begins to draw this vehicle with a rectangular shape. David is already thinking ahead to what the car is going to look like, and we see some preliminary guidelines for the car, including the rounded front.

The car takes shape in this tight penciled sketch, and we can see that this vehicle will be a stylish sports roadster.

A car in the earliest phase.

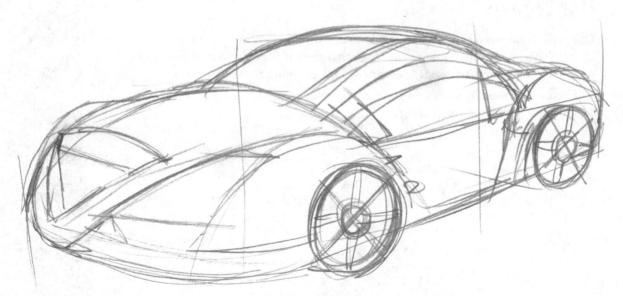

Rough sketch of the car.

Say What?

No other manmade device since the shields and lances of the knights quite fulfills a man's ego like an automobile.

—William Rootes (1894–1964), British automobile manufacturer Here is the final figure, inked, with smooth, clean lines and dark, tinted windows to give the car a more ominous and mysterious look. When designing wheels for your characters, keep in mind that a vehicle tells a lot about its owner, as well as about the world you are creating. By giving your car some personality, you can help give your character personality.

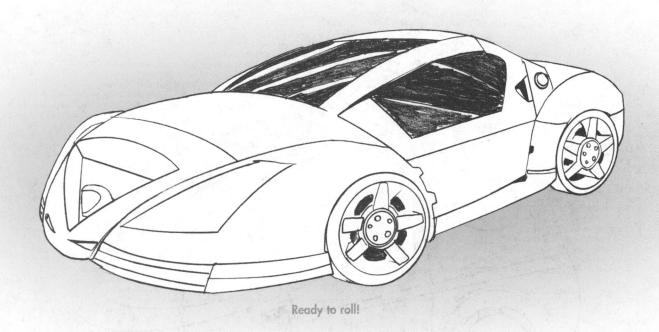

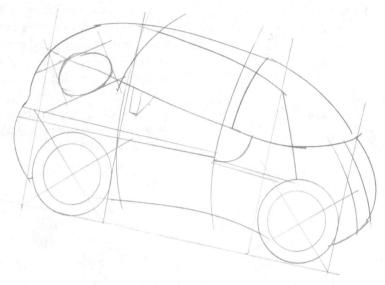

Sketch of a mini-car.

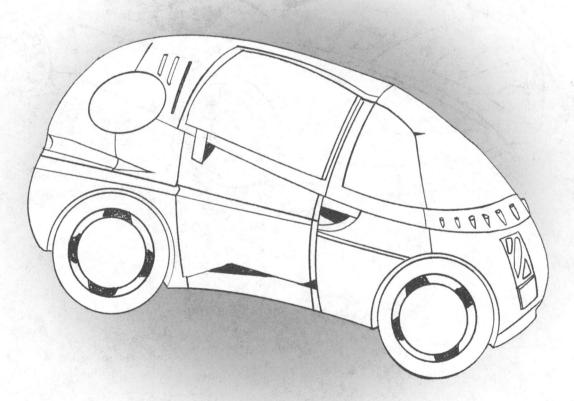

Another marvel in motoring.

David is going for a different type of car here, a space-saving, fuel-efficient mini-car. Even in pencil, we can tell that this car is more realistic than the other cars we've seen, the result of David's using photos for reference. How realistic you want your vehicles to be is your choice. Often manga mixes realism and fantasy. A car might look completely realistic, and an artist might have taken great pains to capture it as exactly as possible, but the character driving the car might have a wild, cartoony, exaggerated expression on his face.

Manga's mixture of the real and the unreal is one of its defining attributes and is certainly part of its charm and appeal.

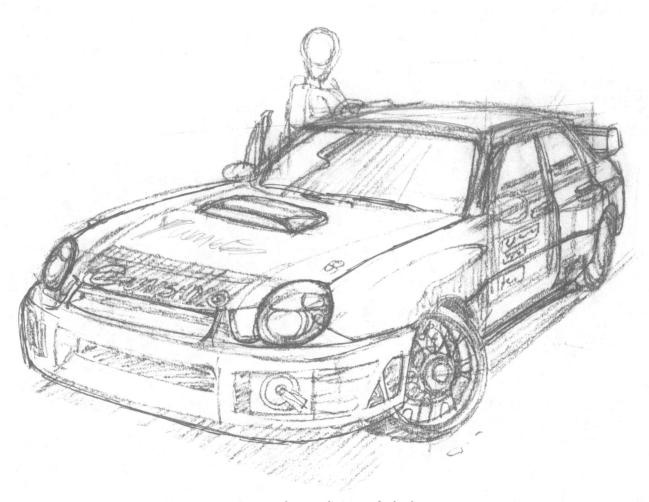

A more photo-realistic set of wheels.

Happy Trails

David offers a rough design for a motorcycle here. Like cars, motorcycles can be easily adjusted to appear faster and more futuristic.

In the final figure, we're able to get a better look at David's design. This particular bike is long and low to the ground, which makes it appear faster and more aerodynamic. The exposed wheel in the back gives the bike a futuristic feel, while the large rounded windshield offers a degree of protection.

Sketchbook Savvy

In addition to books and magazines on motorcycles and motocross, reality TV can be a reference source. In recent years, several TV shows have featured mechanics altering, customizing,

and rebuilding motorcycles. Watch these shows and be inspired by their unique designs.

Sketch of a two-wheeled wonder.

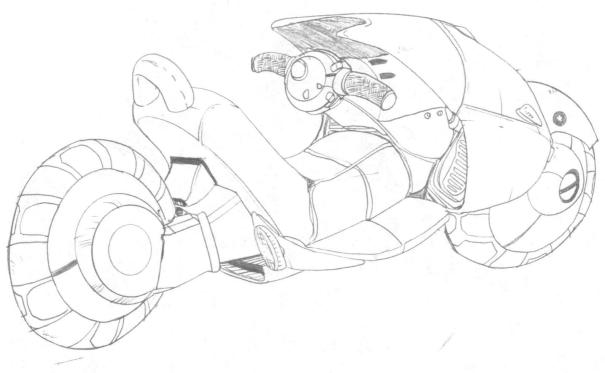

The finished motorbike.

Keeping the Skies Safe

Just as with human or animal figures, it's a good idea to rough out vehicles when you draw them. In the following figure, David sketches out the basic shape of a jet fighter, including, roughly, where the cockpit will be, the wings, and the engines.

David tightens the sketch in pencil, adding detail and definition. Needless to say, you're gonna need references if you want to get it right. But there are plenty of military books out there devoted to this sort of aircraft.

Say What?

I owned the world the hour I rode over it ... free of the earth, free of the mountains, free of the clouds, but how inseparably I was bound to them.

-Charles A. Lindbergh (1902-1974), American aviator

A rough sketch of a jet.

More details are added.

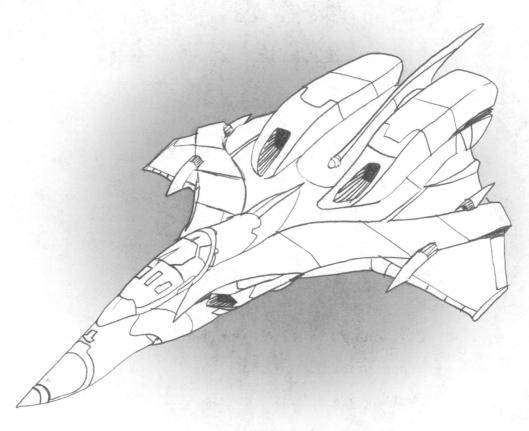

Aim for the sky.

Here is the finished jet. As with other vehicles, you might use an existing airplane as a starting point and then embellish it with things that make yours more unique, high-tech, or futuristic. In this case, the front end of the jet looks very much like current U.S. Air Force fighters, while the back half of the vehicle, the wingspan, tail, and enlarged back jets, comes purely from David's boundless imagination.

The Least You Need to Know

- Vehicles are popular in manga, and the high-speed car chase is a standard action sequence.
- References are particularly important, even if only as starting points for futuristic or fictitious vehicles. Fortunately, vehicle references are readily available.

- It's often best to use a real vehicle as a starting point for the vehicle you invent. Base your vehicle on a real one, then expand upon that design in unique and creative ways.
- Vehicles can be more or less realistic, depending on the tone of your story. Darker stories tend to strive for more real-
- The choice and design of a vehicle reflect the personality of its driver or owner. They might also reflect the society in which your story is set.

In This Chapter

- Envisioning a world for your characters
- What's in the background
- Drawing trees, plants, and grass
- Contemporary, futuristic, and ancient settings
- A few parting words

Chapter 5

World Piece: Backgrounds and Environments

When you create a comic, you must envision a world for your characters. This world-building includes deciding on a setting, the kinds of buildings your characters live or work in, the lands they travel in, the type of civilization they're a part of, as well as the technology available to them.

Overlooked Art

These details should come across in the backgrounds of your panels, the stuff that's *behind* the characters while they are at the forefront of the action. Although backgrounds help round out a panel or page, they are (as their name suggests) background. They are usually unimportant to the story, just providing nuance and atmosphere. In general, readers only notice backgrounds when they are consistently absent from your panels. You don't need a background in every panel, but if you skimp too much, you'll look like a lazy artist and storyteller.

Backgrounds at the Forefront

Of course, we don't want to suggest that every piece of your world will be relegated to unimportant background status. There will be shots without figures, when the focus is on your character's environment—not the character. Establishing shots are a good example. As we've said before, it's a good idea to "set the scene" with an establishing shot each time you transition from one scene to another.

Sometimes you might want to give even more room to an important environment. There will be times where you want to convey the scale and magnificence of a setting with a *splash page* or *double-page spread*.

Manga Meanings

A splash page is a single full-page panel devoted to just one image, usually one that is particularly memorable or dramatic. A double-page spread is a single one-panel image spread over two full pages. This is reserved for the most dramatic shots of all.

Making the Outdoors Great

The basic tree trunk.

Drawing plants is a less exact science than drawing people. You don't have to worry about proper proportions, since every tree is different.

The next step is to add some curved lines around the top of the tree to indicate leaves.

Sketchbook Savvy

Keep in mind the season your comic is set in. Trees will be at their fullest in the spring and summer, have fewer leaves in the fall, and have none at all in the winter. Of course, this varies from tree to

tree, and even climate to climate, and don't forget that certain trees (like pine trees) retain their leaves year-round.

Roughing out leaves for your tree.

Penciling over the rough.

David fills in the circular leaf curves in pencil, making them squiggly. This is an effective way to indicate multiple leaves, without taking the time to draw individual lines.

In the finished and inked tree, David has added differently shaped lines, irregularly placed on each side of the trunk, giving the tree a rough texture. He has shaded the bottom of the tree based on a light source overhead (and to the left). Note that the bottom of the tree is not filled in totally black like the shadows on the right side, which give the tree some added volume and dimension.

A finished tree in full bloom.

Sketching a tree from a different angle.

Here are the beginnings of a tree from a more dramatic angle, a worm's-eye view. Again, David starts with the trunk. The trunk gets smaller as it ascends. This is partially a trick of perspective, showing that the highest part of the trunk is the farthest away from us.

Branches are added.

Here David adds some branches, as well as more detail to the trunk. Again, there is no correct way to make a tree, as they all vary in shape and size, as well as in the number of their branches and their growth directions.

Texture is added to the trunk and branches. The lines of the trunk are vertical, but curvy, to show the irregular texture of the bark. Lines around the branches both roughly parallel the branches and encircle them.

Remember: Trees have branches within branches within branches, each getting smaller as they extend out from one another.

Barking up the right tree.

Adding ink and detail to finish the tree.

In the final inked tree, the light source comes from above. This is why the leaves we see in a worm's-eye view are primarily in shadow.

· Mangled Manga

Don't spend too much time and effort worrying about things like what kind of tree you are drawing. Your readers won't even notice, unless it's an important story point.

An idea is planted.

For a plant, David starts with a circle, with some larger curved lines coming out of the center, leaning outward around in a circle. The circle is cut into "pie slices," with tiny lines denoting blades of grass.

Leaves and grass are added.

Leaves are added, using the curved lines in the center of the figure as a guide. Smaller leaves are added around the base of the plant, and the "grass" around the pie slices is given more length and volume.

Here is the inked and finished plant. Notice the difference between the plant and the grass surrounding it. The plant has wide, smooth leaves, and the grass is smaller and shorter and more dense.

Next we see the same plant as previously, sprouting up across a small plain. Note that you don't have to cover the plain with the plants to show that the plain is overgrown.

Next, the same picture is shown inked. There's not a lot of difference between these pictures, except that there are more lines to indicate grass on either side of the plants, small lines that lean slightly away from the plant.

multi all 11-MA MANMA HAS.

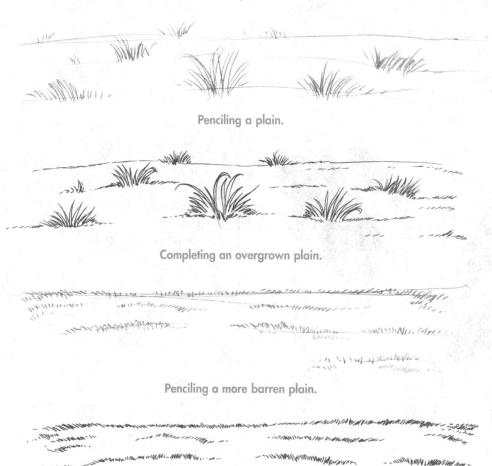

A finished grass landscape.

Sketchbook Savvy

Gardening magazines are good references for cool flowers and foliage. Travel magazines such as *National Geographic* are also good for exotic natural wonders.

For a simple grassy plain, you need only make a horizon line and a few lines to indicate slight curves and grades on the ground. On these lines are some very loose squiggles. Grass can be a bunch of M-shaped squiggles or a bunch of tiled L-shaped chicken-scratches. Which you chose, or whether to chose both, is your own personal preference.

And here is the finished and inked plain. Note that the penciled horizontal guidelines have been erased. All we see is grass, with no lines to indicate ground.

Cities of Manga

From nature we move on to civilization, which are arguably more important than natural settings. Buildings and cities are more exact and much less forgiving—particularly modern cities, which your comic book readers know about firsthand and see every day. Of course, there's more latitude with futurist cities and ancient cities ... and even foreign cities.

Below we see David's picture of a modern cityscape, created with shapes (primarily squares and rectangles) and thin, smooth lines. Make sure you get your perspective correct. In cityscapes more than anything else, bad perspective sticks out like a sore thumb.

In this case, the lack of shadows gives the city a high-tech, very modern luster.

A modern downtown view.

Say What?

The true test of civilization is not the census, not the size of cities, but the kind of man that the country turns out.

-Ralph Waldo Emerson (1803–1882), American essayist and poet

Below is the penciled version of the modern city street. It's one of the best examples of the value of references, particularly photo references. Your average city block assails you with untold numbers of signs and messages and has tons of details, from parking meters and telephone poles to mailboxes.

Laying out a contemporary city.

Final picture of Anytown, U.S.A.

Needless to say, you have considerably more latitude in drawing cities set in the future. Skyscrapers can extend as high as you want; buildings can float; architecture can defy gravity. This rough drawing is little more than some undefined shapes, with a vanishing point in the middle right side.

Sketchbook Savvy

Can't afford all the books and magazines I keep recommending for reference? Try borrowing them from your local library.

And here is David's penciled vision of the future, where the undefined shapes have become oddly shaped buildings. The architecture of the buildings is rounded, and this is reflected in the window design, which is round as well.

Rough sketch of a science fiction future.

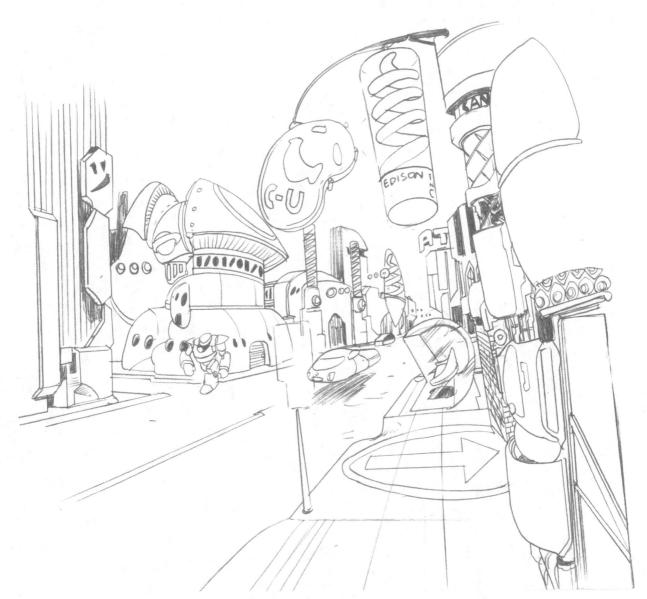

The finished futuristic city.

Here David is going to draw an ancient ruin. David picks his perspective and roughs the drawing with some very basic shapes. This particular shot is modeled after actual ruins in Europe, referenced from a book on monasteries and abbeys.

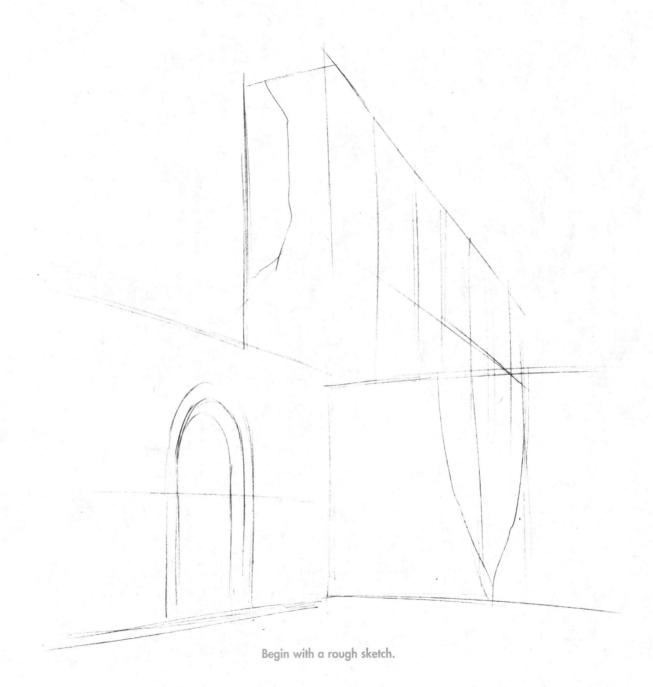

David supplies additional detail, including rocks on the ground and, most notably, parallel lines that will become bricks in the finished drawing.

The inked and finished drawing is dramatically lit and lovingly detailed. For the ruined and dilapidated parts of this drawing, David erased the original section where he wanted

the rocks broken away (which showed no sign of being ruined in the rough) and scribbled to achieve the deteriorating effect. He sharpened this in the inking phases, making sense out of his scribbles and making them look like they belonged.

To show the bricks in shadow, David went in with a quill and white ink and made some lines to denote the shadowing.

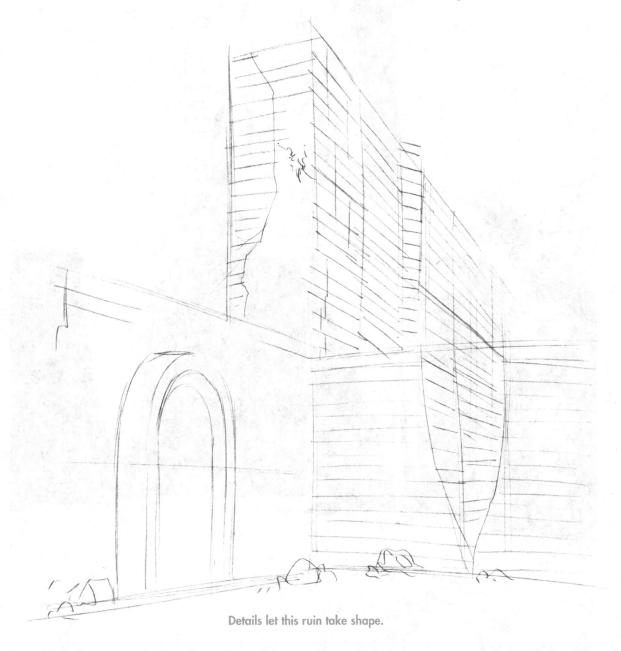

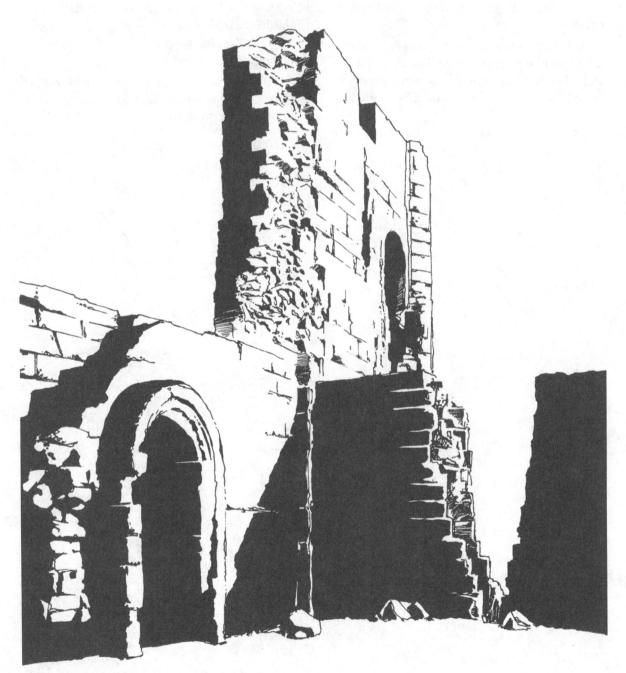

The shadowy, textured, finished figure.

In this second ruin rough, David starts with an outline of the area rather than geometric shapes. This panel, inked with just a bit more detail, would make a sufficient background. You should draw backgrounds most of the time, but they don't always need to be terribly detailed.

David has added more parallel lines, indicating where the bricks will be in the finished work.

An outline serves as your guide.

Add details in pencil.

Here is the finished, inked figure. David has taken what were originally black shadows on the ruins on the right and left and applied a light-to-dark graduated tone to them. The tone changes the lighting dynamic of the drawing, creating the effect of a sunset. The light is clearly closer to the foreground ruins and farther from the background ruins.

The finished ruin at sunset.

Now David takes a different approach to the same figure, keeping the foreground shadows black, and doing a light-to-dark gradient in the background shadow. This achieves a different

sort of lighting and atmospheric effect, this time implying some mist in the distance, as if this shot takes place on a foggy Scottish moor or an equally moody or spooky environment.

Another view of the ruin shrouded in mist.

We should note that in both the previous two pictures, *all* the shadows were inked in and were originally totally black. David scanned the picture into his computer and selected the black area or areas to which he wanted to apply a gradient, or grad. In the first drawing he selected the black shadows on both sides of the figure and applied a grad to the shadows. In the second figure he selected the black shadow in the center of the image and applied the grad to it. The end effect of *both* images is to separate the ruins between foreground and background planes, giving the scene much more dimension than it would have if it were all black shadows.

Just the Beginning

And so we reach the end of our great manga adventure. But perhaps this is just the beginning of yours. We leave you with plenty of stuff to draw and one (and only one) word of advice: practice. You won't become a good comic book artist overnight, no matter how much you want it. Of course, wanting it really badly and working hard for it is an ideal combination.

Ideas, however, are up to you to come up with. As always, the better the idea, the more unique your stories, concepts, and characters, the better your comic will be.

The Least You Need to Know

- Backgrounds are simultaneously important and unimportant. Your book will look stark without them, but backgrounds are not something readers pay much attention to, so don't spend too much time on them.
- Put more detail into a setting when it is important to the story or when your character is interacting with the environment.
- Drawing objects from nature adds a realism to the book, but don't worry about being too realistic. Your reader won't care what type of tree is in the background.
- Photo references can help you capture all the nuances of the modern city, and history and architecture books are good for older, ancient, and historical buildings and civilizations.
- Succeeding as a comic book artist takes hard work, patience, practice, and lots of imagination.

Recommended Reading

Here is a sampler of some of our favorite manga books, noteworthy because they have great art, or great stories, or both. Some are translated from Japanese and some were created by English-speaking comic book creators. All are available in English in the United States—either online, in bookstores, or at your local comic book store.

Please note that many of these books have several volumes. These titles can range in length from a single volume to several dozen different books in the same series.

Manga

- Asamiya, Kia. *Batman: Child of Dreams*. DC Comics, 2003.
- -----. Steam Detectives. Viz, 2004.
- Clugston-Major, Chynna. *Blue Monday*. Oni Press, 2001.
- Espinosa, Rod. *Neotopia: The Enlightened Age*. Antarctic Press, 2004.
- Hutchison, David. *Junction 17: Black Wave*. Antarctic Press, 2004.
- Kawaguchi, Kaiji. Eagle: The Making of an Asian-American President. Viz, 2000.
- Nihei, Tsutomu. Blame! Kodansha Ltd., 1998.
- -----. Wolverine: Snikt! Marvel Comics, 2003.
- Okada, Megumu. *Oboro*. Kadakowa Shoten Publishing Co., Ltd., 2003.
- Otomo, Katsuhiro. *Domu*. Dark Horse Comics, 2001.
- ----. Akira. Kodansha Ltd., 2002.
- Saiga, Reiji, and Sora Inoue. *Real Bout High School*. Kadokawa Shoten Publishing Co., Ltd., 2000.
- Samura, Hiroaki. *Blade of the Immortal*. Dark Horse Comics, 2004.
- Shirow, Masamune. Ghost in the Shell:

 Manmachine Interface. Kodansha Ltd.,
 1995.

- Takami, Koushun. Battle Royale. Viz, 2003.
- Torres, J., and Takeshi Miyazawa. Sidekicks. Oni Press, 2001.
- Usune, Masatoshi. *Eater*. Jump Comics Deluxe, 1991.
- Wight, Joseph. *Twilight X*. Antarctic Press, 2003.

General Art

- Here are some other books that we recommend to educate and inspire you. These books are about manga, comics, and art, and many not only explore exceptional manga artists, but exceptional artists who work in a variety of mediums.
- Bresman, Jonathan. *The Art of Star Wars Episode 1: The Phantom Menace*. Ballantine Publishing Group, 1999.
- Dean, Martyn. The Guide to Fantasy Art Techniques. Paper Tiger, 1988.
- Dini, Paul, and Chip Kidd. *Batman: Animated*. DC Comics, 1999.
- Hamilton, James. Arthur Rackham: A Life with Illustrations. Arcade Publishing, 1994.
- Hogarth, Burne. *Dynamic Figure Drawing*. Watson-Guptill Publications, 1996.
- Kawarajima, Koh. *The New Generation of Manga Artists*, *Vol. 1*. Graphic-Sha Publishing Co., Ltd., 2002.
- Kent, Steven L. *The Making of Final Fantasy:* The Spirits Within. Brady Publishing, 2001.

- Martin, Gary. The Art of Comic-Book Inking. Dark Horse Comics, 1997.
- McCloud, Scott. Understanding Comics. DC Comics, 2001.
- Mead, Syd. Oblagon: Concepts of Syd Mead. Kodansha Ltd., 1996.
- Peck, Stephen Rogers. Atlas of Human Anatomy for the Artist. Oxford University Press, 1982.
- Sadamoto, Yoshiyuki. Der Mond. Kadokawa Shoten Publishing Co., Ltd., 2001.
- Schodt, Frederik L. Manga! Manga!: The World of Japanese Comics. Kodansha International, 1992.
- Shirow, Masamune. Intron Depot. Seishinsha Co., Ltd., 1988.
- Sonoda, Kenichi. Kenichi Sonoda Artworks 1983-1997. Mediaworks, 1999.
- Terada, Katsuya. Rakuga King. Aspect Corps, 2002.
- Toriyama, Akira. Dragonball Daizenshuu 1: Complete Illustrations. Shuueisha Publishing Co., Ltd., 1995.

in the second second

and the second of the

And the second

Appendix D

Online Resources

Comic Book Resources (comic news): comicbookresources.com

Craig Mullins (digital matte painter): goodbrush.com

David Hutchison (our esteemed artist's website): www.David-Hutchison.com

The Drawing Board (artists' community): www.drawingboard.org

Makoto Shinkai Fan Web (animator, creator of "Voices of a Distant Star"): daike.hp.infoseek.co.jp

Newsarama (comic news): www.newsarama.com

Pulse (comic news): www.comicon.com/pulse

Sumaleth's Art Links Archive (artist and reference links): www.sumaleth.com/links

System Apex (links to Japanese artists' websites): apex.syste.ms

TeamGT Studios (conceptual design community): www.teamgt.com/index2.htm

Tokypop (manga publisher): www.tokyopop.com

Udon Entertainment Corp. (comics publisher): www.udoncomics.com

VFXworld (animation and visual effects community): vfxworld.com

Viz Media (manga publisher): www.viz.com

Tell fabulous stories with your art!

The Complete Idiot's Guides® have a long history of bringing easy-to-use, beautiful drawing books to the masses. Find your creative side and tell your story—all while learning the basics and beyond.

ISBN: 978-1-59257-795-8

ISBN: 978-1-59257-738-5

ISBN: 978-1-59257-223-6

ISBN: 978-1-59257-636-4

ISBN: 978-1-59257-233-5